LIBRARY/NEW ENGLAND INST. OF TECHNOLOGY

3 0147 1004 1314 8

W9-DDD-753

QA 76.76 .C672 F54 2013

Finch, Andrew

The Unreal game engine

DATE DUE

PRINTED IN U.S.A.

New England Institute
of Technology
Library

3DTotal Publishing

3DTOTALPUBLISHING

THE UNREAL
GAME ENGINE

A Comprehensive Guide to
Creating Playable Levels

Andrew Finch

NEW ENGLAND INSTITUTE OF TECHNOLOGY
LIBRARY

3-15

865492431

3DTOTAL**PUBLISHING**

Correspondence: publishing@3dtotal.com
Website: www.3dtotalpublishing.com

The Unreal Game Engine: A Comprehensive Guide to Creating Playable Levels. Copyright © 2013, 3DTotal Publishing. All right reserved. No part of this book can be reproduced in any form or by any means, without the prior written consent of the publisher.

All artwork, unless stated otherwise, is copyright © 2013 3DTotal Publishing. All artwork that is not copyright 3DTotal.com Ltd is marked accordingly. Every effort has been made to ensure the credits and contact information listed is correct. However, if any errors have occurred the editors and publishers disclaim any liability and respectfully direct people to our website www.3dtotalpublishing.com for any updated information or corrections.

First published in the United Kingdom, 2013, by 3DTotal Publishing

Softcover: 978-1-909414-04-4

Printing & Binding
Everbest Printing (China)
http://www.everbest.com

Editor: Jess Serjent-Tipping
Sub-editor: Adam J Smith
Designers: Imogen Williams & Matt Lewis
Visit www.3dtotalpublishing.com for a complete list of available book titles.

INTRODUCTION
UNREAL GAMES ENGINE

The author

UDK is the Unreal Developer's Kit free game engine for indie game development, which gives access to the award-winning 3D game engine and professional toolset used in high-end videogames. With this helpful and informative book, you will learn to master the various elements that go into creating exciting, detailed environments using the UDK. Designed for 3D artists at an intermediate level and with a passion to improve their skills, this book will be invaluable in helping to build a portfolio of work to land that dream job within the games industry. And once you've mastered your skills with the UDK, you'll be ready to create awesome games using the Unreal Engine!

My name is Andrew Finch and I currently work as an environment artist at Codemasters Racing Studio, located in Birmingham, UK. I have so far published eight titles and am currently working on my ninth. Before Codemasters, I studied animation at the University of Wolverhampton, concentrating my efforts on the 3D-side of animation. During which time, I felt more and more drawn towards creating environments, rather than animating characters or objects.

In my spare time, I started to get into the MOD community – in particular, *Quake* and *Unreal Tournament*, as I am an avid gamer. Once I got my hands on the engines these games ran on, I realized that this is what I wanted to do in life. So, through self-teaching myself about the tools and engines of the various software, I was soon able to start creating my own game environments and assets, developing a good enough portfolio to land my first job at Rebellion Derby (once Core Design) – the creators of the original *Tomb Raider* games.

After working there for three years, the studio unfortunately closed its doors and I had to search for a new job. The experience I had gained both professionally, and in my personal time, meant I was quickly snapped up by Codemasters, where I have since enjoyed working to the present day.

I always push myself to learn new things because this industry is always moving. There are always new technologies and tools being developed, so you need to keep on top of it or you will be left behind so quickly. I'm always buying books and DVD tutorials, constantly

trying to improve my knowledge and skills. It is hard work, but it's what I love to do and I can't see myself doing anything else. It all becomes worthwhile when you see your game sat on the chart shelf in shops – it's a good feeling!

Once I was approached to write this book, I had to take it as an opportunity to teach other people what I have learned and specialized in over the years, and create a reference that I hope will guide artists through the process of creating playable levels and assets in UDK. When I was learning the trade, the resources I had were minimal compared to what's available today, but the books I did have were invaluable to me. So, I guess this is my way of giving back to the community what it has given me over the years.

This book will cover creating environments, weapons and vehicles – and all the lessons taught within it can be applied to all current and future projects. When you have made your way through this book, you will have an understanding of modeling, texturing, setting up materials, lighting, post effects and how to prepare your images for a portfolio.

I've written a lot of tutorials for 3DTotal's magazine, *3dcreative* (**www.3dcreativemag. com**) and I want to take that extra in-depth step to create this book. We will create simple levels using simple assets that look as good as anything you will find in a game of this type released today. I have really enjoyed putting this book together, and I hope that you will learn new techniques and skills to help you produce your own work.

So let's begin!

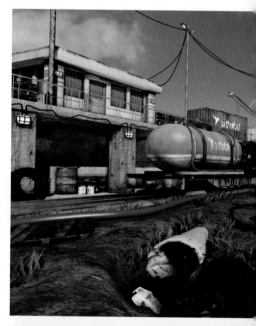

"I guess this is my way of giving back to the community what it has given me over the years"

SOFTWARE USED IN THIS BOOK

UDK – www.unrealengine.com/udk
3ds Max – www.autodesk.co.uk/3dsmax
Photoshop – www.photoshop.com
Marmoset Toolbag – www.marmoset.co
CrazyBump – www.crazybump.com

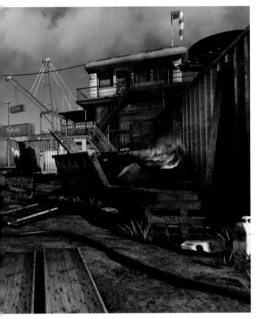

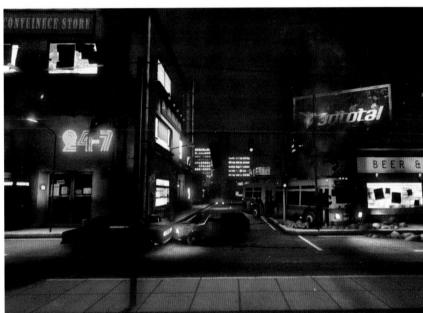

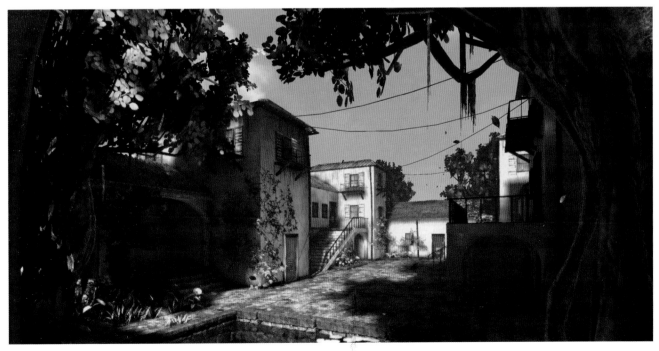

THE
UNREAL
GAME ENGINE

CONTENTS

PROJECT FILES

To help you follow Andrew Finch's processes in creating playable levels and assets, he has provided some relevant game assets, scenes, CrazyBump and BSP files. Before you read on, please download these files to your desktop.

Simply visit: www.3dtotalpublishing.com and go to the Resources section where you will find information about how to download the files.

ITALIAN COURTYARD

A lot of tutorials out there concentrate on creating individual assets. This is okay because it teaches you how to produce a nice detailed asset, but I think if you are going to present it to a potential employer you need to show your asset off by putting it in a scene. This allows you to display your skills, not just modeling and texturing. The level we will create is reasonably small and basic and is hopefully easy to follow, but what it will do is prepare you to start and finish your own projects and produce a really nice portfolio piece.

At the end of this book you will be able to export textures from Photoshop and 3D assets (Static Meshes) from 3ds Max and then import them into the UDK game engine. You will also be able to set up a level in such a way that will allow you to create a standalone, walk-able program to distribute in your portfolio to future employers and friends.

We will cover lighting and post effects to really add polish to your environment, making it stand out and look professional. We will also create assets and textures to use in conjunction with UDK library assets. However, creating every asset yourself would only further impress employers.

CHAPTER ONE
PROJECT PLANNING AND SOFTWARE EXPLANATION

Let's begin by taking a look at the finished scene (**Fig.01**). The scene is made from BSP geometry, Static Meshes, particles, lighting and post effects. So what exactly are these?

BSP geometry – This is basic geometry that is created in the UDK engine and can be textured in the same way you would texture geometry in a 3D package. This is the base that we will build on layer upon layer to get a detailed environment.

> "The BSP geometry is easy to edit so if something is not right we can fix it quickly"

This step is important because it shows us how big the level will be and it will allow us to move about in the world and get a feel for the space and make sure it looks right.

The BSP geometry is easy to edit so if something is not right we can fix it quickly. If we were to create the whole level from

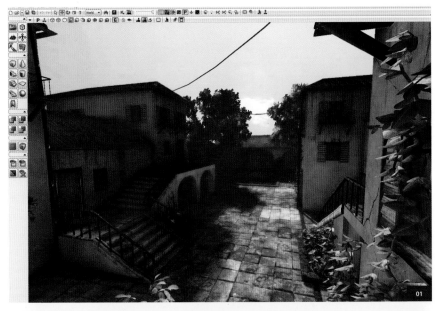

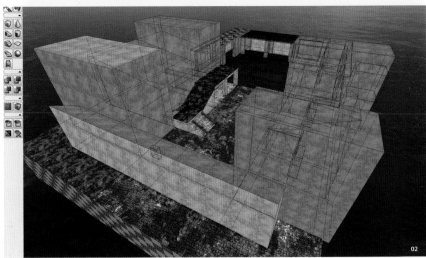

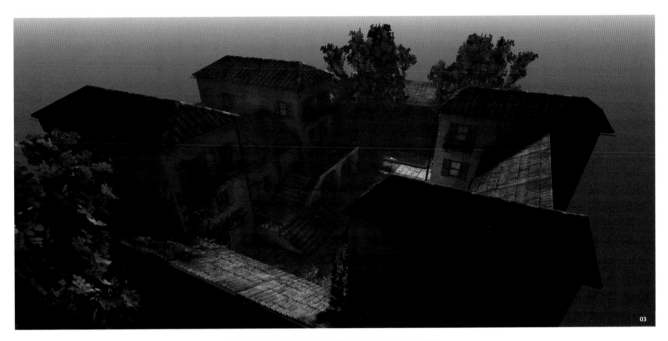

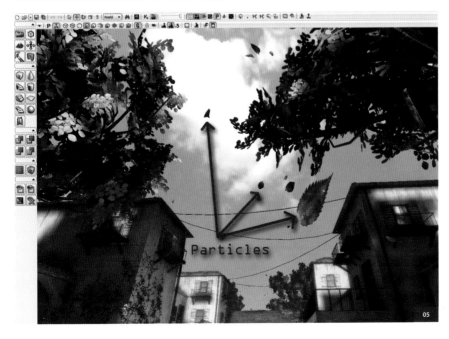

complex static meshes it would take a lot longer to make edits. These images show the BSP geometry and then the BSP geometry with Static Meshes added (**Fig.02 – 03**).

Static Meshes – These are assets such as building sections, objects, vegetation and sky domes, that are created in your 3D package and exported in a format that is recognized by UDK. In 3ds Max you would export meshes as ASCII Scene Export (*ASE) format. The process is very simple and quick; it makes it very easy to get your meshes into UDK (**Fig.04**).

Particles (PFX) – These are a great way to bring your environment to life. In this tutorial, I have used a leaves particle effect to give the illusion of leaves falling from the trees (**Fig.05**). It adds another dimension to your level and gives movement to an otherwise static scene. You can also add particle effects to show water-splashing effects or even birds flying in the sky. The possibilities are endless!

Lighting – The lighting in this scene is very simple but will give us some very interesting areas. The scene is lit by strong sunlight that will produce nice shadows and dark areas, but on the other hand will give us very strongly lit areas and bounce-lit areas. We will use the Lightmass technique to create the sunlight and bounce light.

Post effects – these are things such as motion blur, color correction and depth of field. I will show you how I used these techniques to create a polished-looking final result. **Fig.06 – 07** show the scene with and without post effects. As you can see, post effects add a lot to the final scene.

Open up UDK and let's make a start. In **Fig.08** I have highlighted the main areas we will be working in. I'll give you a brief breakdown of what they are, but I will go into more detail as this tutorial progresses. If you want to know what each icon does then hover your mouse over the icon and it will pop up a quick description.

1. These are your building tools. You will use these tools to create your BSP geometry and edit their shape.

2. These tools allow us to add or carve out geometry that we have placed using the BSP brushes above.

3. These tools allow us to add special volumes to our environment, such as water and collision. They allow us to isolate areas in the map and give them special properties that don't affect the whole map.

4. These are our viewport controls, similar to what you get in 3D software. They allow us to view the viewport in different modes.

5. Highlighted in a cyan box, this is the Content browser. We will be using this tool a lot. This is where we import all our assets for the environment and browse the library of assets that come with UDK.

6. This is where we build our level. When you make edits to the world, you have to rebuild the geometry and lighting in order to get the changes to display correctly. We will be using this area a lot during the tutorial.

7. Finally, these tools get us in the game and playing our level so far. Very important for viewing how our level looks.

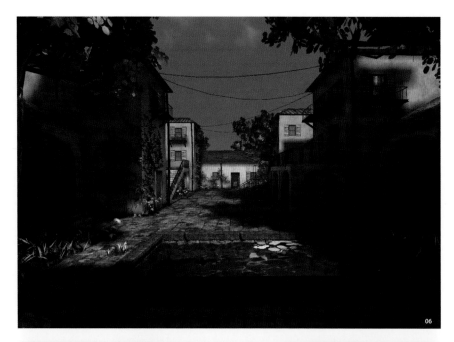

06

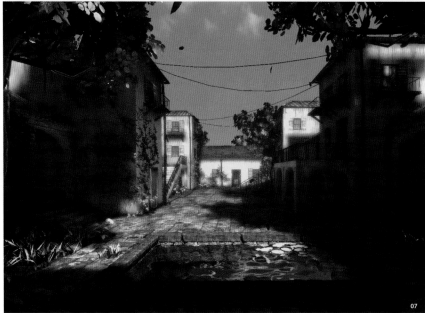

07

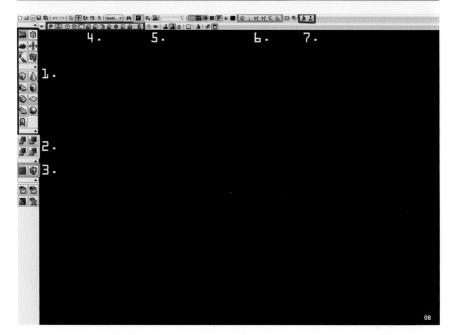

08

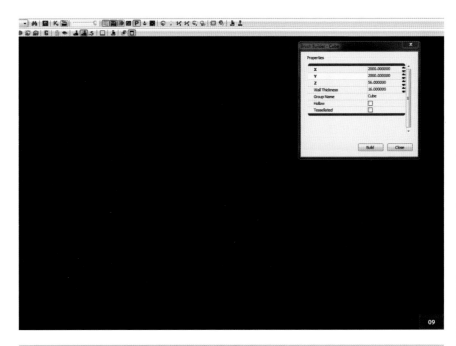

To control the camera in the viewport:

- Click and drag the left mouse button to move the camera back and forth.

- Click and drag the right mouse button to rotate the camera on its pivot point.

- Click and drag the left and right mouse buttons to move the camera up and down.

- Click and hold the right mouse button and use keys W, S, D, A to allow you to move about the viewport in a more natural game-control system.

"Right-click over the Cube brush and the settings for the brush appear"

Let's create a playable little area to get us more familiar with these tools. Click File > New Map > select Additive for the Geometry style. This allows us to add geometry to the map. Right-click over the Cube brush and the settings for the brush appear.

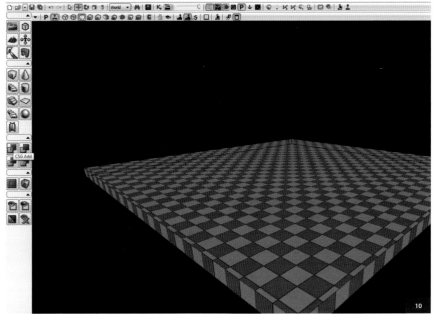

Use the same settings I have used in the screenshot (**Fig.09**) and you will see the red builder brush change shape to match the settings you typed in. Then click on the CSG ADD icon, as shown in **Fig.10**. If nothing happens you need to make sure you are in Unlit Mode for the viewport, located in area four of **Fig.08**.

Because there are no lights in the scene at the moment, the geometry may not be visible. So let's add a light to the environment.

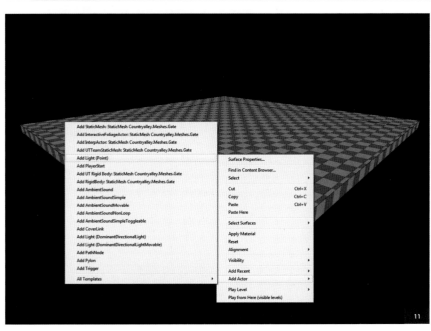

Left-click on the top surface of the new geometry and it should turn a blue color. Then right-click to show a menu. In this menu, scroll over Add Actor and a further drop-down menu will now appear. Select Add Light (Point) (**Fig.11**). This will drop an Omni light into the scene.

Now in the viewport options, select Lit Mode to display lighting in the viewport. With the new light selected, press F4 to display the settings. Here you can adjust things such as Brightness, Color and Radius (**Fig.12**). I will go into further details later in this tutorial, but for now keep the settings as they are. Move the light up in the Z axis to get it off the ground and allow the light to spread across the floor. We now need to build the lighting, so click the lightbulb icon located in area six of the tools described earlier (**Fig.08**). This will pop up a new window of options. Leave all the settings as they are, except for Use Lightmass.

Uncheck this option for now. Lightmass is a new tool that calculates bounce lighting and something I will go into later in the tutorial (**Fig.13**). Click OK and UDK will calculate the lights in the scene and then display the correct lighting.

"In order to be able to move around the level we need a starting point for the player"

In order to be able to move around the level we need a starting point for the player. We can do this by using the same process we used to add a light start point. Left-click on the top surface of the new geometry and it should turn a blue color. Then right-click to show a menu.

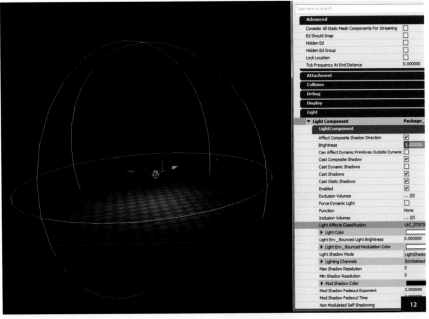

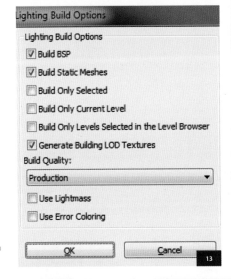

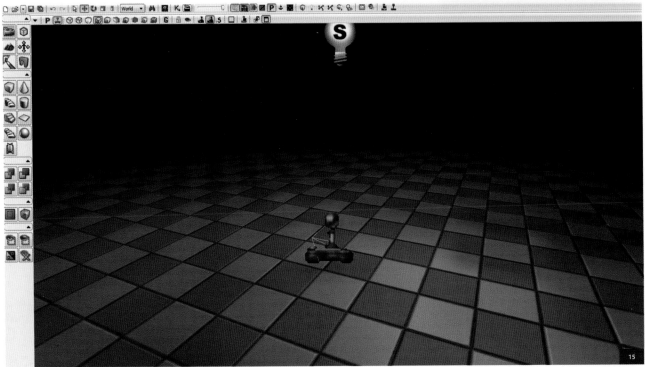

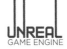

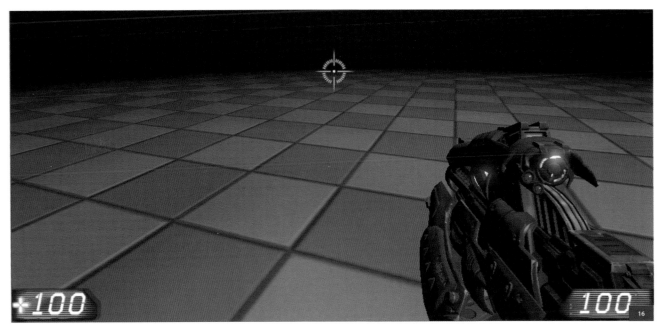

In this menu, scroll over Add Actor and a further drop-down menu will appear – select PlayerStart (**Fig.14**). This will drop an icon of a joystick in the scene (**Fig.15**). The player will always start from this point.

Be careful not to move the icon in an up or down direction as it will affect the player. Too high and the player will drop onto the floor; too low and you will get error messages that the player is starting in the floor geometry.

Now here comes the fun! It's time to play what you have created. Click the joystick icon located in area 7 of **Fig.08**. This will pop up a game window and you will be able to walk around and shoot your gun (**Fig.16**). When you are done walking around, just press ESC to quit out of the game window.

You should now have a basic level setup and be ready to start working up into a detailed environment. In the next chapter, I will complete the BSP geometry of this environment and apply temporary textures and draft lighting (**Fig.17**). I will also cover how to test your environment and make any changes that are needed.

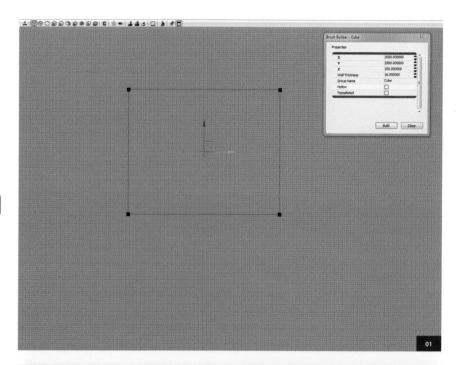

ITALIAN COURTYARD

CHAPTER TWO

BSP CREATION – DRAFT LIGHTING

This chapter will cover creating the BSP geometry that is the foundation of the level. Before we start adding lots of detail, we need to make sure the level looks and feels right and we will use BSP brushes to carve out the geometry quickly and easily.

We will also add temporary textures to the geometry and basic lighting so we can run around the level and make sure it looks correct. By the end of this chapter we will have a basic level which we can then build on and add more detail to, eliminating as much re-work as possible.

In the first section, I explained the UI and what each tool did, so in this chapter I will assume you are aware of where the tools are.

To start, we need to make sure we are using the correct method to create geometry. There are two modes: Additive, which allows you to add geometry to an empty environment; or Subtractive, which allows you to cut away geometry. I prefer to use the adding method.

You can click on File > New Map > then select Additive for the geometry style.

Right-click on the Cube BSP brush to bring up the settings window (**Fig.01**). Use the settings shown in the screenshot. You don't have to be exact at this stage because we will be able to make changes at any point. This is what's good about using BSP geometry to start your level; it's so easy to make changes quickly.

With your brush now in place you need to add the geometry, so click Add and you will see the blue-and-white checkered

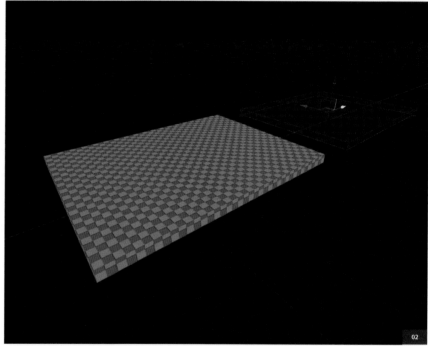

geometry appear where your Cube brush is. You can move the brush to the side so you can see your new geometry (**Fig.02**).

If you look in the other viewports, you will see the new geometry has a blue wireframe. If the geometry looks black it is because you are viewing it in Lit Mode and as you do not have any lights in the scene it won't show up. Simply switch the viewport to Unlit Mode, (we will add lights later in the section).

If you get stuck and can't find the tools, refer to section one ('Project planning and software explanation') for a breakdown of

the UI. This geometry will be the base that the player walks on and what we build our structures on. Remember: we will add more detail later, so keep it simple at the moment so we can make quick edits if needed.

We will now block out one of our buildings. As we did for the floor, right-click on the Cube Builder brush to bring up the settings window and use the settings I have provided (**Fig.03**). I found these settings worked best by just experimenting; we don't need to be exact at this point. In the screenshot, I have shown the other

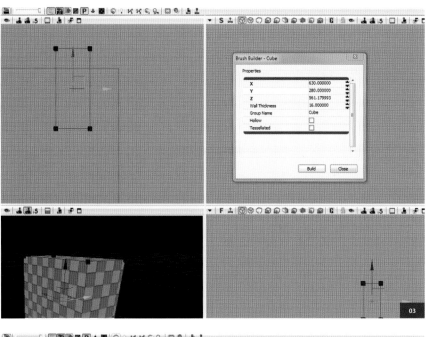

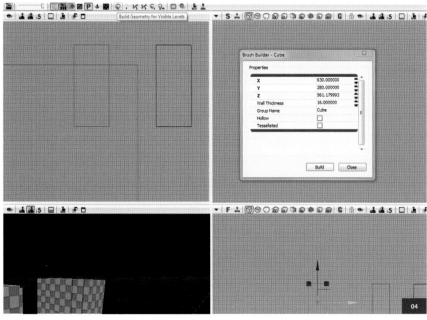

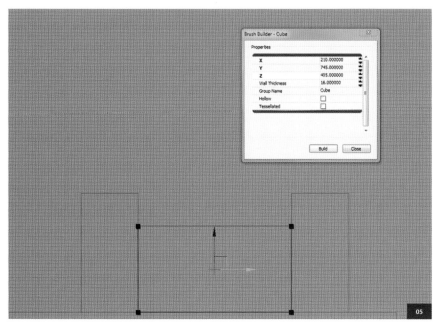

viewports to show the position of the building on the base. Click Add again and your blocked-out building should appear.

Now that we have our first building, we can duplicate it around our environment to quickly block-out our scene (**Fig.04**).

In the top viewport, select the blue wireframe of the building, press-and-hold Alt, then drag the building to the Y axis. You will see that a copy of the building has been created. You will be able to see the second building's wire mesh in the top viewport, but no new geometry in the camera viewport. This is because we need to rebuild the geometry, because already existing geometry has been edited.

When you create geometry from a BSP Builder brush, UDK automatically builds the new geometry; we have to do this manually when we edit existing geometry. Click Build Geometry (I have hovered my mouse over this icon in the top-left section of the UI. You can see the explanation of the tool now visible in **Fig.04**.

To link these buildings and create the geometry, I used these settings in **Fig.05**. Position the brush between the two buildings and make sure it sits perfectly on the base geometry. If you don't do this you will have a gap under your building and it will look like your building is floating.

I've shown the front viewport in this screenshot to show its position more clearly. You can see it's not as tall as the other buildings. This is because I wanted to create an interesting silhouette and break up the skyline. I also want this roof to be pitched a little to add more interest. Click Add to build the new geometry.

To create the pitched roof, we need to edit

the geometry. This is done in the same way you would do it in any 3D software package, by moving vertices or edges (**Fig.06**).

You need to enable Edit Geometry mode, which is located next to the camera icon; I have it selected in the screenshot. This will pop-up a new window with some editing tools to allow us to add cuts and extrude faces – a very basic version of the tools you have in 3D packages. We don't need to use the tools at the moment, so this window can be moved out of the way.

You should notice that now we are in Edit Geometry mode; the vertices have appeared and we can select them. Holding Ctrl to allow us to select multiple vertices, select the two upper vertices at the back of the building and drag them in the Z axis to create a pitched roof. Again, there's no need to be exact, just do enough to give the impression of what we want.

Because we have edited existing geometry, we need to rebuild it so we can see our changes in the camera viewport.

Using the methods described previously, copy the pitched roof building and position as shown in the viewport (**Fig.07**). Rotate the building 90 degrees (press the spacebar to quickly cycle through Move, Rotate and Scale). When the new geometry is in place, rebuild the geometry to show your new building.

To complete this section of the environment select the three buildings, duplicate them, drag them to the other side of the floor and rotate them 180 degrees (**Fig.08**).

Once these buildings are in place you can vary their size a little and push one or two of them back just to add variety. Don't be exact; just make sure all the buildings are sitting on the floor geometry so they are not floating. Rebuild all geometry to make sure your changes are all up-to-date in the camera viewport. We need to enter the level now to give us the opportunity to test the scale and layout so far (**Fig.09**).

In order to play it, we need to tell the engine where we want the player to start. We do this by adding a PlayerStart Actor. Click on the floor so it turns blue and with the mouse on the area you want the Actor to be placed, right-click to bring up the options.

Navigate to Add Actor > Add PlayerStart and

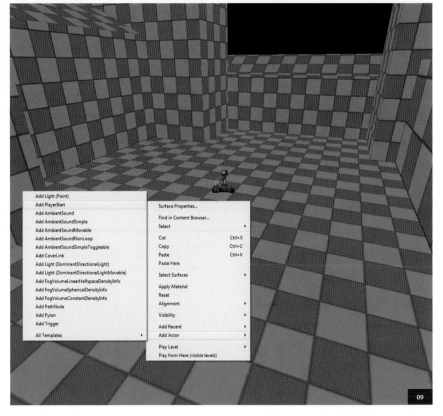

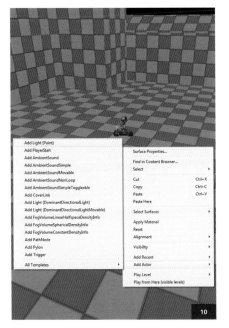

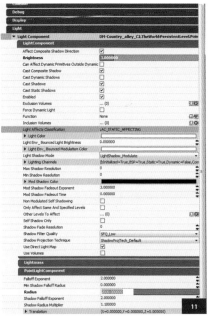

10

11

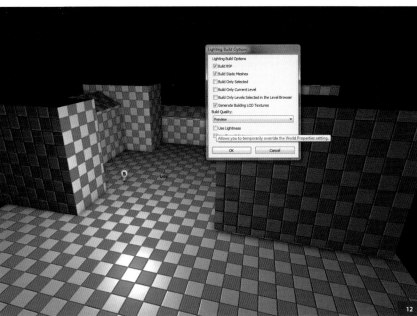

12

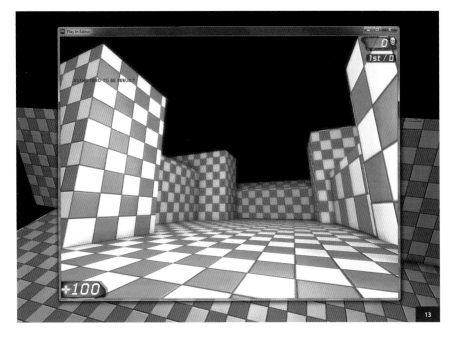

13

you will then see a joystick icon appear. We can't play the level yet because we won't be able to see where we are going, so we need to add lights to the scene.

Using the same method as before, select the floor so it turns blue and right-click. Then navigate to Add Actor > Add Light (Point) (**Fig.10**). This will add a light-bulb icon to the screen. You will have to make sure you switch your viewport to Lit Mode, so you can see the effect the lights have on the scene.

With the light still selected, move it above the top of the buildings. This will only be a draft lighting setup so we can see the level properly. Press F4 to bring up the light settings (**Fig.11**). There is no need to be exact with the settings; don't spend too much time on them.

Increase the Radius of the light enough to encompass the whole scene and also adjust the Brightness if needed, to make sure all of the level is illuminated.

The level is almost ready for viewing in-game. But first we need to build the level. This builds the changes to the geometry and bakes all the lighting. As our level is just getting started and is very basic it won't take very long to build. In the build section of the GUI, to the right of where you click to build geometry, there is an icon with a cube and lightbulb. Click on this to bring up the options (**Fig.12**).

You can leave these settings as default except for the Lightmass tick box – make sure you switch this off. Every time you build your level you will need to switch this option off because we don't have Lightmass set up yet. Once UDK has built your level you will notice a slight change in the viewport. This is because the lighting has been properly calculated and looks better.

Time to play the game! Click the joystick on the far right of the build tools and the level will load up in a new window (**Fig.13**). You can now walk around and get a feel for the environment. If the scale doesn't feel right then go back and change your buildings until you get a result you are happy with.

I'm quite happy with what we have

"The player can never be able to see outside the world; otherwise it will ruin the illusion"

so far and so we can now move on to finishing off the base of the level.

There is a large hole to the left of the buildings where we haven't built any geometry yet. We need to fill all the gaps with something. The player can never be able to see outside the world; otherwise it will ruin the illusion and just spoil the level.

I wanted to do something different with this side of the level. I wanted the player to go inside some sort of structure as this will give this part of the level its own identity and atmosphere.

Using the same method as before, create a small platform that stretches from the buildings to the end of the floor. I've shown the settings I used in the screenshot (**Fig.14**). When you play the level again you may find

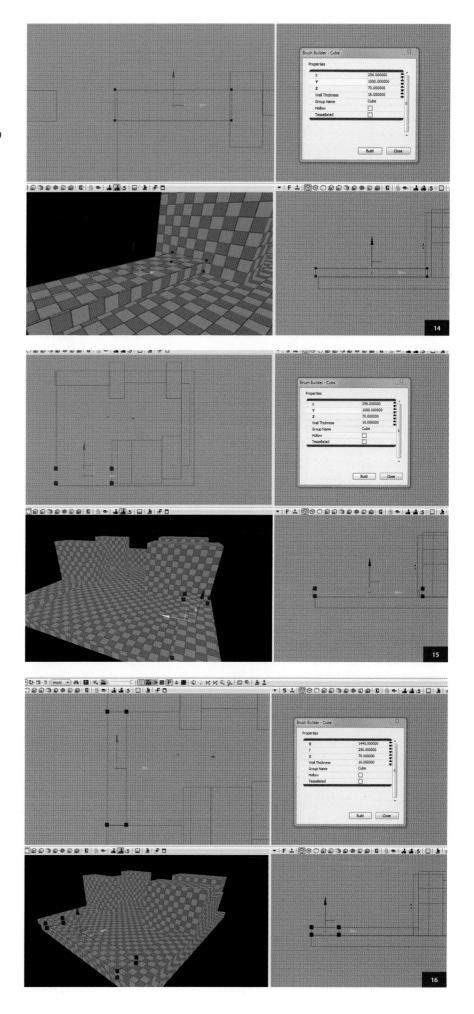

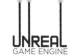

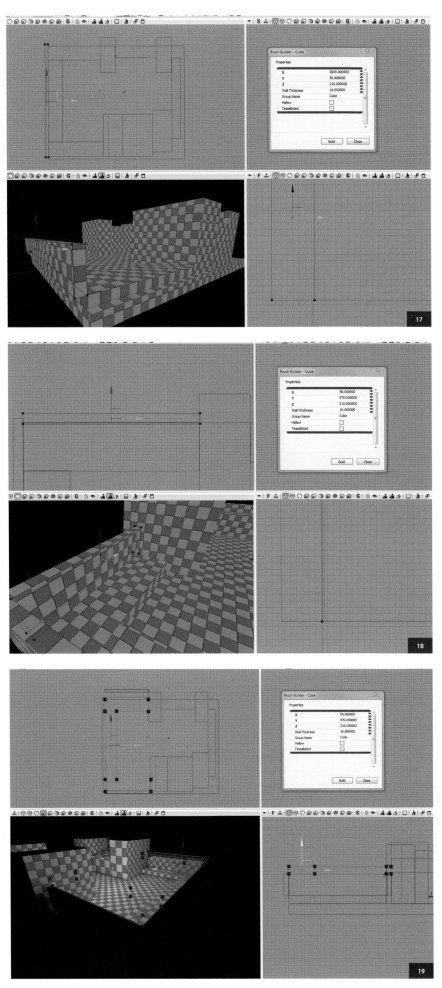

the player can't step up onto this platform; this is okay because we will add stairs to allow the player to get up onto the platform later. For the time being you will have to jump up there.

In the top viewport, select the new platform and Alt-and-drag it to the opposite side of the floor to create a duplicate (**Fig.15**). Click Rebuild Geometry to update the camera viewport with the new geometry.

You can create the connecting platform either by using the method above, rotating it and then editing the vertices to the size you need, or you can create a new cube and position it in place (**Fig.16**). This is the option I chose but it is up to you. Either way you will get the same result.

We now need to build the walls around the platforms to close the area completely (**Fig.17**). Use the settings I have provided for the back wall and side wall (**Fig.18**). Alt-and-drag a duplicate wall to the other side of the platforms.

This area now needs a roof in order to close the player in and get that 'indoor' feeling (**Fig.19**). Select all three platforms and then Alt-and-

drag them, so that they sit comfortably on the walls we just made (**Fig.20**).

The roof is a little bit thick, so in Geometry Edit mode, select the top row of vertices and drag them in the Z axis to get a more suitable thickness for the roof. Rebuild all lighting and geometry so you can see your changes, play the level and explore the new area (**Fig.21**).

I don't like to look at the default checker pattern textures that get applied to new geometry for very long, so I always add temporary materials to get rid of the default material. This will help us to see more of what the level will look like.

In order to apply textures we need to open up the Asset browser. This is located at the top of the GUI, next to the binoculars (Search) icon. With the Asset browser open you will see on the left side all the packages available for us to use in our levels. Later on in the book, we will create our own package to save all our assets in. For now, we will use what's available.

Because this library is so big we need to make our search easier. In the Packages section, click on Content; this will show everything that's available to us (**Fig.22**). Check the Materials tick box and this will only show the materials we can use in our scene.

In the Object Type section select Materials and this will filter through every asset and show us only materials. Select a suitable material for the floor. You can see in the screenshot I have selected the cobbled stones material. With the material still selected, hold Alt

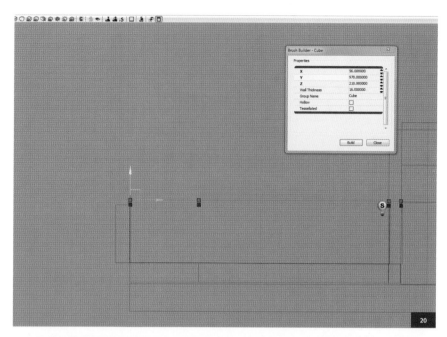

20

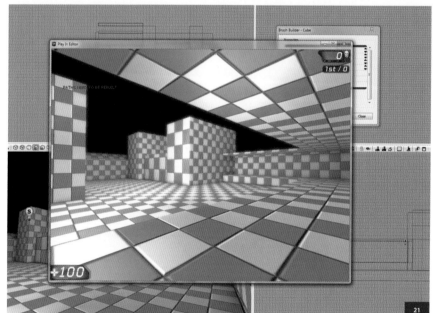

21

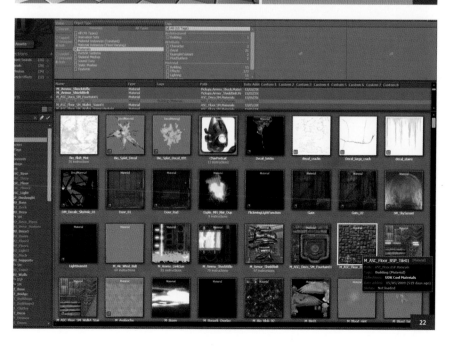

22

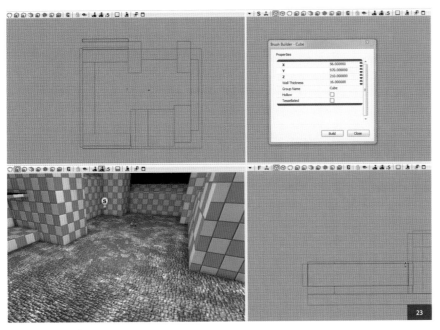

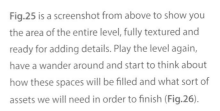

and click on the floor – you should see the material you selected appear on the polys you clicked (**Fig.23**). Make sure you click on all the polys that make up the floor in order to get complete coverage.

Go back into the Asset browser and search for a suitable wall material (I found a light concrete material). Using the same method as above, apply the material to all the polys that make up the walls (**Fig.24**). You can also mix up the wall materials a little in order to break up the surfaces.

It may get a little hard to see where you are going if all the walls are the same. Find a contrasting material and apply it to some of the walls. You don't have to be perfect here as everything is temporary.

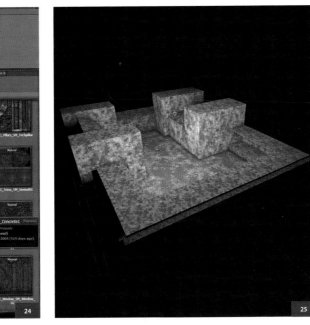

Fig.25 is a screenshot from above to show you the area of the entire level, fully textured and ready for adding details. Play the level again, have a wander around and start to think about how these spaces will be filled and what sort of assets we will need in order to finish (**Fig.26**).

Save the level under a name of your choosing and this completes this stage of the building process. The foundation has been laid and it's time to build on that, layer by layer, until we have a polished, detailed level you can have in your portfolio.

Save a copy so it's safe and have a play around with the geometry before the next chapter. You will learn more from experimenting, and find new ideas you can use as we develop it further.

ITALIAN COURTYARD

CHAPTER THREE

STATIC MESHES AND TEXTURING – PART 1

In this chapter I will be covering the process of creating an asset from scratch in 3ds Max and texturing it in Photoshop. Then I will explain the export process to put it into your game. I will also cover how we should organize our custom asset collection into packages and sub-folders.

For this chapter I would expect you to have knowledge of 3ds Max and a basic knowledge of the rules for creating game assets.

Fig.01 is a reference I have collected for our wooden gate (**www.cgtextures.com**).

This reference image is perfect for the look I want to achieve – a weathered old gate. I do want to add some color to the asset so I won't keep the wood bare – I will add paint to the gate to add some spot color to our final composition.

Let's create the model! With 3ds Max open, select the front viewport and then click View > Viewport Background. A new window should open (**Fig.02**).

Click the Files button in the Background Source section of the window and navigate to the reference image we are using. With this window still open we need to make sure we click the tick box for Lock Zoom/Pan.

This option locks the image in position, and allows us to pan and zoom around the viewport while keeping the image in the same position, allowing us to model around the image perfectly. Click OK and you should see the image in the front viewport.

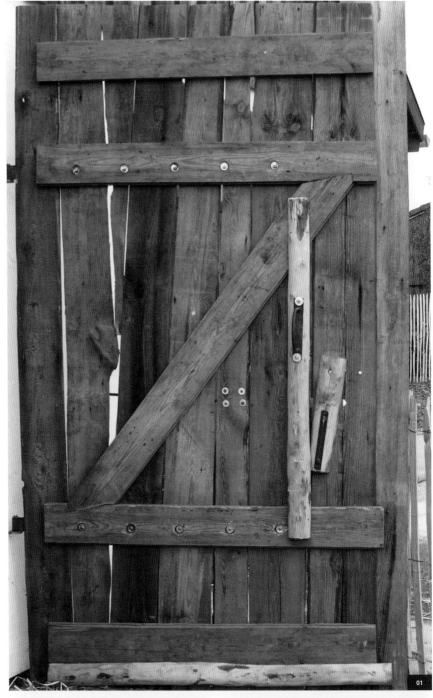

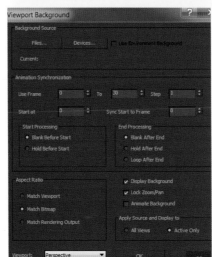

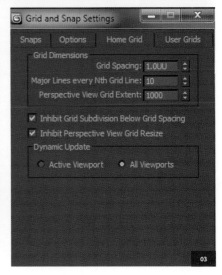

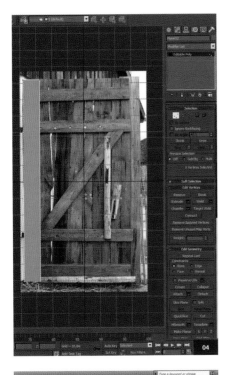

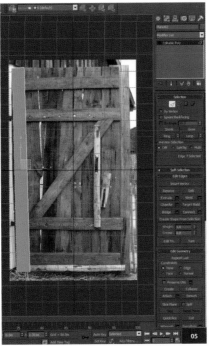

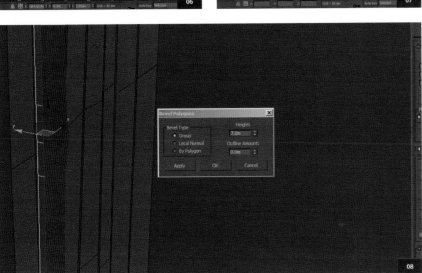

We need to set up the units correctly so that what we create in 3ds Max is a good representation of what will appear in Unreal.

In Unit Setup, select Custom type in UU (Unreal Units). In the Value option type 2.54 and select Centimeters. Now select System Units and type in 1 Unit = 2.54 centimeters. In Grid and Snap, use the settings in (**Fig.03**).

With these settings, 1 unit in 3ds Max should equal 1 unit in Unreal. A typical height for a character is 96 units, so you can use this measurement as a guide. Time to start modeling!

For games models you have to be clever about how you use the very limited polys to get the best-looking result as 'cheaply' as possible. It's best not to make your mesh too triangulated because this will open doors for lighting errors later on in the project.

Create a plane and turn it into an editable poly. Make it almost the same size as the first wooden plank that makes up the gate (**Fig.04**).

Next select the vertical edges of the mesh and click Connect in the Editable Poly tools. This will add a horizontal edge and two extra vertices, which will allow us to make more precise edits to the mesh and helps us to follow the outline of the plank of wood (**Fig.05**).

Do this a few more times until you are happy you have created a mesh that matches the reference image (**Fig.06**).

Using this technique, continue the process for the rest of the vertical planks that make up the gate. Try to keep it basic. Remember that this is a game model so don't get too detailed with the cuts. You should end up with a group of meshes that fit the silhouette of the gate's planks (**Fig.07**).

Select one of the planks and all the polys of that plank. In the Editable Mesh tools, click the Options button next to the Bevel tool. This will open up a new window and allow us to type in measurements to extrude and scale the polys that make up the plank.

For Height, use 7.0 and click Apply (this applies the setting but keeps the tool open to allow us to continue editing) (**Fig.08**).

Then use 4.0 for the Height and -4.0 for the Outline amount. As you can see, the mesh now has a softer edge, which will help achieve the rustic worn look we are after (**Fig.09**).

Continue using this method for the remaining meshes (**Fig10**).

To finish modeling the gate we need to add the horizontal planks. Using the above techniques, model the remaining planks from the reference image (**Fig.11**).

Select one of the planks. In the Editable Poly tools click Attach and then select all the remaining planks so we have one complete model. The back of the planks have holes in them, which is not good and can cause lighting issues later on in the project.

In order to stop any lighting errors from appearing we need to fill in the holes, so select Border in the Editable Poly tools and select all the planks. In the Editable Poly tools select Cap. This will then fill in the holes with polys and hopefully not give us any lighting errors (**Fig.12**).

To UV the gate model, we want to make sure the front of the gate uses up all the space available in the UV window and the back panels can use the space outside the UV space. This is because you will never see the back of the gate so we don't need to waste space or time mapping it. In **Fig.13** you can see how to lay out the UVs.

"We can use Flatten Mapping to quickly and neatly map each face within the UV space"

Unreal uses a second mapping channel for its light baking so, in the UV Edit tool, select Mapping Channel 2. Then select all of the faces of the object and click Mapping > Flatten Mapping to bring up the Options window.

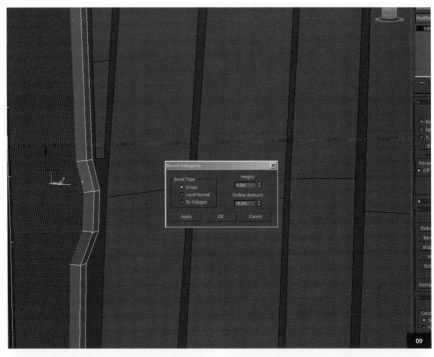

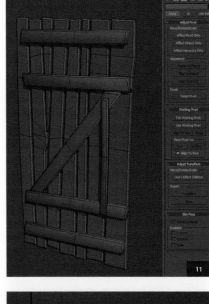

We can use Flatten Mapping to quickly and neatly map each face within the UV space. Change the spacing option to 0.002. This will pack all the faces close together and make best use of the space available. Your UV window should look similar to **Fig.14**. Render out the UV window that is available in the tool's options. This will aid us later when we are texturing the gate.

To export to UDK we need to export the asset in the correct file type. Select the gate and click File > Export Selected.

In the Export window name the asset 'Gate' and change the file type to ASCII Scene Export (9*ASE). UDK can now recognize this file and import it into the engine, which I will talk more about later in this chapter.

It's now time to create textures. Here is the base texture in Photoshop before it has been edited in any way (**Fig.15**). We want the gate to look like it once had a coat of paint on it that has been worn away over time, exposing the wood beneath it. So, in order to do this, we need to create a mask for the paint.

The easiest way to do this is to desaturate the texture so it is grayscale, and then adjust the levels to create a strong definition between the black areas (the wood) and the white areas (the paint). Use the values shown in **Fig.16** to get a good balance of paint and wood.

You can now hide the mask as we don't need it at the moment. Create a duplicate of the base texture and name it 'Color' (this will be our paint layer). Adjust the Color Balance until you get the color you have chosen. I went for a cyan/light-blue color.

"As a guide, I like to import the rendered-out UV texture so I can see what parts of the texture will show on the model"

At the moment, this color is applied to the whole of the texture, so we need to use the mask we created earlier to reveal the wood beneath and the Color layer still selected. Add a New Layer mask and then copy and paste the mask layer into the Layer mask (**Fig.17**).

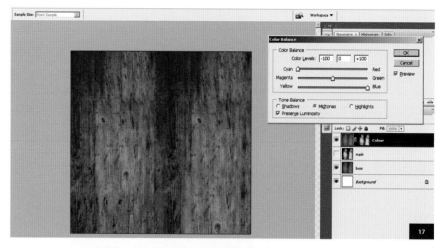

As a guide, I like to import the rendered-out UV texture so I can see what parts of the texture will show on the model. Also, if we want to paint in anymore detail, we will know where to do it. So, set the layer to Screen so it removes the blacks from the texture (**Fig.18**).

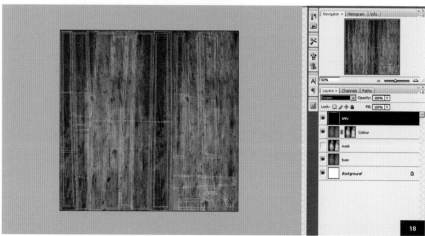

To break the texture up, let's add a layer of damage and dirt. Using a scratched, grungy texture, make it grayscale and then set the layer to Multiply. Adjust the Opacity to get the desired effect.

It's also good to paint in some heavier dirt by hand. Using the UV texture as a guide, paint in some dirt around the areas you think would most likely collect dirt, such as the base of the gate and in the corners of the cross beams (**Fig.19**). Adjust the Opacity of this layer if it becomes too heavy – subtlety is the key to creating a realistic texture (**Fig.20**).

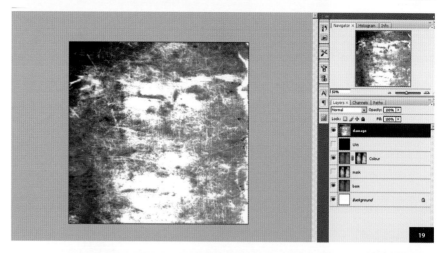

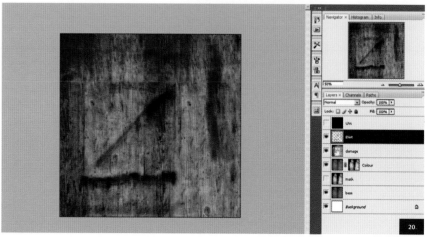

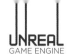

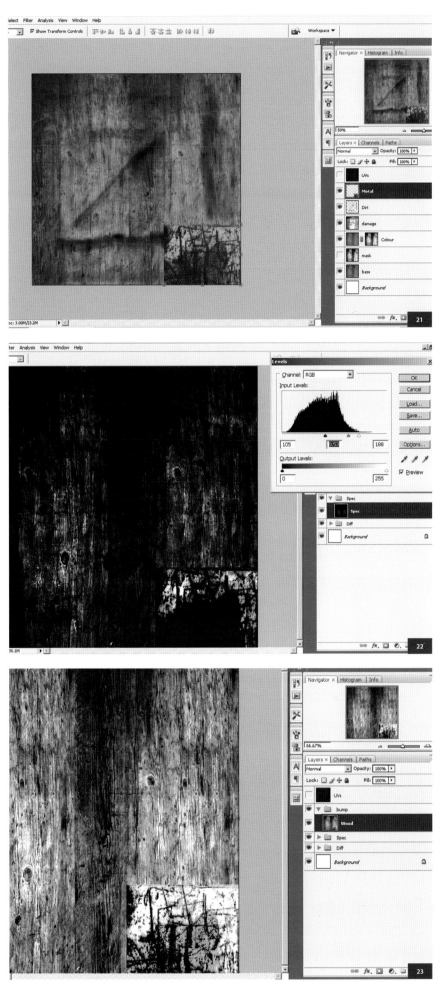

Add some rusty metal texture to the bottom corner of the texture as this will be used for the hinges and handle. You don't need to spend much time on the metal as it won't be very visible on the asset, and once it is in the scene it won't make much of an impact (**Fig.21**).

The diffuse texture is now complete so we need to create the specular and normal maps. For the specular, duplicate all the layers and collapse them into one. Also, it's a good idea to organize the Photoshop documents into folders so everything is in its right place.

"A Bump map is a grayscale texture that allows you to add height information in a material"

Desaturate the specular layer and adjust the levels to create something similar to **Fig.22**. The paint should reflect a bit of light and therefore be a bit lighter.

To create the Normal map, we first need to create a Bump map. A Bump map is a grayscale texture that allows you to add height information in a material. Games use Normal maps to create this height, so once we have created the Bump map we will convert it to a Normal map using CrazyBump (**www.crazybump.com**).

The Bump map should look similar to **Fig.23**. Import this image into CrazyBump and adjust the sliders to create the required look in the preview window.

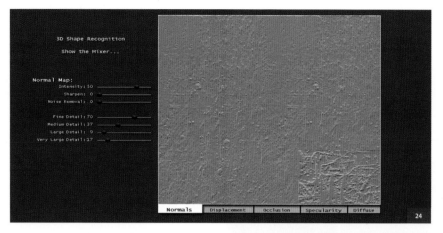

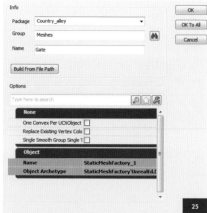

The settings shown in **Fig.24** create a good result in Unreal. Save this Normal map out of CrazyBump.

Now the fun bit: putting your artwork in the game engine! Open the scene from the previous chapter. We will be using a lot of assets to create our environment so we need to start as we mean to go on. Keep things organized and in the correct folders.

In the Asset browser, click Import and this will bring up the Import options (**Fig.25**). Name your package the same as your Level name so you can easily find it later on.

In Group, label it as the type of asset you are importing. In this case, I called it 'Meshes'. Lastly, enter the name of the asset – in this case 'Gate' – and click OK. The asset will now appear in the Asset browser and under the folder structure you just created.

Now do exactly the same process and import the three textures we just created, keeping the same package name. In Group, enter 'Textures', and in Name, enter the name of the textures. You will see this adds a new folder to the directory, called Textures, and the three textures are now stored here.

In the Asset browser, next to Import, there is another button labeled New. Click this button and select Material. As above, name the material correctly and create a group called Materials. A new window should appear. If not, double-click the newly created material and then a new window will appear. This is your blank material ready for us to set up and import our textures.

In the Asset browser, select the diffuse texture so it is highlighted yellow. Then return to the material and on the right, scroll down the

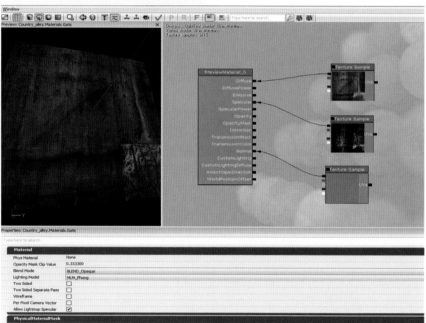

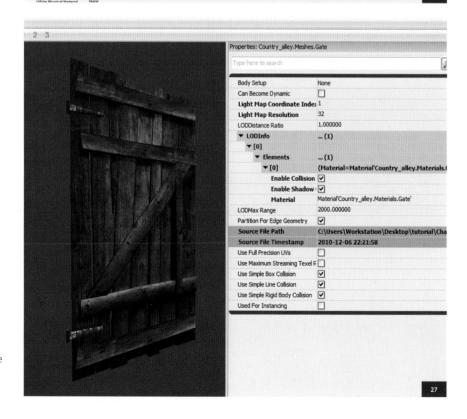

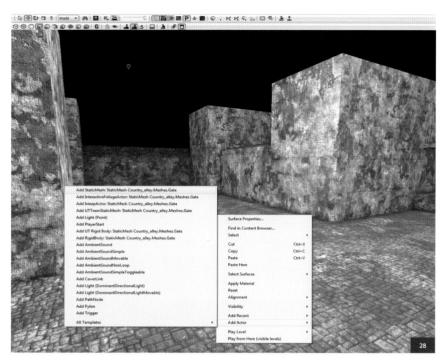

28

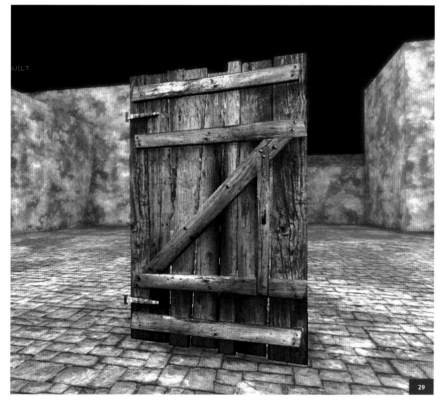

29

list, select Texture Sample and drag it into the blank area. The diffuse texture should be displayed in the Texture Sample. Click and drag from the black node of the Texture Sample to the diffuse slot of the material. Do this for the remaining textures and link them to their appropriate channels.

You can now close the material. It should look like **Fig.26**. This is a very basic setup for a material. They can get quite complicated and create some stunning results. I will go into more detail in the chapter about creating a more complex material, but for now, this serves its purpose.

Double-click the gate mesh in the Asset browser to open its options. On the right, expand the LOD Info settings until you find the material slot. In Asset browser, locate the newly created material and select it so it turns yellow. Return to the mesh setting and click the green arrow in the Material slot; this will apply the gate material to the gate mesh and you should see the fully textured gate in the preview window on the left (**Fig.27**).

To get the gate asset into the game select the gate mesh in the Asset browser, then navigate to a space in the camera viewport and right-click on the floor. Select Add Actor then Add Static Mesh Country Alley > Meshes > Gate. The gate asset will now appear in the camera viewport, fully textured (**Fig.28**).

To view the finished gate in-game you have to build the lighting and geometry again (remembering to de-select Lightmass in the light settings – refer to the previous chapters on how to do this). Then click the small joystick and you will be able to see the gate asset in-game and fully textured (**Fig.29**).

As you can see it is quite simple to get your artwork into the Unreal Engine!

ITALIAN COURTYARD

CHAPTER FOUR

STATIC MESHES AND TEXTURING – PART 2

In this chapter I will explain how to create a reflective window asset to put in our level, including the slightly more complicated material setup in UDK. I will then show you the process of creating the tileable textures in Photoshop and how to apply it to the BSP geometry.

Use the same techniques mentioned in the previous chapter to create this window asset, and simple extrusions and bevels to create the geometry (**Fig.01**). The textures are also created the same way as the gate asset, using Photoshop. Here is the diffuse texture (**Fig.02**). I have included the 3ds Max file and textures with this tutorial (**www.3dtotalpublishing.com/resources.html**).

In the last chapter we created our folder structure to make sure everything is kept organized. Make sure to maintain this folder structure when you're importing your assets, as it will be very useful later on in the project, and will help keep our workflow quick and easy.

To create a reflective material, it is really simple. **Fig.03** shows how I created the material for the window.

First, place a Lerp node, which allows us to combine two textures controlled by an alpha texture. To create the reflection, place a Reflection Vector node and link it to an RGB Mask node. This is then linked to the UV channel of a Texture Sample node. This node is to apply a texture to the reflection so we can see something being reflected in the glass.

Add a sky texture to simulate the sky being reflected. Link the Texture Sample node

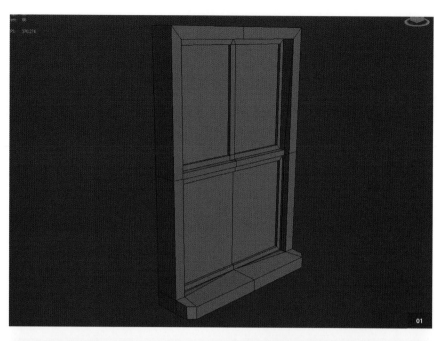

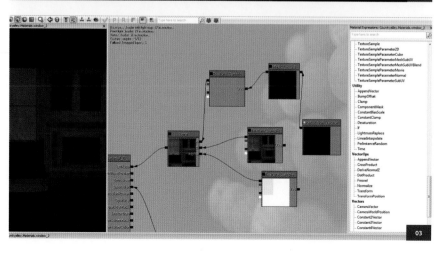

04

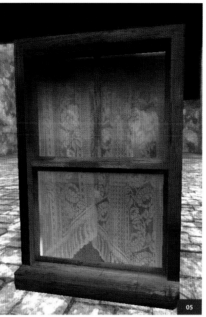

05

06

to the Lerp node we created earlier. This completes the A channel of the Lerp node. The B channel is just a Texture Sample node with the diffuse texture applied.

The problem now is that the reflection is applied across the whole model. We don't want this because wood is not reflective. Create a mask texture and add it to a Texture Sample node; this is then linked into the Lerp node's alpha channel (**Fig.04**).

The mask texture is a black-and-white texture. Where it is white, the reflection is blocked, and where it is black, the reflection is allowed. In my mask, the black is a very light gray; this is to reduce the amount of reflection in the windows because we don't want it to be overpowering.

Also add the Specular and Normal maps to the material. You can now apply this material to the mesh and this should complete the window asset (**Fig.05**).

I often use **cgtextures.com** to source my textures. I also found a few textures that would be suitable for editing to create a single texture by looking at details in photos.

For an Italian courtyard, the colors will be a mixture of reds and yellows. The wall's diffuse texture will not have very much detail in it, and this will aid in helping to make it tile correctly when placed on the walls. Most of the detail will be coming from the Normal map and the lighting will aid in helping to achieve a convincing wall texture.

To create the variety of colors, simply change the Color Balance or the Hue of the original texture. Here are the three varieties of wall texture used in the game level. I have also included the original textures with this tutorial (**www.3dtotalpublishing. com/resources.html**) (**Fig.06**).

To make a texture tileable, Photoshop has a handy filter called Offset. This allows us to move a texture left, right, up and down. So for the wall textures, size them at 1024 x 1024 then duplicate the diffuse layer and apply an Offset filter, which opens up an options box (**Fig.07**).

We want the corners of the images to be in the middle of the texture. Moving the texture to the side by half its size would do this, so enter 512 in both the boxes and click OK.

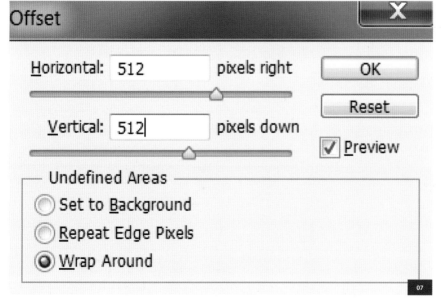

07

In this example image, you will now notice a seam down the middle of the texture, which can be painted out (**Fig.08**).

You can use a Clone Stamp brush to paint over the seam. Repeat this process of offsetting the texture until you can no longer see any seams and the texture is now fully tileable. Do this same technique for all the wall textures.

Use the techniques previously described in this chapter and earlier chapters to import the textures and create their materials in UDK.

To apply the new materials to the BSP geometry, select the new material in the Content browser so that it is highlighted. Then, by holding Alt and clicking on the poly, the material will be applied to the surface.

We need to map the texture correctly across the surface by using Surface properties. With the poly still selected, press F4 to bring up the options (**Fig.09**).

Change the alignment to Planar. You can do this on mass by selecting all the polys that make up the building and clicking 'Planar', then 'Apply'. All the settings are applied across the whole building. This should save some time when texturing BSP geometry.

If you do this for the whole of the environment, you should end up with something like **Fig.10**. You will notice some repeating details in the texture, which you can go back into Photoshop and fix. I'm not going to do that on this occasion because the surface will be populated by static objects, hiding a lot of the texture, so the repeat won't be noticeable.

I will also show you how to create decals that project a texture onto the walls to add things like dirt and grime. This also helps hide repeating patterns in the diffuse texture.

I have made some very quick edits to the BSP geometry to add detail to the environment and make a more interesting level. I wasn't precise with these edits at this point because we will need to edit the geometry to fit the Static Meshes when they are imported.

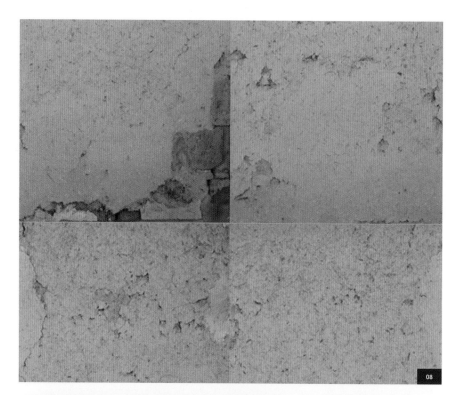

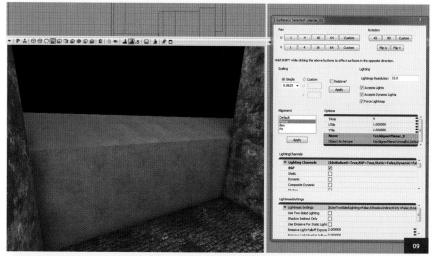

11

12

You can follow the images provided as a guide, or you can look for reference images on the internet to get some ideas on some interesting architecture to put in the buildings. I explained in chapter two how to create the BSP, so refer to those for more information.

"Create different levels of height in the buildings. This gives the environment some verticality"

Add a staircase and a platform that reaches halfway up the front of the building (**Fig.11**). Also add some pillars around the edge of the lower platform (**Fig.12**).

Then add a staircase and platform, as in **Fig.13**, which also creates a little porch under the stairs.

Create different levels of height in the buildings. This gives the environment some verticality and makes for a more enjoyable level to walk around.

Use the techniques I have explained to bring in as many objects as you can think of that will suit the environment. It's a very easy and simple process to get your assets into the game. This is what makes UDK so easy to use and I hope you can now see why it is so popular among the game-developing community.

13

Movement is very important in a game environment. It brings the environment to life and really helps to get the player immersed in the scene.

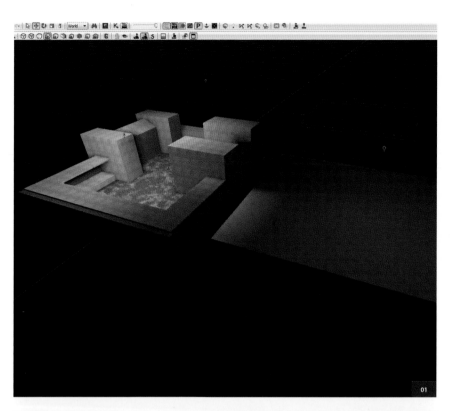

01

ITALIAN COURTYARD

CHAPTER FIVE

LAYOUT – A

In this chapter, we will add assets to the environment and really start to bring it to life. This process will add lots of detail and help us to achieve a convincing level of detail. This is my favorite part of creating an environment, because you can literally watch as your changes give it life. I won't complete the layout of the environment, but we will get a good idea of the direction it will take.

Before I start placing assets, I like to create an area outside of the main level where I can drag and drop assets, and create a pallet of assets to be used in the main area. It will also allow easy access to assets and allow you to instantly browse exactly what you have.

Using the techniques described in earlier chapters, create a platform to the right of the level and give it a texture. Also, place a light above this area so we can see the assets that get placed (**Fig.01**).

With the pallet area now set up, we can start browsing the assets available. I've added some of my own assets into the browser using the exact same techniques described in the previous chapters. I have provided all the files for these assets with this tutorial (**www.3dtotalpublishing.com/resources.html**).

The assets are quickly assembled, but when you're making your own, you should spend a lot more time on them, adding detail that will, in the end, benefit your portfolio piece. We will also use existing assets that come free with UDK to populate the environment.

If you open up the Asset browser (**Fig.02**), in the left-hand column scroll up to Content and right-click and select Fully Load – this

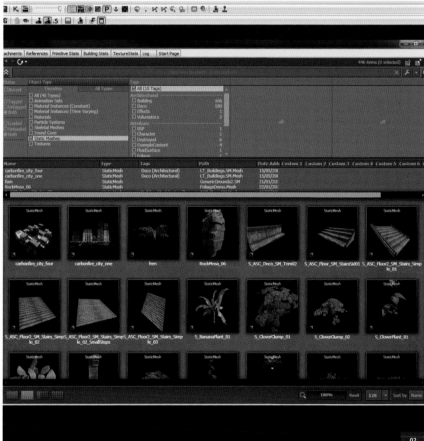

02

will load every asset available to you in the Asset browser. To filter all the content we can display certain types of assets, so we can easily go through the suitable assets.

In the top column, tick Static Meshes; this will display only the Static Meshes in the

browser. Now you can browse through all the assets and drag-and-drop them into your pallet area – even your custom assets. Try to select assets that will keep within the artistic style of the environment, so for example, no futuristic assets – unless that's what you want to do, of course.

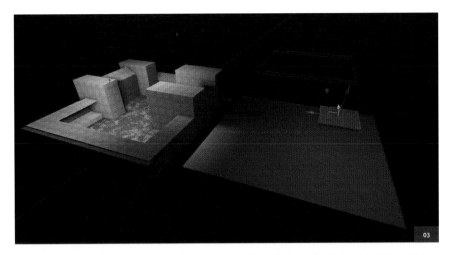

I've stuck to a more traditional style to keep with the architecture and feel of an Italian country alley. **Fig.03** shows a section of tiled roofing that I have dragged and dropped into the pallet area; we will use this asset to create the rooftops for the buildings.

After you have gone through the Asset browser and dragged and dropped assets, you should have a pallet area that looks similar to **Fig.04**. You don't have to get everything right now, just enough to get you going and grow your imagination as you place them.

Don't place much vegetation at the moment; we want to make sure we get all the basics placed, such as windows and doors. If we start placing trees and bushes, you can easily get distracted and overuse them, so we will keep them until last.

In **Fig.05**, you can see the left-hand building with all the windows and doors placed, and with some roofing placed on top. This part doesn't need to be perfect; I've placed these assets to help get an idea of what works and what doesn't. We can also leave this area and keep looking at it while we work in other areas, helping to achieve the overall look we want.

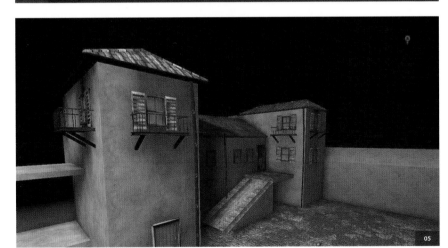

I've also started to place the floor slabs shown in **Fig.06**. Just copy and paste the slabs asset in rows and columns until the entire floor area is covered. Continue the process around the other side of the environment, covering the middle and right-hand side buildings.

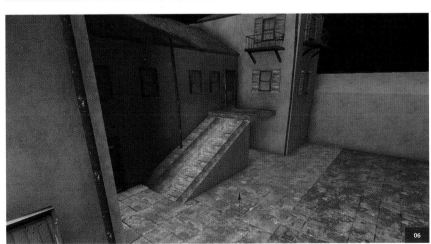

"By continuing to place windows, doors, stairs and railings on the buildings you will start to create a more convincing-looking building"

Vary the color of the windows and doors so things don't look repetitive (**Fig.07**). Place two of the large trees in this area (**Fig.08**). Because they are so large and make up a lot of the scene's composition, it is a good idea to get them placed earlier in the process.

By continuing, place windows, doors, stairs and railings on the buildings, you will start to create a more convincing-looking building. Also place some arches to help give the scene some architectural points of interest (**Fig.09**).

From the aerial shot, you can see the main environment with some assets placed and the pallet area with the available assets (**Fig.10**).

When you bring in static objects, you may find that the BSP geometry doesn't match up correctly and will need adjusting – a good example of this is the staircase in **Fig.11**. You can see the stairs are in place, but the BSP geometry is too short so you can see a gap. Clean this up using the Edit Geometry tools I explained in the earlier chapters.

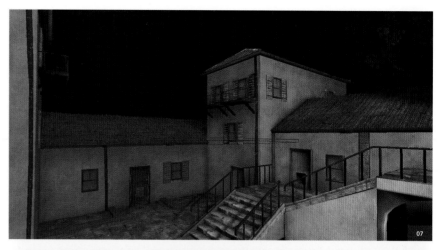

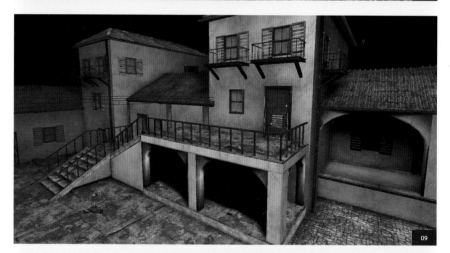

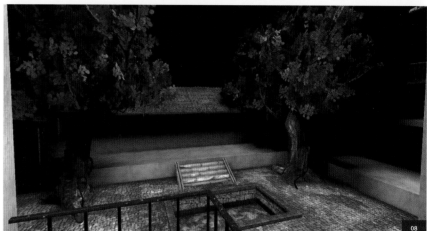

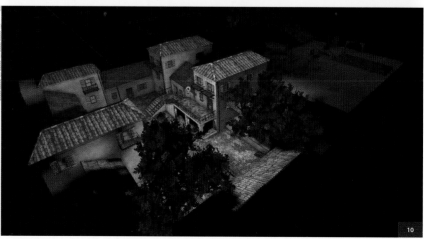

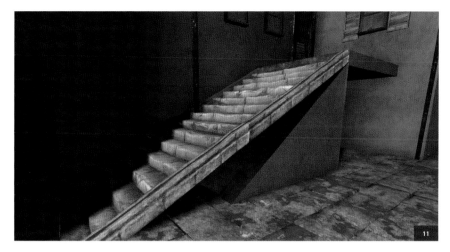

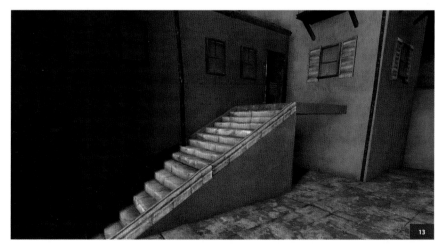

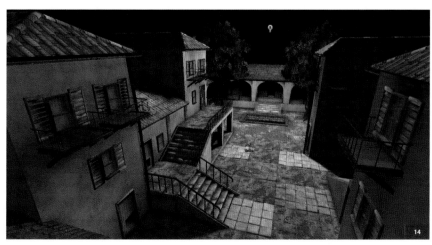

In **Fig.12**, you can see I have switched to a side view in order to get a more accurately fitting geometry. Make sure you rebuild the geometry and lighting to see the latest changes (**Fig.13**).

As you can see, the environment has suddenly taken shape (**Fig.14**). Before we started, the area was very bare and it was difficult to see the end result, but now we've quickly placed some assets and suddenly the scene jumps to life, and you can start to see the direction it will take.

At the moment, there is only a default lighting setup so the scene will always look a bit 'off' and not very polished. We will get to the polishing stage later on in this series, but you have to use your imagination to see how the scene will look at the end, and not be disheartened at this stage that the scene doesn't look good enough. This is the stage that I always struggle with as it is so easy to just give up and start something else.

"If you don't find something suitable in the Asset browser, make it yourself"

Keep searching through the Asset browser, picking out assets that you want to use, and experiment with the composition of the scene. Also, if you don't find something suitable in the Asset browser, make it yourself. Eventually you will want to replace all the UDK assets with assets that you have created yourself so you can say to potential employers your portfolio is 100-percent your own work.

ITALIAN COURTYARD

CHAPTER SIX
LAYOUT – B

In this chapter, I will be talking you through the final stages of the layout process and making a start on the final polishing tasks to really make this environment come to life. I will show you how to create decals and place them in UDK to add details such as grime and cracks. This not only adds life to your levels, but helps us break up repetition in the texturing.

Continuing where we left off in the last chapter, using the assets I provided you with, and also the assets that are in the UDK library, continue to place static objects on and around the buildings.

You can see in **Fig.01** that I place handrails up the side of the staircase. Also add an archway under the stairs to provide some architectural difference and break up the hard lines of the BSP geometry.

> ## "Don't worry if you think it is too simple at this stage. We are building this environment up layer by layer"

You can also see that I add a cut horizontally across the main building, and apply a different colored texture. We do this to break up the colors, as there is too much orange in the scene. To aid this break up of textures, add a row of trimming from the UDK library. You will notice in the tutorial that we use this asset a few times. It helps to break up surfaces and add detail.

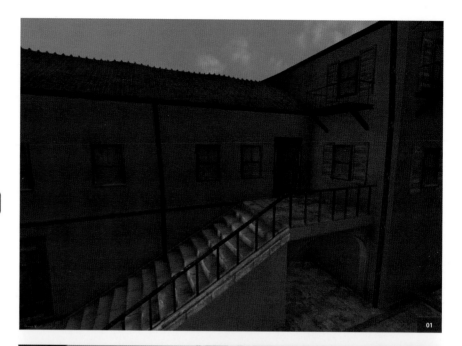

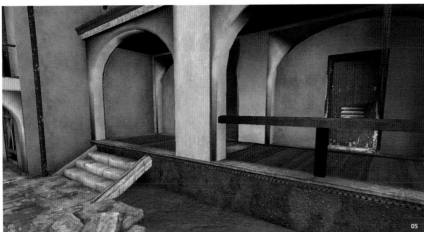

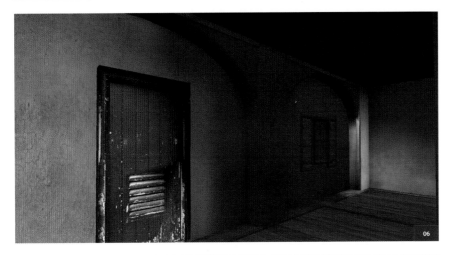

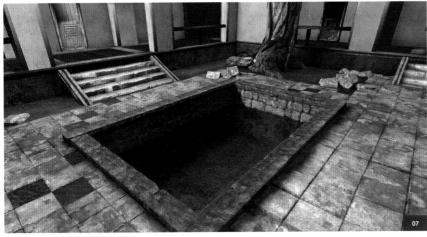

Again, here is a very simple layout (**Fig.02**). Add a small stone wall on both sides of the white building. We will use this area as a planting area later on to add vegetation. Don't worry if you think it is too simple at this stage. We are building this environment up layer by layer, so we have equal amounts of detail throughout. Don't get too bogged down in one area and neglect others.

Do the same in **Fig.03** as we did in the area in **Fig.01**. Add railings and trims on the buildings. A good tip here is to add a trim around all of the structures, as this helps gel the buildings and the floor together. Also, note the addition of the planting area behind the stairs. Later in the process, we can grow a climbing plant in here to break up the wall surface further.

Add archways underneath the porch. You will also notice I have cut a hole into the BSP geometry to add a door frame to sit the blue door into the wall. Cutting a hole into the wall will also give us a nice shadow behind the door, giving the illusion of a room behind it (**Fig.04**).

You can see in **Fig.05** that I have left a dirt area so we can plant grass and bushes on the floor. This will really break this area up and make it into a small garden area, which will perfectly suit the pond we have cut into the floor.

Add trimmings all around the edges here to break up the simple BSP geometry. Also add a wooden, tileable texture to the floor of the corridor and place trim assets horizontally and vertically to break up the repetition, and give some 3D detail to the floor surface (**Fig.06**). All the additional textures and assets are contained in the resource pack of this tutorial (**www.3dtotalpublishing.com/resources.html**).

Fig.07 shows the whole of the pond area. I will explain later how to add water to the pond. Water is great for adding movement to the environment, as is vegetation. It is very important to add signs of life to your environments by adding movement in assets. It convinces the player they are *in* the environment.

Using particle effects is also a good way of adding movement. We will use all these methods to make it really come to life.

"You can always place existing assets to get the composition right, and then replace the assets with your own later"

Use a tile asset that has a few tiles removed; this adds a bit of decay to the level and makes it look like a lived-in area. It also gives us the opportunity to add grass. This benefits us by not only breaking up the assets' repetition, but also adds a bit of spot color to avoid the environment looking dull.

This aerial shot shows you what's outside the level (**Fig.08**). It's important to have something out there, just in case the player manages to see outside your level. Add a water surface, even though most of it will be covered by fog when we come to the final polishing stage.

I have also added the Sky Box asset, which is in the UDK library. I have added my own texture to this asset as I couldn't find a suitable sky. I will show you how I added my own texture later in the tutorial.

Now it's time to place the vegetation. For this chapter, I will use only what UDK has provided in its library due to time constraints. But, for your portfolio, I strongly urge you to create your own assets to place. You can always place existing assets to get the composition right, and then replace the assets with your own later.

Fig.09 shows a collection of vegetation assets in isolation, and on the left I have an assortment of them in the plant box areas we created earlier.

In **Fig.10**, you can see I have used the climbing ivy asset and placed it climbing up the walls in the corner of the buildings. This really helps to tie the buildings together and hide any seams and texture repeats.

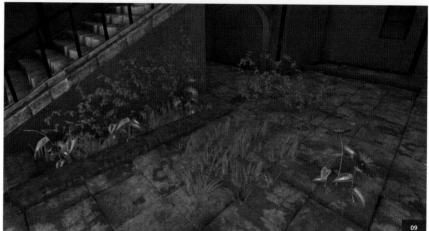

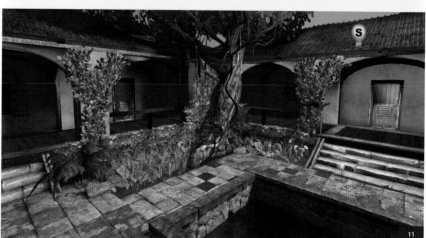

12

"A Sky Box is just a sphere that is halved with a sky texture applied"

Fig.11 shows I have combined both techniques to create the garden area around the pond.

Now we will create a custom Sky Box. A Sky Box is just a sphere that is halved with a sky texture applied. You can create your own semi-sphere, or you can customize an existing one.

If you type 'sky box' into the search section of the Content browser, you will find a variety of Sky Boxes. None of the textures would fit our scene, so we need to create a sky texture that is 2048 x 1024, and replace the texture on the skydome with our custom one (**Fig.12**). You can get a lot more complex with sky setups, but this suits our level's needs for the moment.

Creating the water surface is very simple. Create a BSP plane in position over the pond area, shown in **Fig.13**. For the watery material, use M_Water_02_opt, which can be found in the Content browser; just search for that name and apply it to the BSP plane geometry.

If it is out of scale, you can increase the tiling of the material by pressing F4 with the polygon selected in the options; increase the tiling until you get a suitable result (**Fig.14**).

13

14

45

"A decal is an 'Actor' that we place pointing at the surface and projecting a texture"

Decals are very simple to create and add a lot to the final composition of your scene. Decals can be used to add damage and grime to the walls, which will help break up the texture repeats and add little pockets of detail and interest. A decal is an 'Actor' that we place pointing at the surface and projecting a texture.

Create three decal textures (see **www.3dtotalpublishing.com/resources. html**) using textures from **cgtextures. com** (**Fig.15**). Isolate the details we want to keep and be projected. Then, create a new material. Import this new texture (**Fig.16**) and link it to the Emissive and Diffuse nodes. Use the settings shown in **Fig.17**.

With this new material selected, in the viewport select the mesh where you want the Decal Actor to be placed and right-click and select Add Decal Actor > 'material name' (**Fig.18**).

A new icon will appear and your decal texture will be placed on the surface you selected (**Fig.19**). You can scale, rotate and move

"You can scale, rotate and move these decals to get the desired effect"

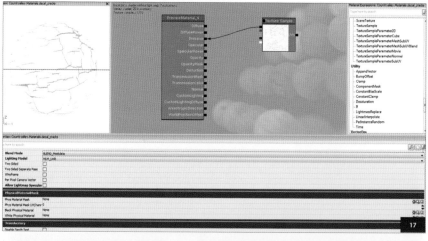

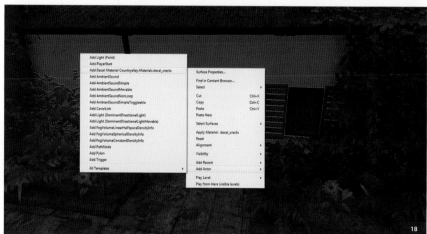

these decals to get the desired effect. Use these same techniques to create and place the remaining decals, or feel free to create your own decals. **Fig.20** shows a completed building with a variety of decals placed.

Fig.21 shows a final aerial shot of the environment, with all the meshes and vegetation placed, and the decals in position. The Sky Box seals the scene and completes it – all that's left now is to add the finishing touches and make this environment look as good as it can.

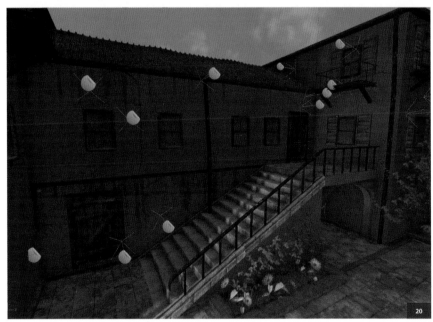

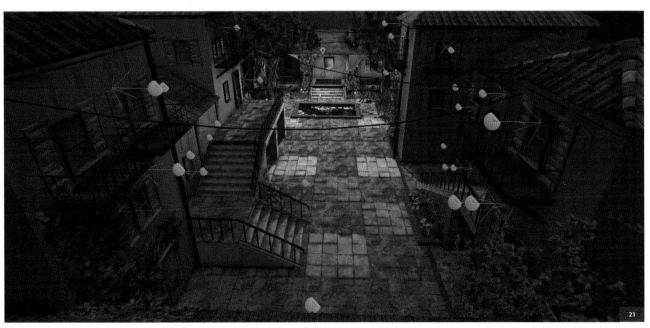

ITALIAN COURTYARD

CHAPTER SEVEN

LIGHTING AND POST EFFECTS - A

Lighting has to be my favorite part of any CG art that I do. If done correctly, it can really bring your work to life and can make it go from looking 'okay' to looking professional. You should spend as much time as you can lighting your scene and doing the post effects, because it will really make or break your portfolio piece.

You could spend days modeling and texturing a detailed model, only for it all to go to waste because the audience can't see the detail due to a poor lighting setup.

UDK lighting is very advanced, and you can create some stunning lighting setups really easily. UDK has introduced Lightmass to its tools. Lightmass helps to create realistic lighting by calculating bounce light – similar to what is done in the 3D package renderers on the market today.

> "UDK has not only made the process easier and quicker, but the results you get will be a lot more realistic"

A scene in UDK could consist of just one light (the sun, for example) and Lightmass will fill in the shadows with bounce light. In the past, you would have had to manually place lights to fake the bounce light, and this would have taken time. So UDK has not only made the process easier and quicker, but the results you get will be a lot more realistic. Another important feature I will explain in this chapter is Ambient Occlusion. This

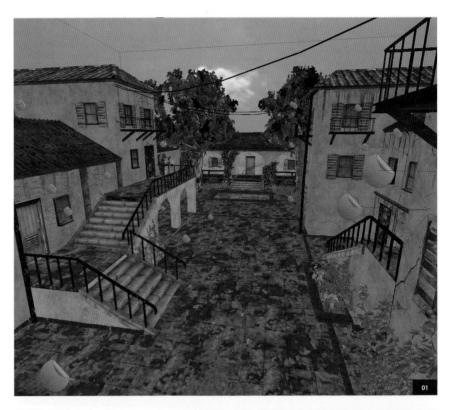

process will create a soft shadow when an object is close to another, for example by a wall. This soft shadow really helps the object to sit in the scene, and again, makes the scene more believable. I will explain this process more later on in the chapter.

In **Fig.01**, you can see the scene with no lights at all. Delete the temporary ones previously placed to illuminate the work area. Looking at this image, we want to get an idea of where we want the source of light to come from. After a few tests, I found the sun was best placed behind the far building in this image; with the sun in this position, it

casts more interesting shadows across the floor and against the other buildings. You should take time to test your environment and see what works best to give you the most interesting end result.

In **Fig.02**, I have placed a spot light high in the sky, and pointed it at the middle of the environment. You can tell in which direction the light is pointing by the arrow that is emitted from the light – which makes it easier to place. You also get a draft shadow to further guide you.

03

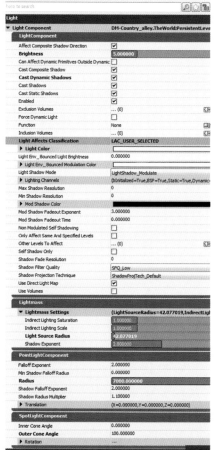

04

05

Fig.03 shows the light's Radius. You need to make sure the Radius encompasses the environment, because it is sunlight and should never fade or run out of power. The Radius of your light will differ from mine, depending on how close or far away your light is in the scene to the floor of the environment.

We don't change many of the settings of the light – keep most of them as default. Change the Brightness to 5.0 as we want a bright, sunny day, and therefore need a more powerful light. Feel free to play with the settings to get a feel for what works in your scene, though.

For the color of the light, go for a warm, yellow-orange, to simulate the sun and give the illusion of a warm summer's day. If you want to use my settings for the sun color, the RGB values are: R=255 G=244 B=148. In the Point Light Component settings, change the Radius to 7,000 – as explained earlier, this setting ensures my Sun light covers the entire environment. Under Spot Light Component settings, change the Inner Cone Angle to 0 and the Outer Cone Angle to 100, which ensures the light is wide enough to cover the entire environment and doesn't create any hotspots or falloffs.

For the Lightmass settings, keep all the settings as default, except for the Light Source Radius, which we change to 42. I got this number by doing draft light bakes and changing the settings until I got a result I was happy with. I found this number gave me the best shadow and quality of light emitted from the Sun spot light. **Fig.04** shows all the settings I used for the Sun spot light.

To enable Lightmass and Ambient Occlusion, click View > World Properties (**Fig.05**), scroll to the Lightmass tab and tick Use Ambient Occlusion and Use Global Illumination. We will now be able to view the AO within the viewport and use Lightmass to calculate the bounce light emitted from our Sun spot light.

Next time you build the lighting, you should notice the soft shadows that appear when an object meets another object; they are quite subtle, but very important shadows. I will point this out more when we have baked our scene. In the Bake Lighting window, make sure your build quality is set to High and that this time Lightmass is switched on. Previously we have been switching this off to save time in the build process.

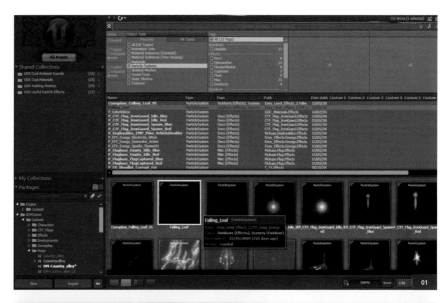

ITALIAN COURTYARD

CHAPTER EIGHT

LIGHTING AND POST EFFECTS - B

In this chapter, we will be adding the final touches to the scene to make it look as good as possible. We will also be covering adding environment effects such as fog and particles. We will take a look at the post effects system and I'll show you how to add effects such as depth of field and color balancing. I will also be showing you how to compile your level into a standalone EXE file that can be distributed to potential employers – or just passed around friends to play for fun.

"Movement is very important in a game environment"

The scene is very static at the moment; the only movement we have is the water in the small pond. Movement is very important in a game environment. It brings the environment to life and really helps to get the player immersed in the scene. To add more movement, we can add particles (PFX) to our level.

Particles are used for effects such as fire, smoke or falling leaves, which is what we are going to use for our level. In the Content browser, tick Particle Systems in the Object Type section; at the bottom all the available particle effects will be shown (**Fig.01**). There is a particle effect called 'Falling_leaf' – select this, drag it into the viewport and drop it anywhere on the floor.

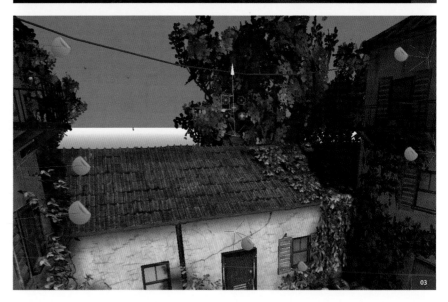

Fig.02 shows the particle icon. Position the particle system between the two trees and move it up so that it is about the same height as the roofs of the surrounding buildings. Now you can see the actual leaf particle (which is shaded blue).

In the Viewport toolbar, you will notice an icon that looks like a joystick. If you click this, the viewport behaves like it is in game mode and the particles will start moving and falling to the ground. To make life easier, you can duplicate this

particle system and use it on the other side of the level to the same affect. This gives the illusion of leaves falling from the trees located behind the buildings and entering the courtyard (**Fig.03**).

04

05

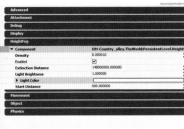

Even though it is lit correctly, the environment is still quite flat. This is because we need to give the player the illusion of distance. We do this by adding effects such as fog or smog, creating a layered effect. As objects are further away from the character, they are influenced more by the fogging.

In real life, if you can get high enough and see the horizon, you will see that colors are desaturated and faded. It depends on the weather conditions how obvious the fogging is, but it is always there.

To add fog to our level, you need to go to the Actor Classes tab, located in the Asset browser. Locate the Actor called 'Height Fog' under the Info group (Fig.04).

Right-click anywhere on the floor in your level and select Add Actor > Height Fog and an icon of a bird's head appears (I don't know why it is a bird's head). Raise the icon so it is

"To start creating a more realistic and polished image we need to add screen effects or post-effects"

above all the geometry in the environment. With the icon still selected, hit F4 to bring up the properties for the Height Fog.

Fig.05 shows the properties I used to get the final result. Play around with the settings to learn what they all do – they are pretty self-explanatory. For the color, I went for a shade lighter than the sun color. Try not to overdo it with the fog – be subtle. Our environment is not very big so you won't see much of the fog anyway, unless you're going for a foggy weather art style.

To start creating a more realistic and polished image, we need to add screen effects or post-effects. By adding screen effects, we can create depth of field, bloom, motion blur and make color corrections. These are simple settings that you adjust to get the desired effect, and if used correctly they can really make your art stand out from the crowd.

The settings for screen effects are located in the WorldInfo_Properties (click View > World Properties). Fig.06 shows all the settings as default. They are all quite self-explanatory and shouldn't be too hard to understand, but it is best to just adjust the settings and see what happens on the screen. I find this is the best way to learn.

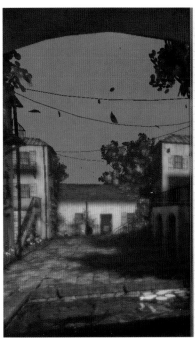

06

07

To enable DOF (depth of field) there is a check box in the WorldInfo_Properties. I have shown the settings used to get the following result in **Fig.07** (previous page). Be subtle and don't overdo it. DOF can mess with the viewer's eyes and make them feel sick. It also blurs your artwork and hides detail, so it's best to use it subtly. This will, in turn, be more realistic.

If you are adjusting the settings and not seeing the changes in the viewport, you may need to enable the viewport to render screen effects. You do this by pressing G on the keyboard. There is also a check box in the WorldInfo_Properties called 'Enable Screen Effect' – you may need to turn this on to be able to see the effects.

Bloom is very simple. You just enable it by checking the tick box and adjusting the settings in the Bloom_ Scale. This effect adds a slight glow around the Specular highlights – an effect you often see in cameras.

Color correction is one of my favorite tasks as you can totally change the look of your work instantly and get some stunning effects. The process also helps to create a polished, professional piece of work. To start color correcting, you need to adjust Scene_ High Lights, Scene_ Mid Tones and Scene_ Shadows. Each section has three channels to adjust. I have shown my settings in **Fig.08**.

These settings give the scene a warm, orange hue and help to create the look of a sunny, hot day. Use my settings as a guide, but play around with the settings to really understand what they do and how powerful the effect can be.

Fig.09 shows a side-by-side shot of the scene with screen effects on and off. As you can see, the difference it has made is drastic and improves the quality.

Fig.10 – 11 show aerial shots of our environment to give you an idea of how the screen effects have influenced the environment and raised the quality. I hope you can see how important this process is, and how beneficial it will be to you when it catches the eye of potential employers.

You can't send your maps, textures and assets to a game studio for them to look at. It's just not logistically possible. But what you *can* do is package your game files into one standalone, easy-to-install EXE file.

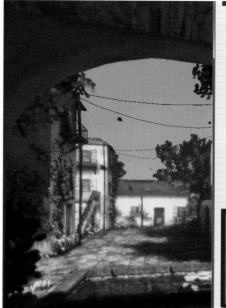

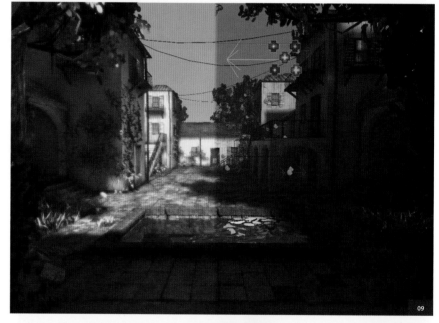

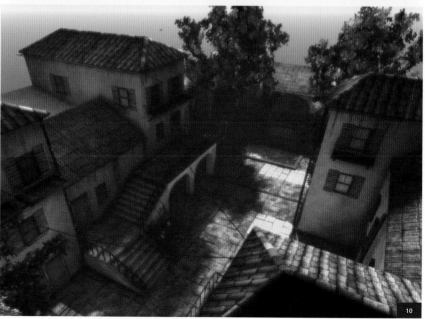

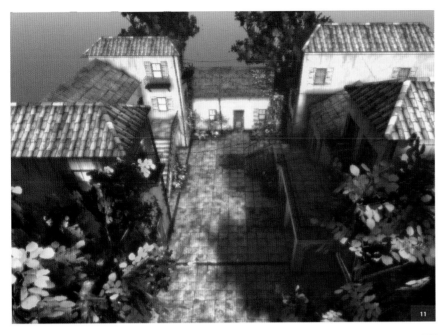

The process gathers all of your assets and packages them into one file, allowing you to easily distribute your artwork in an impressive way. Screenshots are okay, but to actually be able to walk around your artwork and study it should really impress the person viewing it. It would also show you have some technical ability and understanding.

To create your installer file, you have to use a new program called 'Unreal Frontend' (**www.udn.epicgames.com/Three/ UnrealFrontend.html**). With the program open, under the Game tab, browse to your saved map file, highlighted in **Fig.12**.

I left all the settings as default and clicked Cook in the top toolbar. You will notice a lot of text starts streaming on the right-hand side of the program; this text is useful to keep an eye on, as it will show you any errors that may occur and how the general progress of the cook is going.

Once this process is complete, click Package Game. This will open up another window for you to name your EXE file (**Fig.13**). Once you have decided on a name, click the Package Game button and Unreal will start to compile your EXE file.

The notes will tell you when the process has finished and where the file was created on your hard drive. Test your EXE by installing it and running the game. I have included my EXE with this tutorial for you to look at (**Fig.14**) (**www.3dtotalpublishing.com/resources.html**).

Getting into the games industry is a hard path to go down, and can be a very frustrating and lonely journey. Spending days, weeks or even months on a piece of artwork just to add a few screenshots to your portfolio, not knowing if it will lead to a job or even an interview, is hard!

It is definitely a path worth taking, though. Only the most determined will complete the journey, but the reward is that you get paid to do your absolute dream job. I couldn't imagine working in any other field; the thought alone sends shivers down my spine. There is nothing quite like seeing your game on the shelf in a store, or a screenshot of your level in a magazine.

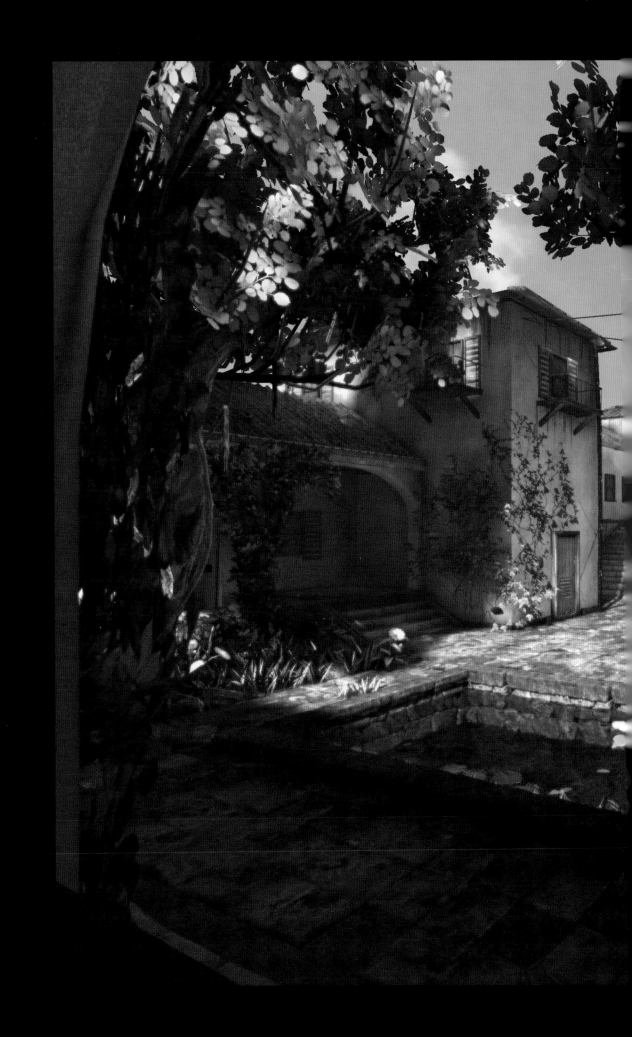

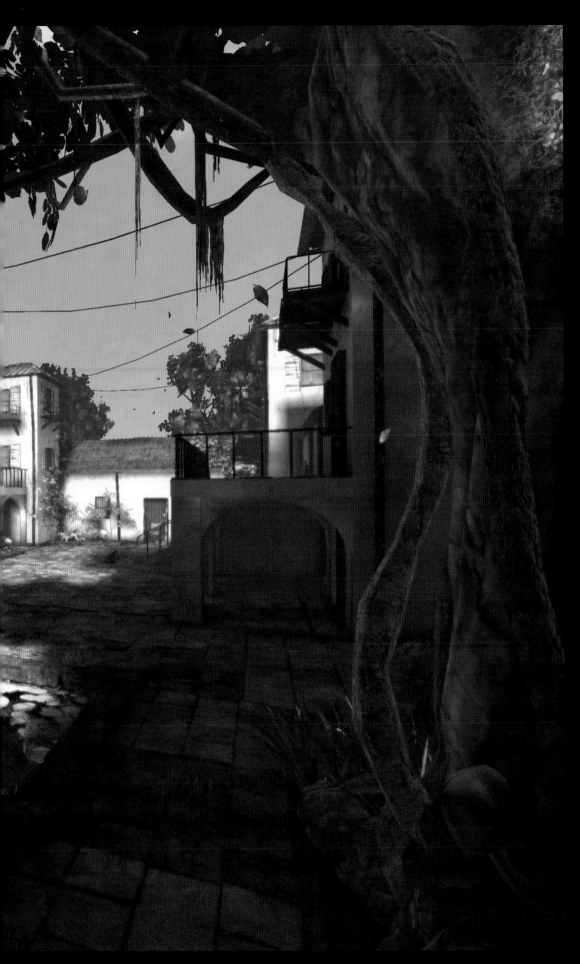

The final image of the Italian courtyard with all the lighting and PFX added

WEAPON DESIGN
HANDGUN

In this section, I will guide you through the process of creating a weapon asset that can be used in-game. I will show you how to model each element of the weapon and then move on to unwrapping the asset and texturing it.

We will use a blueprint of a weapon that you can easily find using a search engine. We should also use a search engine to gather good reference images of the weapon that will aid us in the modeling and dimension-sizing process.

CHAPTER ONE
MODELING

We need to prepare the scene before we can begin modeling. Start off by importing the blueprint image of the weapon. I managed to find this image just using a search engine and I have modified the colors so it's easy on the eyes in the 3ds Max viewport.

It's best not to use a white background, because when you have a mesh selected, the wireframes are usually white, so you can't see it. I've chosen a pale green – this way we know I'll be able to see the meshes clearly.

In 3ds Max, right-click on the viewport text and select Viewport Background as shown in **Fig.01**. You will be presented with a dialog box. From here, you can browse to the required image file.

Also, make sure that Match Bitmap and Lock Zoom/Pan are enabled – these will ensure your mesh and background image are locked together, so when you pan and zoom they stay together (**Fig.02**).

In **Fig.03**, you can see the image in place in the 3ds Max Front viewport – we are now ready to begin modeling.

Start to model the trigger with a simple plane with no subdivisions, then turn it to an Editable Poly. Using the Edit Poly tools, extrude and subdivide the polys to reach the desired shape. You can see how I have kept to the outline of the gun blueprint in **Fig.04**.

01

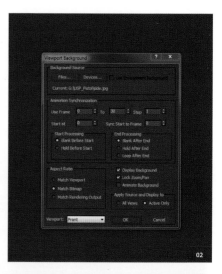

02

03

04

05

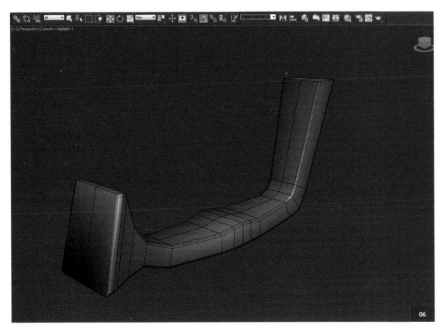

06

"Don't go overboard with the divisions and increase the poly count of the asset. We can always optimize the mesh at a later date"

When modeling, remember this is a game asset, so don't go overboard with the divisions and increase the poly count of the asset. We can always optimize the mesh at a later stage of the modeling phase, but it's always good practise to think of this as you go along.

Grab the outline of the mesh and extrude inwards to about half the depth you think the trigger part should be – it doesn't have to be perfect yet. When you are happy it's about halfway, apply a symmetry modifier to the asset shown in **Fig.05**.

This mirrors the asset and welds it together, but doesn't destroy your modifier stack, allowing you to keep modeling on the original half of the asset while the symmetry modifier updates the new mirrored half. This cuts down on the modeling and re-working times. You should keep the modifier stack intact for as long as possible so we can edit the mesh at a later stage.

Fig.06 shows the final model. Add a chamfered edge along the asset – this will allow the surface to catch the light nicely when in the game, and improve the finished look of the asset overall.

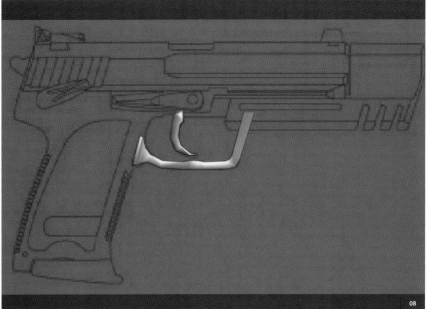

Using the techniques described previously, continue to model the rest of the trigger assembly of the pistol. You can see the complete modeling assets in **Fig.07 – 09.**

"Subdivide the mesh, so it can be welded to the two curved geometies later on – this will cut down any potential lighting risks when being lit in-game"

Build the hand grip in a couple of sections, then weld it together when it's complete. Start with the palm area and follow the contours of the blueprint shown in **Fig.10.** You can see I model up to the areas where the handle begins to curve around. Subdivide the mesh, so it can be welded to the two curved geometries later on – this will cut down any potential lighting risks when being lit in-game.

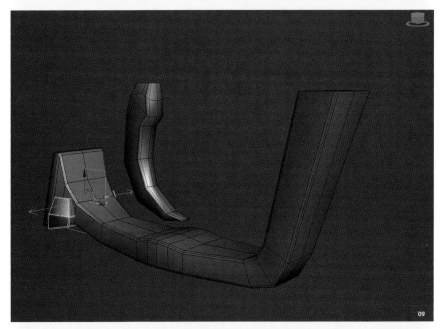

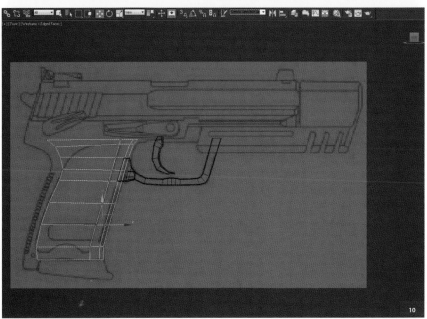

"Don't forget to model the top of the gun that the metal element sits on"

It's best to have good topology in your meshes, as heavily triangulated meshes can sometimes light weirdly. **Fig.11** shows the back of the handle modeled and attached to the front of the handle. You can see where it is welded onto the palm-grip area. The symmetry modifier completes the other half of the handle for us.

Continuing to model the black plastic parts of the pistol, don't forget to model the top of the gun that the metal element sits on. **Fig.12 – 13** show the basic shape, modeled by following the lines on the blueprint and using the basic Edit Poly tools.

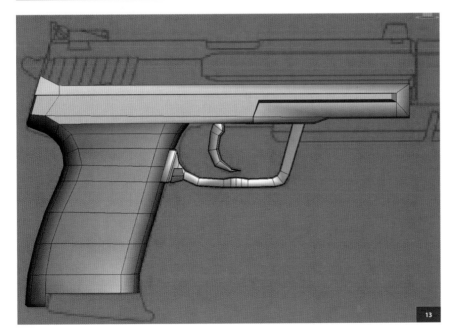

WEAPON DESIGN HANDGUN

CHAPTER TWO
MODELING FINALIZATION AND UV-MAPPING

Following on from the previous chapter, we will finalize the modeling of this weapon asset and move on to UV-mapping and packing the UVs into the UV space, so we can texture efficiently and get the best pixel density for the weapon asset.

We must model the metal-sliding element of the gun. Collapse the modifier stack – the Symmetry Modifier no longer has any effect on the model, which means if we make a change to one side of the model, we will have to repeat the process on the other side (**Fig.01**).

We do this because this part of the gun is not symmetrical. In the middle of the metal element, there is a section that ejects the used bullets. Using the Cut tool, carve out this area and extrude the edges until you're happy with the final model (**Fig.02**).

Now, with the main body of the gun modeled, it's time to add the finishing touches, like the sights and switches. Again, just using simple plane- and box-modeling and the techniques used in chapter one, create these elements, shown in **Fig.03 – 04**. This completes the modeling phase of this chapter.

Moving on to the UV-mapping, we want to make sure that all the elements are UV-ed to the correct proportions. So, as we unwrap each element, apply a checkerboard material – this allows us to scale the UV islands visually, by making sure they all have roughly the same sized squares from the checkerboard material.

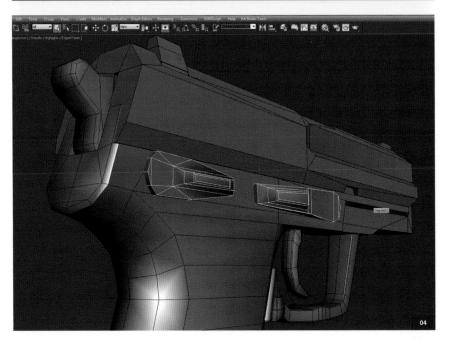

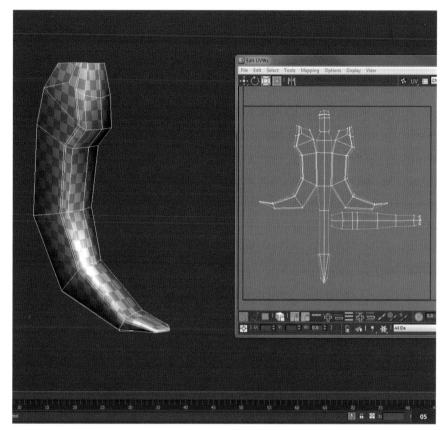

Starting with the trigger, use Planar mapping to flat-map each surface, then weld the seams together using Vertex Weld and Target Vertex Weld. **Fig.05 – 06** show these elements fully unwrapped and centered in the UV space. As you can see, the squares of the checkerboard material are almost identical, so they are in correct proportion to one another.

Sometimes, using these simple mapping techniques won't give us the results we need. For example, the switches on the side of the gun have curved surfaces, so using a Planar map would cause the UV space to be bundled together and cause insufficient resolution on the model. To resolve this issue, we use the Relax tool in the UV-Unwrap modifier.

After applying a Planar unwrap, select the UV element and apply the Relax tool. There are a few settings you can choose from – try all of them to get the best result. I often keep boundaries, as I don't want the outline of the element to be warped.

Fig.07 shows the switch Planar-mapped and relaxed to allow the best possible resolution on the texture. The rest of the gun is UV-Unwrapped using the same techniques (**Fig.08 – 11**).

The last phase of the unwrapping process is packing the UV islands into the UV space efficiently and effectively, to allow the best possible resolution of texture on our model. I enjoy this process – it's like a puzzle getting everything to fit correctly and to the right scale.

After attaching all of the elements together, apply a new UV-Unwrap modifier and start to arrange the UV-Islands into the UV-Space. When we need to scale the elements down in order to fit in the space, select all of the UV islands, Uniform Scale them down and rearrange them to fit the space. You can also rotate the UV islands to fit in the

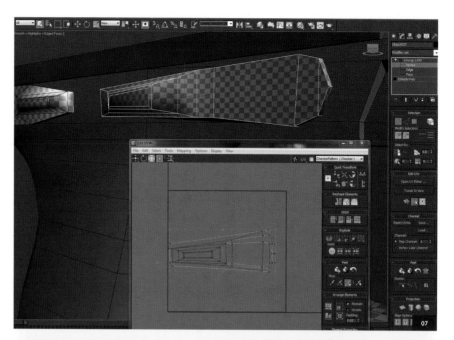

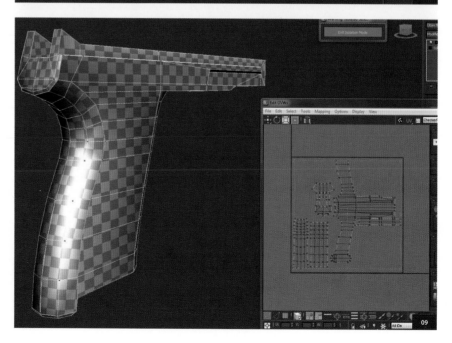

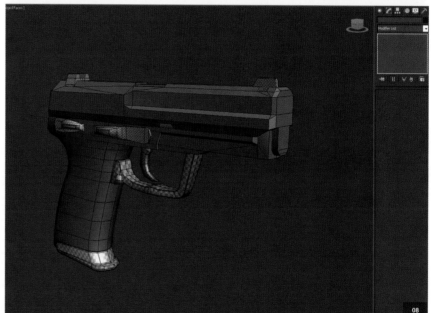

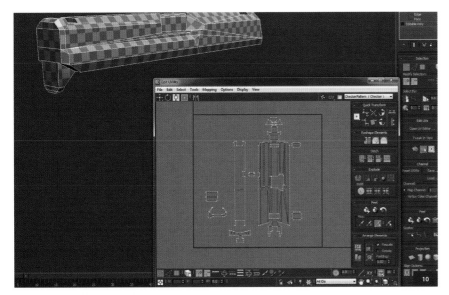

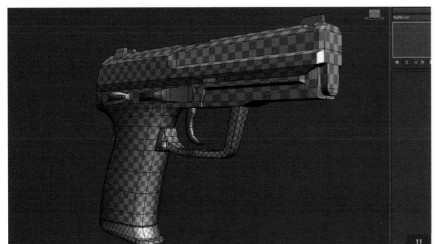

"The highest resolution has to stay on the largest surface area, especially where text will be visible"

best possible way. When it becomes hard to find the space to fit everything in, you can select the smallest elements and scale them down independently from the base of the gun.

The highest resolution has to stay on the largest surface area, especially where text will be visible. With the UV islands tightly packed and correctly scaled – to give the best possible resolution on the weapon asset – render out the UV space to a map that we can use in Photoshop to guide us while texturing, using the Render UVs tool in the UV-Unwrap modifier.

Fig.12 shows the finished UV-Space rendered out as a usable map.

WEAPON DESIGN
HANDGUN

CHAPTER THREE
TEXTURE CREATION

When creating textures for assets, it needs to be easy to select the different material types in Photoshop, especially when you work with many layers.

To do this, render out a Material ID map using Render to Texture in 3ds Max. Firstly, apply different-colored materials to each separate element of the asset.

In this case, blue represents the brushed-metal material, green represents the black plastic, red represents the darker-gray, brushed-metal, and yellow represents the black plastic for the trigger and magazine clip.

With the mesh selected, open the Render to Texture dialog and select Diffuse Map to be rendered out using the existing UV mapping channel 1, at 2,048 x 2,048 resolution (**Fig.01**). The resulting render is a flat, multi-colored texture that we can use to mass-select areas within Photoshop, as shown here in **Fig.02**.

Using the Magic Wand tool in Photoshop, mass-select each color of the Material ID map and apply a flat color that matches the reference images. So plastic would be a very dark gray and the brushed-metal would be a very light gray. **Fig.03** shows the multiple layers in Photoshop.

To help give the weapon a more realistic look in 3ds Max, I like to bake out a draft Ambient Occlusion (AO) map and apply it over the texture. With the gun selected, use the Render to Texture tool and choose AO map.

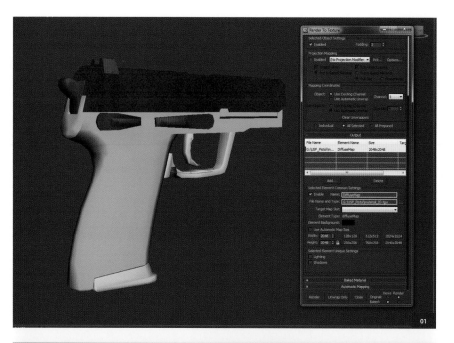

01

02

03

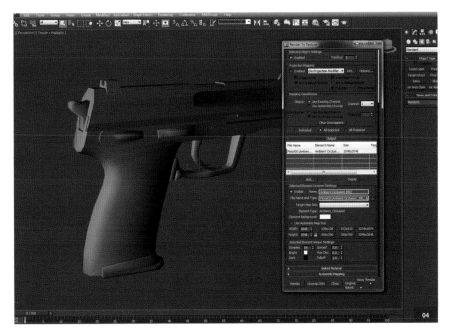

If the AO map is not visible, it's because you do not have mental ray chosen as your default renderer. Change your renderer in the Render settings dialog and assign mental ray. Now the AO should be available in the Render to Texture options. Render a 2,048 x 2,048 map and set the samples to 64 – this gives us a good-enough result from the render (**Fig.04**).

Import the rendered AO map into your texture file in Photoshop and change the layer style to Multiply to remove the white from the texture (**Fig.05**).

Save the texture and apply it to the model. At this stage, it's nothing special – but it gives us a better idea of how the gun is going to look when it is finished (**Fig.06**).

The Diffuse texture of the weapon will be quite basic. It's the material that will really sell the realistic look of this asset, so it's important to have a good, clean Normal map and Specular map.

The Normal map will be made in two parts: the first for the large details like the engraved text, joins and carvings in the surface. The second part will consist of the smaller details, like the rough, noisy plastic and brushed-metal surfaces. Blending these two maps together in Photoshop will ensure there is no interference from the details.

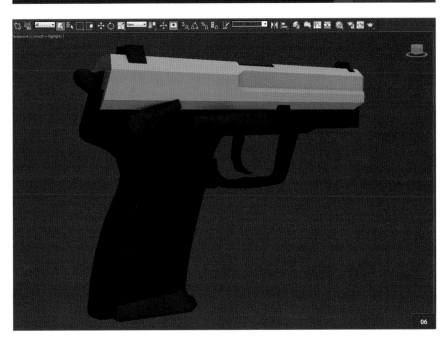

Starting with the large details, make a layer and fill it with a light gray color. This is the base layer, so if we want to have a raised surface we could color it white – and if we want an indent we could color it black.

If we fill the layer with white, it would already be as raised as it could be, so using a light gray allows us to add a positive and negative Normal.

To help us add details to the correct position on the weapon, import the UV render texture we made earlier on. Set the layer

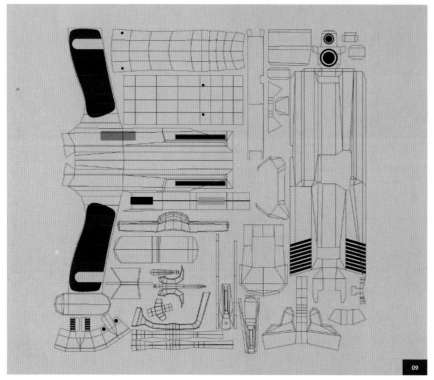

to Difference to allow us to see through it and see the wireframe clearly (**Fig.07**).

Using the photo reference as a guide, create black-colored boxes that represent the deepest engravings on the weapon. Also use the Pen tool to create custom shapes for the handgrip area. Color these a darker gray, as we don't want them as deep as the other details we make (**Fig.08**).

To add all the larger details you can see on the weapon, continue to follow the photo reference and add shapes and hard-edged brush strokes. Add the hole where the bullet leaves the gun, seams where the plastic joins together and holes for the screws (**Fig.09**).

Also add a shape the same color as the background over the handgrip's dark-gray shapes. This is an area that is flat, with a logo imprinted on it. The color means it remains the same height as the base of the gun.

The rivets on the gun are simple circular shapes with Layer Styles added to give the effect of beveled edges. In this example, the circle has a Stroke and Inner Glow effect applied. When we convert this image to a Normal map, it will give the illusion of a tight, beveled, raised rivet.

Behind the rivet, add a dark gray circle that fades around the edges, allowing the rivet to appear as if it sits in a dip on the surface of the weapon (**Fig.10**).

On the hand grip, there are small raised squares on the front and back of the gun. Create one using the same technique as the rivet. Duplicate it until they cover the correct area.

"The small Details map is created fairly quickly using simple Noise maps"

On the back-side of the handgrip, use the Warp modifier to get the curved distortion to match the curve of the surface (**Fig.11**).

The brushed-metal surfaces contain text engraved into the surface. Using the Text tool, place all the text in position on the gun.

For a little detail, add a very thin, white-colored stroke effect to the text and change the Opacity to 50% so it isn't too strong. This will give the effect of a slight, raised area around the text that was made when the text was being engraved. It will also help to catch the light on the gun when the model is being lit in-game (**Fig.12**).

Fig.13 is the final image of the large details before we convert it to a Normal map.

The small details map is created fairly quickly using simple Noise maps. The plastic surface uses a light and denser noise to give us the effect of a rough surface, that isn't too rough – but just enough to break up the flat surface when we apply the Specular and Reflection to the material.

Use the Material ID map to make the selection and mask off the unwanted areas (**Fig.14**).

The handgrip area has a larger and darker noise to give it a deeper and rougher surface than the rest of the plastic area.

To get a brushed-metal effect is easy to achieve by using a lightly-colored Noise map and applying a Motion Blur filter in a vertical motion. You have to make sure this map is very light because if it isn't, when it gets converted to a Normal map the detail will be too deep and could end up looking like wood.

You want it to have just enough of an effect to disrupt the surface reflections and specular. **Fig.15** shows the finished small details map completed.

Use CrazyBump to create the Normal map. Firstly, load the small details map, then when the CrazyBump automatically generates the Normal, turn all of the details to 0 so you are left with a blank, Normal map in the preview slot.

Adjust the Very Fine Detail to 50 and the Fine Detail to 99. We need to make sure the small details Normal map has very little influence on the material, so turn the Intensity down to 10. Any higher and we would lose the material types we were trying to create. Surfaces like concrete should have higher numbers, as their surfaces are very rough.

With the settings now giving us the results we want, export the Normal map from CrazyBump. You can see the final small details Normal map in **Fig.16**.

For the large details, import the map into CrazyBump and set all the settings to 0 again to start with a blank, Normal map. Adjust the Very Fine Detail to 50 and the Fine Detail to 99 – but this time also adjust the Medium Detail to 25 and the Large Detail also to 25. Adjusting the larger detail values give us a more rounded edge on a Normal map, to create a softer blend in the areas that require it. **Fig.17** is the finished large details map.

Now that we have the two separate Normal maps, we need to blend them together. Import them both into the texture file in Photoshop. Place the small details map below the large details map, and set the large details map layer to Overlay.

This allows the two layers to combine, while not adding or taking anything away from the other. However, it leaves us with a problem: now the Small Detail map is showing up in areas that we don't want it to, such as on the rivets – so we need to paint them out…

Find a flat area of the Normal map and sample the color. Now when we use the paintbrush, the painted area will be flattened out. To select the required areas, such as the rivets, you can go back through the layers, find the layer with the detail on that you want to paint out and, while holding Ctrl, select the layer. This puts a Marquee selection around the object.

Make sure you are still editing the Normal map and begin painting out the noisy surface. **Fig.18** shows the painting-out of the noise affecting the label on the handgrip area.

Continue to paint out the unwanted noise on the flat areas of the weapon, and this should finish the Normal map (**Fig.19**).

WEAPON DESIGN HANDGUN

CHAPTER FOUR

TEXTURE FINALIZATION AND PORTFOLIO PRESENTATION

The Diffuse texture needs to be completed next. So, continuing where we left off, select the basic colors of the parts for the weapon; dark-gray for the plastic, light-gray for the metal parts and an almost white area for the brushed metal.

To start painting in the details for the Diffuse texture, use the layers created in the large and small details Normal map groups.

On the safety switch, duplicate the Text layers S and F, and color them as shown in the reference images: white and red (**Fig.01**).

The same technique is used for all of the details. For the sights, use the dots and color them green. This is all that's needed to give us the effect we need – it's simple, but the material will be doing all the work for us when it's in the engine. There is no need to over-complicate the Diffuse texture and risk making it look muddy and low-resolution (**Fig.02**).

Because some of the parts of this gun are metal, the edges of the surface are likely to be worn away after a period of use – so it's a nice little touch to add this effect to further add to the realistic look we are trying to achieve.

Duplicate the layer of light-gray metal and use Levels to increase the brightness of the texture to almost white. This will represent the exposed metal. Add a Layer Mask and fill it with white so the texture is no longer visible, unless we paint black onto the Mask Layer.

Use a Chalk brush for a noisy texture when you paint, using solid black as the color. Also enable

the UV map for painting guidance. Ensure the Layer Mask is selected and trace the lines that represent the outer edges of the metal elements on the gun. Duplicate the brushed-metal layer and make it virtually transparent;

just visible enough to enhance the brushed-metal look. For the dark-gray plastic, paint a very faint area around the handgrip – again, just subtle enough to give a little variation in the surface, to show wear and tear (**Fig.03**).

Fig.04 shows the final diffuse texture. Very simple, but should be more than good enough for what we need.

The last texture to create is the Specular map. This map consists of both the small bump group and the Diffuse group of our Photoshop document.

The brushed-metal of the gun is pure white because we want it to be totally reflective and as shiny as possible. Don't include any of the brushed-metal details in this area.

For the dark-gray, plastic areas, copy the small bump noise layers and put them on a slightly lighter background. Also, turn the Opacity of this layer down to 40% – this will give us subtle variations of the specular highlights to give the illusion of a rougher plastic.

Do the same to the handgrip areas, but have the Opacity at 25% because it is rougher and we don't want it to be too noisy (**Fig.05**).

The worn-away details on the metal elements are pure white, so that they catch as much of the light as possible – this will make them 'pop'. Adjust the base of the metal elements to represent the type of metal surface, so the darker switches have a darker gray background and the sights are lighter (**Fig.06**).

"Because we have added new depth details to our Normal maps, the Ambient Occlusion map we rendered at the start of the texturing process is now out of date"

To achieve the final Specular map, continue to adjust the metal elements by using different shades of gray to increase or decrease the specular and reflectivity. For example, the rivets are almost pure white to make them almost 100% reflective and of a high specular value (**Fig.07**).

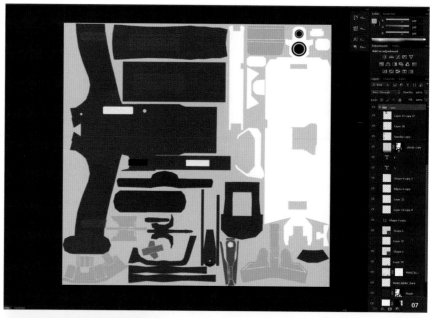

Because we have added new depth details to our Normal maps, the Ambient Occlusion map we rendered at the start of the texturing process is now out-of-date. We can create a second AO map to place over the old map containing the new details. CrazyBump can create this for us using our Normal map.

Import the Normal map into CrazyBump and select the Occlusion tab. **Fig.08** shows the settings to use to get a tighter AO map and enhance the smaller details. Save the map out and import it back into Photoshop.

Don't remove the original AO map, as we still need this for the larger details. Set the new AO map's layer to Multiply – this combines it with the older AO map. Making sure only the Diffuse layer group is visible, save out a new Diffuse texture with the new AO maps also visible (**Fig.09**).

That's the texturing phase now complete. It's time to show off our model and present it for the portfolio. We will use the Marmoset Toolbag (**www.marmoset.co**) to render screenshots of the weapon in a real-time engine.

To get the weapon into the Marmoset Toolbag, we need to export our model. Export the selected mesh as an OBJ format from 3ds Max. With Marmoset now open, click Open Mesh and select the newly exported OBJ.

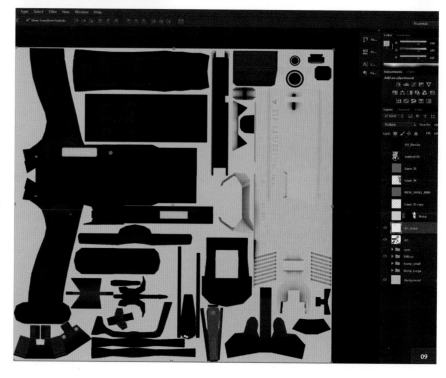

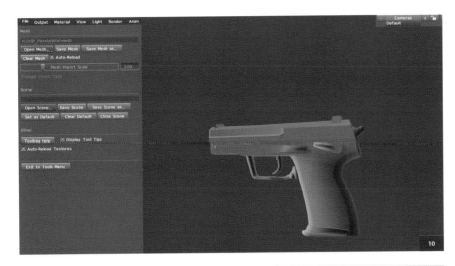

You should now see the weapon
in the viewport with the default
gray material applied (**Fig.10**).

Switch to the Material tab and turn on
Diffuse. Select the saved Diffuse map
we created earlier. Do the same for the
Normal and Specular slots (**Fig.11**).

At the moment, Marmoset is using the
default lighting setup. Fortunately, it has
a number of presets we can choose from
to really make the weapon stand out.

In the Light tab, choose Blue Sky as the
preset. If it looks like your asset is orientated
wrong, just rotate the mesh and camera until
you have the correct position. If you cannot
see the sky background, then you must
make sure it is enabled in the View tab.

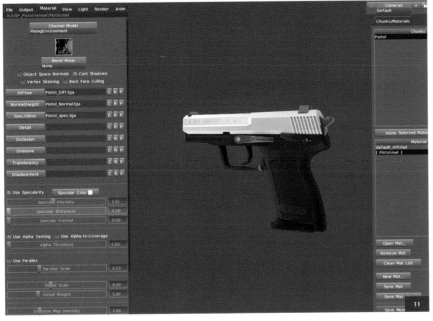

I use this feature when I want to know which
direction the sun is at, so I can easily get a
good lighting angle on my asset (**Fig.12**).

Once we are happy with the position of the
sun, turn off the Sky Visibility so only the asset
is showing against a gray background. We
do this so it doesn't take anything away from
my asset visually. We only want the viewer to
be interested in the model and nothing else.
Keeping the sky in there would be a distraction.

Marmoset has some very nice post-processing
tools available to really give our renders that
extra level of polish and professionalism.

In the Render tab, you will see all of these
features. Use my settings as a guide, but it
really is up to you to play around with the
settings and get the best look for your asset.

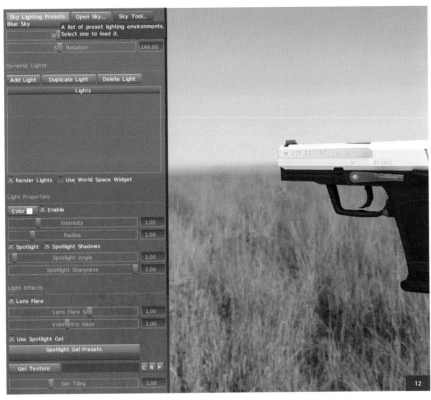

Make sure the Ambient Occlusion is enabled, as well as Shadow Casting. Depth of Field is good to get a photorealistic look. It also has Bokeh, which will give us some camera-lens effects when the image is out of focus. Again, this all adds to the photorealism (**Fig.13**).

Further down the tab, you can control the Brightness, Contrast and Saturation of the image, and add Bloom and Vignette. But I tend to keep this option disabled as I want to be able to edit my renders, and keeping the asset on a flat gray background allows me to do this easily.

Lastly, I like to add a little Chromatic Aberration. This shifts the blue, red and green channels of the image slightly, giving the impression the render was taken with a real camera. Combining this effect with the Bokeh will increase the chances of your image looking photorealistic (**Fig.14**).

That's the scene set up, so now all you need to do is start taking screenshots of your asset using interesting angles, showing off all the little details in your model.

When showing game companies your work, it is usually good practice to include wireframe screenshots so they can see that you truly understand how to model assets.

Marmoset allows you to include the wireframe mesh over the renders. This option is visible in the View tab. You can also set the Wireframe Strength so it's not too overpowering (**Fig.15**).

When you have enough shots of your asset as a singular entity, try creating little scenes using your mesh and make the renders a little more interesting to look at. It's even better if you can show off your asset from multiple sides at once, such as **Fig.16**.

Going forward, you can start adding more and more details, such as dirt and grime build-up. You can even start to be more imaginative and create add-ons, such as torches and silencers; and if you wanted to be more adventurous you can get more futuristic with your ideas and create something really different (**Fig.17**).

13

14

15

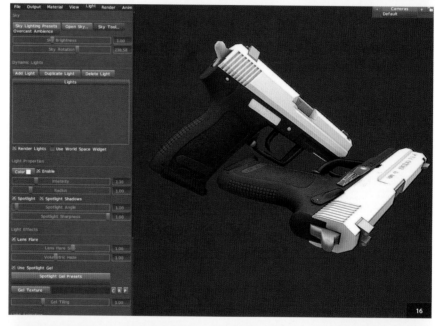

16

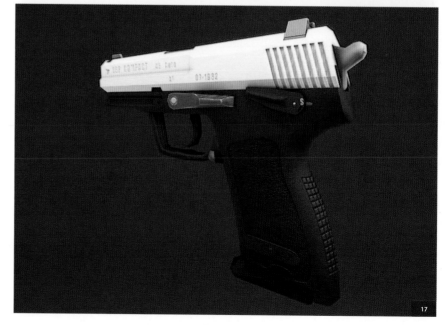

17

SUBMARINE PEN

This section will guide you through the creation of a submarine pen using UDK as the game engine. It is a more intermediate-level tutorial, but I will guide you through each step and make sure it is easy to follow. By the end you will be able to export textures from Photoshop and 3D assets (Static Meshes) from 3ds Max and import them into the UDK game engine. You will also be able to create a standalone, playable program of your level to distribute in your portfolio to future employers, or even just to your friends.

The following chapters will focus on the creation of an environment by looking at the bigger picture; creating a good composition through the demonstration of an efficient workflow. It will also cover lighting and post effects to really add polish, making it stand out and look professional. We will be using 3ds Max, Photoshop and CrazyBump to produce our artwork, and UDK to create and view the completed level.

CHAPTER ONE
CONCEPT TO WHITE BOX

When I create environments I use various techniques to achieve the visual effects I want. Some people like to create everything from Static Meshes and not use BSP brushes at all. I tend to use a mixture of the two methods to create the final composition. However, to start with we will use only BSP brushes because it's so easy to change the size of our environment in no time at all.

We have a rough idea of what we want to achieve in this project so let's start by creating what we call a 'white box' level in UDK. This is just a very basic blocked-out version of the environment. No detailed textures are applied; it's just simple boxed geometry. This provides us with a sense of the space and tells us quickly if it works or not as a scene.

> **"The depth doesn't really matter as the gap between the two platforms will be filled with water"**

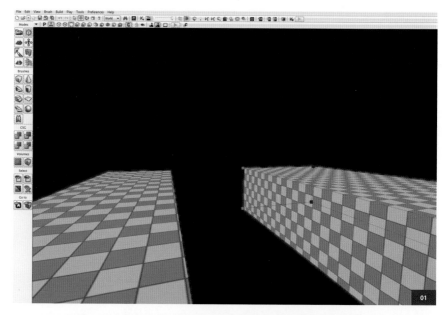

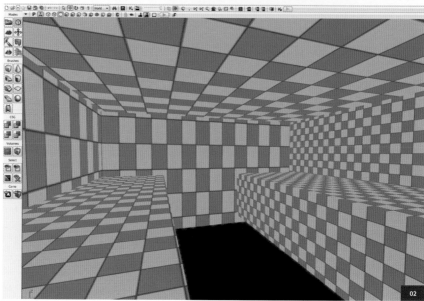

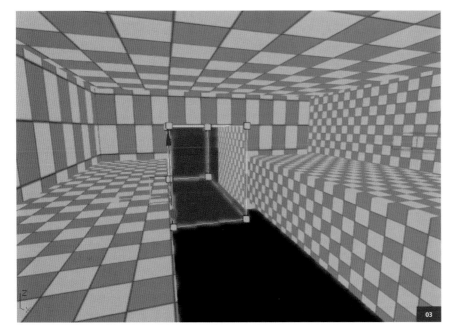

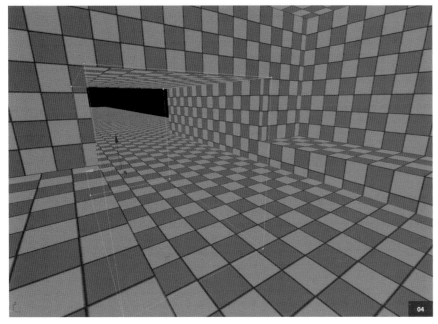

We can also make very quick changes if we need to so we can get the perfect space to work with. The white box will not be the final version of the environment – it will change throughout the whole process as we think of new ideas. This means we can adjust the geometry to suit our needs.

Using the box builder brush, create two cubes to form the platforms. They don't have to be perfect at this stage; a rough estimate in size will do. The depth doesn't really matter as the gap between the two platforms will be filled with water and we will eventually build a bridge between them, allowing the player to fully explore the level (**Fig.01**).

Using the same techniques, create walls, a ceiling and also the end wall. This provides us with a sense of the dimensions within the environment as we start to close the player in and create internal space. We will also start to see if there are any problems with the dimensions early enough to be able to edit them, without causing too much re-working later on (**Fig.02**).

Using the same box builder brush, create an opening in the back wall. Instead of adding the BSP geometry, let's subtract it to create a very simple opening (**Fig.03**).

Add a temporary plane to act as the water level. As you can see, the environment is now closing in around the player and, using our imagination, we can visualize what the finished level will look like. It is also a good idea to search the internet for reference images of places similar to this. We can build simple boxes for now, laying down the foundations for us to build on later (**Fig.04**).

On the opposite end of the environment, cut out another opening. This time we want to add an extra edge to create an arch shape. Eventually we will build a real arch mesh to replace this BSP version, but for now this will do fine in aiding our imagination to visualize the finished artwork (**Fig.05**).

Behind the arch, build a smaller room with three smaller platforms – this will add something different to the environment and give us some great opportunities to create some nice details and points of interest. Build part of this room at an angle to break up the straight edges; when viewed from the other room it will give the impression of a larger space and guide the viewer's eye around the environment (Fig.06).

With all the geometry now in place, it is time to add some temporary lights so we can play our level and judge if the space we have created is in proportion.

Place a few simple Point lights throughout the tunnel – nothing advanced, just with enough intensity for us to see where we are and with big enough Radiuses to project light onto all the surfaces. Let's also switch off all the textures so they don't distract our imagination (Fig.07).

Add a red light near the archway; in part to break up the scene, but also to aid us in visualizing what we want to change later on in the project. We can also add a player start point on one of the platforms.

Now if you play the map and walk around the environment, you can start to see if what you have is correct in dimensions and feels right. At this stage it is really simple to correct any errors. I'm quite happy with what I have now and I would consider this white box complete (Fig.08).

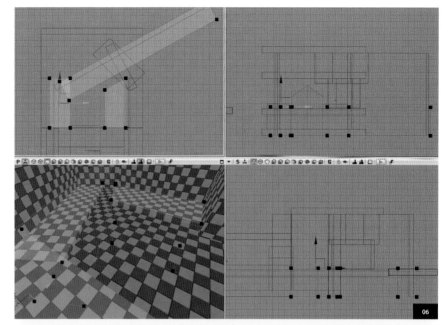

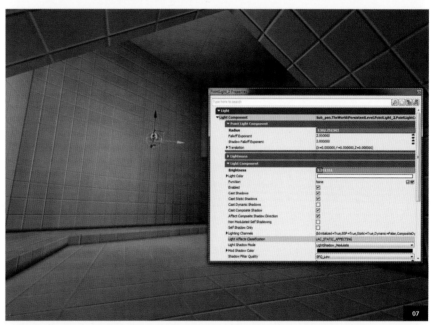

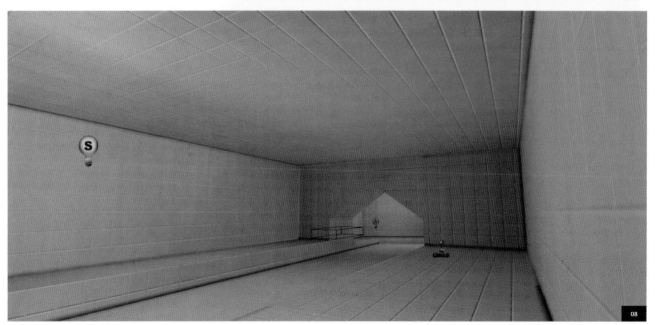

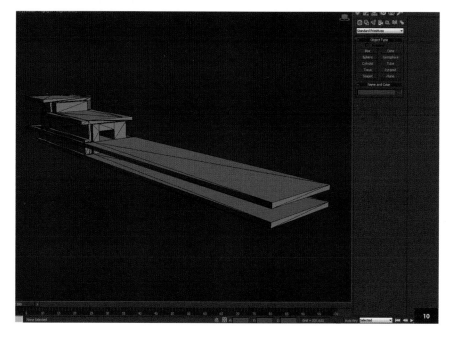

"We can then detail these modular pieces, texture them and re-import them back into UDK"

Now that we are happy with the size of our environment, it is time to export the geometry into 3ds Max so we can chop it into sections or 'modular pieces'. We can then detail these modular pieces, texture them and re-import them back into UDK. Simply select File Export > All… and this will export the BSP geometry in OBJ format, which is readable in most 3D packages (**Fig.09**).

With a new scene in 3ds Max, open File > Import and locate the OBJ that was exported from UDK. An import window will appear with a few options. Leave all of these as default and select Import. Now that the white box mesh is in 3ds Max as one solid object, we can use the modeling tools to break the object up into workable sections (**Fig.10**). The exported OBJ file is one of the downloadable resources included, so you can view it and play around with it (**www.3dtotalpublishing.com/resources.html**).

Near the cave entrance of the sub pen with various assets in place

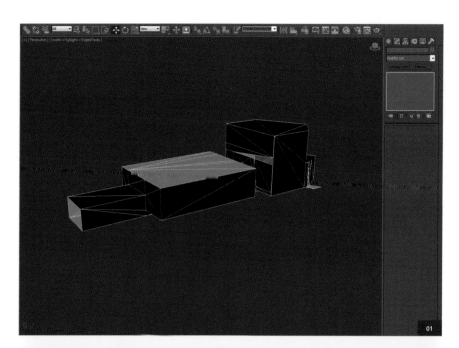

SUBMARINE PEN

CHAPTER TWO

WHITE BOX TO CUSTOM MESH

We are now ready to start detailing the mesh for eventual export back into UDK. So, let's get started!

The exported mesh is one big object so using the Edit Poly tools, select the faces that make up the different sections of the large model and detach the elements into multiple objects. There are also a lot of unnecessary polys that we don't need, such as the exterior and the back faces.

> **"With the elements broken up, we can easily isolate the ones we want to work on and detail them"**

Fig.01 – 02 show the before and after of this process. I've colored the different elements in **Fig.02** to make it easier to see. With the elements broken up, we can easily isolate the ones we want to work on and detail them. We're going to start with the arch in the middle of the environment, which separates the two rooms.

In **Fig.03** you can see I've used simple Edit Poly tools to add more edges to the archway so it doesn't look low poly. We're not going to spend a lot of time modeling the perfect model; remember this tutorial is all about the 'bigger picture' and completing a finished environment. For this reason, a lot of the models we make for this tutorial will be quite basic and allow for the time restrictions we normally have in which to complete a project.

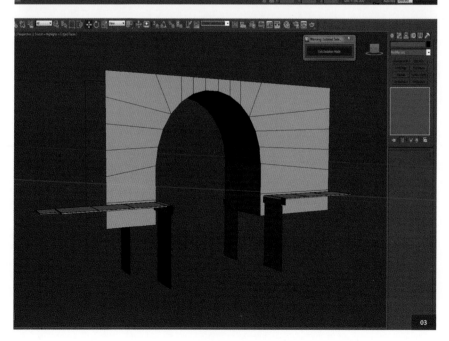

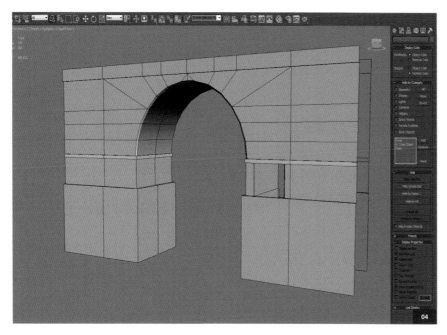

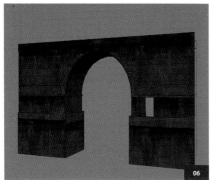

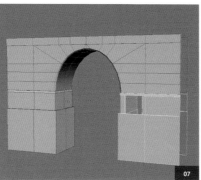

Fig.04 shows the finished model as far as I want to take it. As you can see it is quite simple; once it is in UDK we will add more models, such as pipes and light fittings, to add further interest.

Fig.05 shows an example of the textures that will be applied, while **Fig.06** shows the textures applied to the model within 3ds Max. Again, nothing too special – I'm keeping it very simple. Of course, if you wish, you can spend a lot more time working on your models and textures, but for now this suits our needs.

The archway is nearly complete now, but we still need to think about lighting at this stage before preparing it for export, because UDK bakes its own lighting and generates Light maps. We need to ensure we have enough UV space to get a good shadow baked onto the model later in this process.

Because this mesh is quite large, break it up into three pieces. Each piece can then have its own Light map UV space, and in turn have a higher resolution shadow. **Fig.07** shows the different colored sections.

Apply a UV Unwrap modifier to the top of the archway model and make sure the UVs are set to mapping channel 2 (this is important as this is the channel UDK uses to map the Light maps). Selecting all the polys in the top of the archway model, use the Flatten Mapping tool in 3ds Max's UV Unwrap. This automatically flattens all the surfaces and lays them out within the UV. It doesn't overlap any polys as this would cause shadow errors. **Fig.08** demonstrates the final UVs for the second mapping channel.

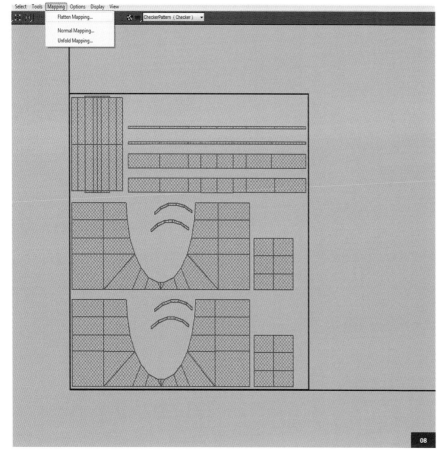

Now we will need to select each element individually by going to File > Export > Export Selected. Select ASCII as your file type and give each element a suitable name. Do this for the remaining elements to complete the archway model.

Using the same processes as above, continue to create modular meshes using the larger exported BSP object. **Fig.09** shows the edging of the platforms; again a very simple modular mesh that we will duplicate in UDK to build up the environment. The final textured model that will be used is illustrated in **Fig.10**.

Continuing in UDK where we left off in chapter one, you should have the white box level open so we can start importing our newly-created meshes and textures. In the Content browser, import the Arch and Edging ASCII files we exported from 3ds Max. Also import the textures for both meshes and create two separate materials. Your content browser should look similar to **Fig.11**.

> ! By breaking up elements, you can easily isolate the ones you want to work on for future detailing.

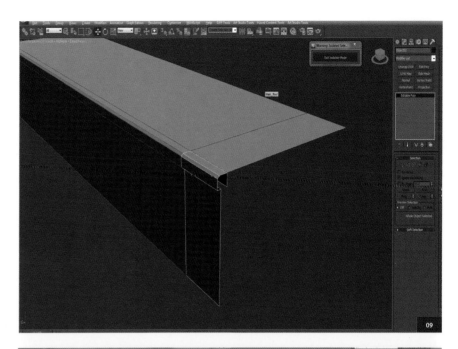

09

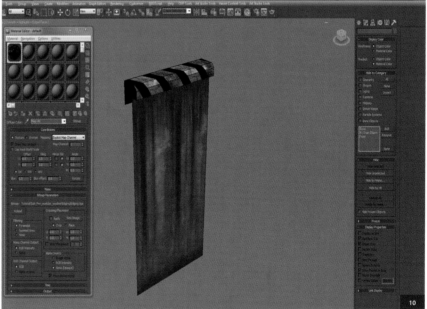

10

11

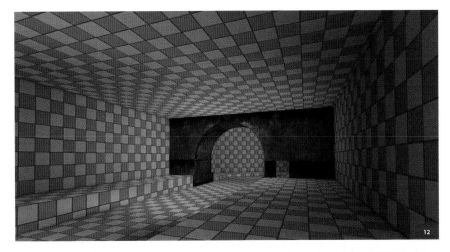

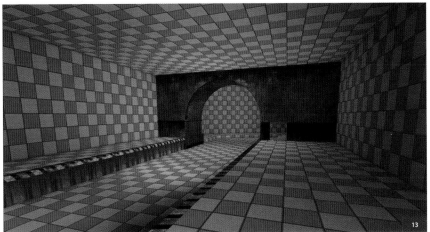

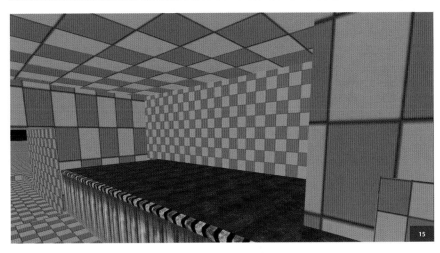

"You can now go back to 3ds Max and create more meshes to use in the level"

Now apply these materials to your Static Meshes. Once that is done, we can drop them into the environment by dragging and dropping the Static Mesh. Drag the archway Static Meshes into the environment and align them to their BSP equivalent. You can now delete the BSP archway mesh so it doesn't interfere with our Static Mesh version (**Fig.12**).

Now drag the edging into the environment and align it to the platform's edge. Once this is aligned, hold down Alt and drag a copy of the edging mesh to the side and continue all the way along the platform. Then do the same for the opposite platform. You should now have something that looks like **Fig.13**.

You can now go back to 3ds Max and create more meshes to use in the level. Remember, we're only interested in the infrastructure meshes at the moment; we will concentrate on creating the decorative objects in a later chapter; for example, barrels and shelves. Also, feel free to add to the BSP mesh – I won't be replacing all of it with Static Meshes.

Fig.14 shows a corner room I've added using the BSP brushes. I've also cut out a simple doorway which we will texture up later on in the series. The platforms are looking a little narrow at this point – things will get particularly cluttered when we start to fill the scene with objects – so let's push the wall back to give us double the room to work with on the one platform.

We're also probably going to be adding some natural elements at a later stage, such as rocks to give the impression the submarine base is built inside a cave.

Fig.15 shows the edited BSP geometry. Continue to do this around the environment to create some extra interest and help generate some ideas for the final look of the level. Keep on editing what we have and keep the ideas flowing.

Keep the entrance/exit free of clutter to add to the realism

SUBMARINE PEN

CHAPTER THREE

FINALIZING THE ENVIRONMENT – PART 1

In this chapter we will continue to use the exported BSP geometry in 3ds Max to help build more architectural assets. We will also start to flesh-out the environmental space, before we populate the scene with objects and effects.

We will also apply temporary materials to the BSP surfaces in UDK, because it will give us a better idea of what the finished scene will look like, and it'll be easier to look at than the default texture.

It's time to start replacing the blocked-out areas with more detailed geometry. The models I've created are simple, but for this project will suit my needs. You should spend a lot more time on your assets and get as much detail in them as possible.

Fig.01 – 03 show the completed assets with textures applied and placed in the UDK engine. Use the same import process described in the previous chapter to import your models and texture. I will go through the process again later in this book when we are bringing in our set-dressing assets.

Fig.04 illustrates the right-hand-side walkway of the submarine pen. The surface area is quite large and this will create problems for us when tiling textures – as it could be a dull area that takes up a lot of screen space.

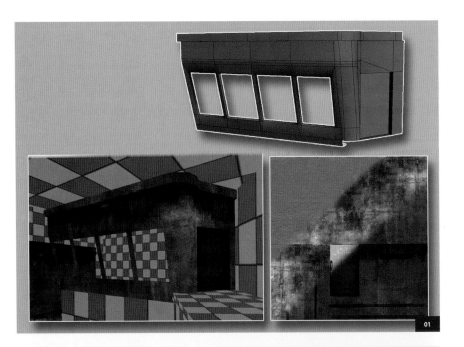

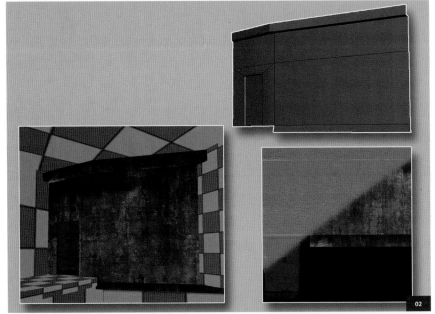

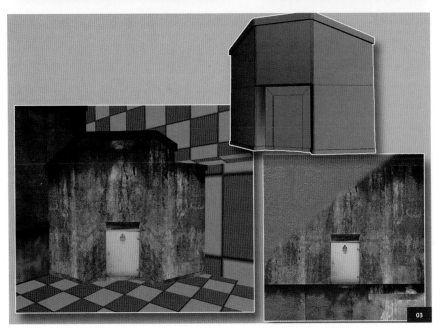

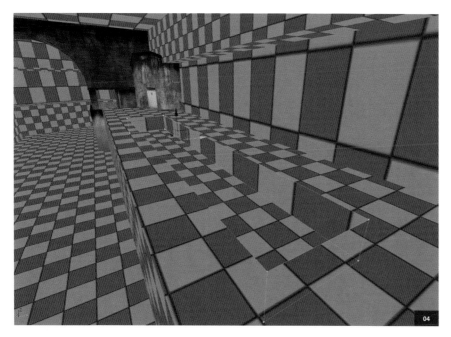

To help overcome these issues, we can break it up by adding a feature into the geometry. I had the idea of adding pipes that run underground and making them visible with a grate covering them. This also gives us the chance to add upward lighting from underneath the grate that will cast some interesting shadows on the surrounding areas. Something as simple as this can give us so much in return; it adds multiple layers to our scene, making it more believable as a working environment.

Subtract a volume from the BSP geometry that is roughly big enough for what we need. It doesn't have to be perfect at this stage. We will dress the area with new assets later on in the project – but for now this is sufficient.

At this stage of a project, I like to add some temporary textures to the environment; again, this is to aid us in visualizing the end product and will hopefully inspire us to create some nice little areas within the environment. I usually search for existing materials and just apply them to the BSP geometry.

Fig.05 shows the temporary wall material I'm using. In the Content browser > Packages section, highlight content in the UDK Game folder. In the Object Type section, make sure Materials is selected, as this filters all the content and only displays the materials.

Then, browse through the available materials until you find a suitable wall material. I'm using M_LT_Floors_BSP_Dark_TileBreak_02 on the floors, which is highlighted in the image.

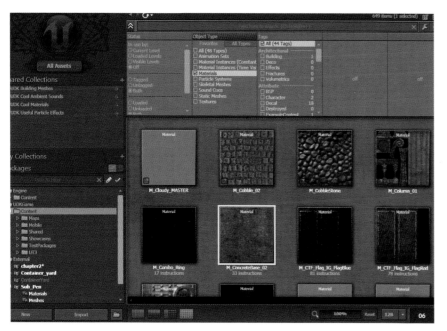

Highlighted in **Fig.06** is the material I've applied to the walls, which is M_ConcreteBase_02. To quickly apply the material to the walls and floors, select the material in the Asset browser. Then hold down Alt and navigate through the viewport, clicking on each wall or floor surface to apply the material automatically. This is a quick way to flood-fill the entire scene with a material. We don't have to worry about UV-mapping at this stage, as long as the textures are applied to break up the surface areas.

91

In **Fig.07** you can see the temporary floor and wall textures applied to the BSP geometry in the scene. You can also see that the custom assets are in place and are almost ready for set-dressing. I still have the draft lighting in place – this is good enough for now before we start to move on to the next stage.

"Once the water is placed, it will give us a totally different feel to the space around us"

Fig.08 – 09 show the second room and a viewpoint looking back through the archway at the main hall. Apply some more temporary materials where needed and use Omni lights to illuminate the scene.

The environment looks a little open at this stage – I think it is giving us a false representation of the space available. I believe this is because the water is not in the scene. Once the water is placed, it will give us a totally different feel to the space around us.

So, for now, let's add a simple Plane BSP geometry to represent the water's surface. We don't need to worry about adding a nice water material just yet, as that will be part of our polishing stage.

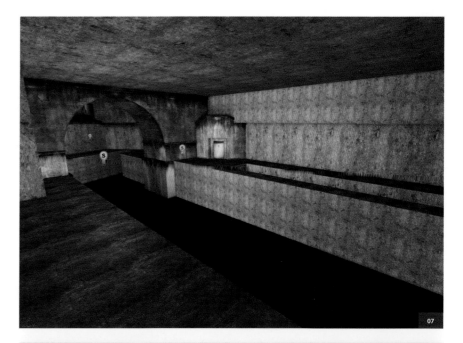

10

11

Add a simple BSP plane that stretches the entire map and sits just below the walkway edge. Shown here in **Fig.10 – 11** are the main room and second room. As you can see, the whole environment feels a lot more claustrophobic now and gives us a better idea of the available space around us.

A large feature of this environment is the bridge that connects the two sides of the map. As this will play such a big part in the composition of the environment, we will add in a temporary bridge. Again, this is just to give us a rough idea of the scale of the bridge and if it will fit okay within the environment.

Create a simple plane and in Edit Geometry mode, split it three times horizontally. This gives us six extra vertices in the middle of the plane. Select these six vertices and move them up to create a ramp on either end of the bridge.

As in **Fig.12** add two small, red, temporary lights, just to add a bit of interest and make the bridge stand out from the rest of the environment. This won't be the final position of the bridge, but it's good enough for us to get an idea of what it will look like.

We now have our final draft of the environment, with all the necessary navigational meshes and three main architectural assets in place. We also have temporary textures applied to all the surfaces and draft lighting, ready to fill the environment with polished assets.

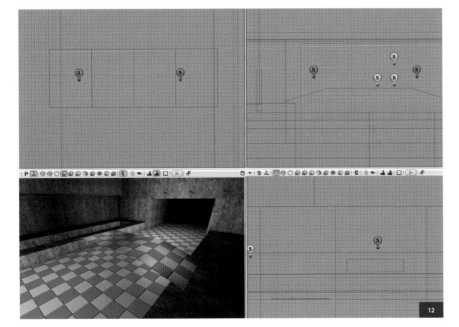

12

An overview of the sub pen with all the Spot Lights in place

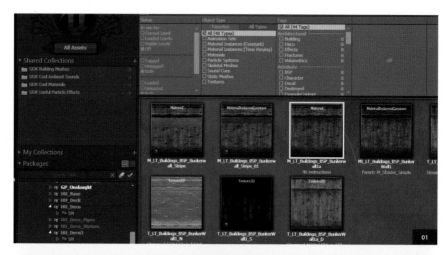

01

SUBMARINE PEN

CHAPTER FOUR

FINALIZING THE ENVIRONMENT – PART 2

It is now time for us to place the final materials and correctly UV-map them to the surface of the BSP geometry. Remember, this is just the start of our layering process; we will build upon this layer by layer, adding objects and decals to finish off the environment.

To make this process quicker, I will use already existing materials and objects in this chapter, but I encourage you to create your own textures, materials and objects for your portfolio piece.

We will use only two different materials for the entire BSP geometry; a dark one that can be tiled in any direction, and a lighter one tiled in one direction, to add contrast. Use the lighter material for some of the walls because it also has some trim details to help break up the repetition – this adds some interest to the plain areas where objects aren't placed.

Fig.01 shows the lighter material applied to the BSP geometry, called 'M_LT_Buildings_ BSP_Bunkerwall1a'. As you can see, the UV is not correct. If you double-click on the surface of the wall, it will bring up the surface properties window (**Fig.02**). This window allows us to correct the UVs and correctly align the texture to the position we want it in.

We do this by selecting the entire surface we want to affect; so in this case select the whole of the wall, as we want it to match perfectly all the way along. Select Planar from the alignment and hit Apply. The texture will look like it is scaled wrong, so edit the UTile and VTile settings until you get the correct scale of the texture for the size of the wall.

02

03

04

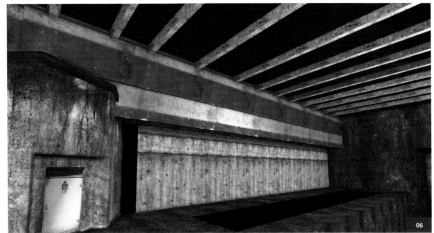

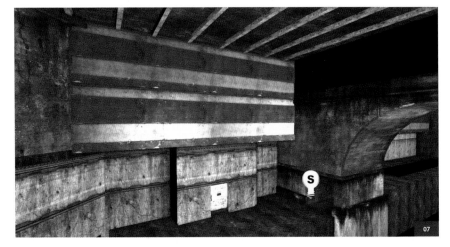

Now that the texture is scaled correctly, it still doesn't align how we want it. So, using the Pan tools we can scroll the texture up and down until the texture is in the correct position. All the settings I use can be seen in the image and the finished UVs are also visible. The trim runs along the top of the surface, so it looks like it joins in some way to the connecting geometry.

"The material is metallic, and we can use this to our advantage when lighting"

Do this for all the remaining surfaces and the darker materials until you are happy with the way the environment is UV-ed. You can see a completed area with the darker material applied in **Fig.03**.

As you can see in this image, there is a huge hole in the environment on the right-hand side; this has been done on purpose, as we want this wall to be made of rocks to give the impression of the submarine pen being built into a cave of some sort.

Fig.04 shows the already-existing asset in UDK called 'RockMesa_06' placed in the level, ready to be scaled and maneuvered into position.

In **Fig.05** you can see the finished positions of the rocks; I also thought it would be a good idea to place these rocks in the entrance to the submarine pen, to further give the illusion of there being a rocky cliff outside of it.

In order to start adding more interest to the walls and break it up a bit, we can use a wall Static Mesh called 'S_HU_Walls_SM_Flat'. This is a good mesh to use because it is in contrast to the rest of the walls; the material is metallic and we can use this to our advantage when lighting, because the specular will catch the highlights and give us some nice visual effects.

Fig.06 shows multiple wall objects placed horizontally across the top wall. You can continue to use this object throughout the environment, as shown in **Fig.07 – 08**.

"It's a good idea to think about how the buildings are constructed in real life, as it will help us to create a realistic world"

A common problem in the games art world is making objects sit together, particularly where walls meet floors. So, as in **Fig.09**, add a skirting object around the outskirts of all the walls to meet the floors. It just helps to gel the world together and make it more believable.

Start to add support columns or girders to the scene. Place them along the edges of walls to give the illusion of creating a support structure to hold the walls up. It's a good idea to think about how the buildings are constructed in real life, as it will help us create a realistic world and add points of interest to break up the environment.

Fig.10 –12 shows how I arranged the support beams. Add them going across the sub pen from one side to the other. This is so we can add cranes running along them later on – again adding to the believability that this is a real-life working environment.

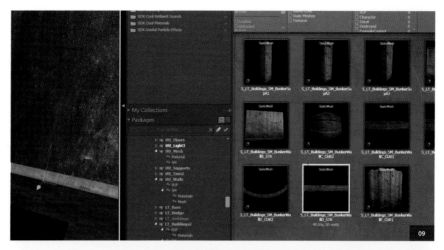

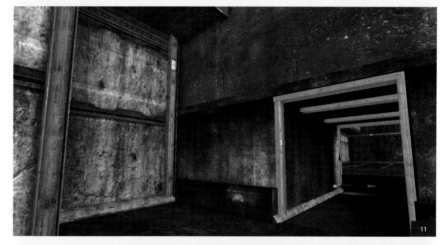

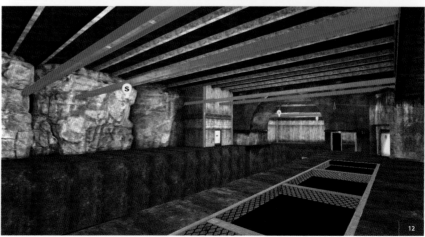

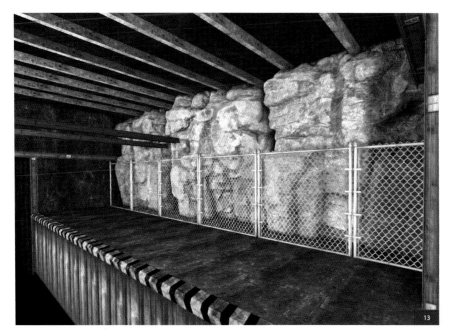

I also thought it would be a good idea to add a wire-meshed fence along the rocky wall; this will give us plenty of options later on to add some areas of interest, such as multiple layers of objects and interesting lighting placement (**Fig.13**).

This concludes the placement of ready-made objects in the UDK library. You should search through the library and find suitable objects to populate your scene with.

Fig.14 – 15 show the final stage of this chapter with all the existing assets placed. If you are doing this as a portfolio piece, then I would say not to use any objects from the library and only use your own assets – that way when you show potential employers it will be 100-percent your own work. I will cover this process in more detail in the next chapter.

Using ready-made assets is a good technique if it's to quickly see if a composition will work correctly before you spend a lot of time creating artwork that may never get used. Keep playing around with placement, generating ideas and creating your own art assets to be placed in the environment.

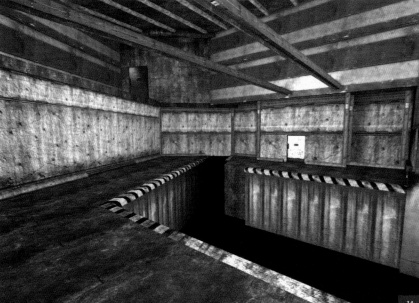

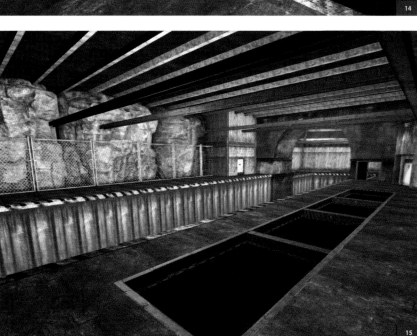

SUBMARINE PEN

CHAPTER FIVE
BUILDING OBJECTS AND PLACEMENT

In the last chapter, we started to populate the environment with existing objects that are available in the UDK Asset browser library. We cannot create the whole environment from existing assets; we need to make custom assets to suit the type of environment we want to create.

I stated in the last chapter that I encourage you not to use any existing assets for a portfolio piece. You should always use your own work when showing potential employers what you are capable of doing. I only used existing assets due to the time restrictions of creating the environment for this guide. Also, this tutorial is about creating the whole environment, so I can't go into much detail about how I created the models and textures – if I did then this would be one epic book!

You should, by now, be able to import assets into UDK, as this is a more advanced chapter – my previous chapters cover this process in more detail. I need to cover a lot of ground, so we'll keep it simple to follow. All the assets for this tutorial are included in the available download (**www.3dtotalpublishing.com/resources.html**).

To start, create a small crane that sits along the side of the water's edge (**Fig.01**). The crane geometry should be very simple and mainly created from primitives. The base

> ## "Take more time when creating your assets, so you can show off your best work"

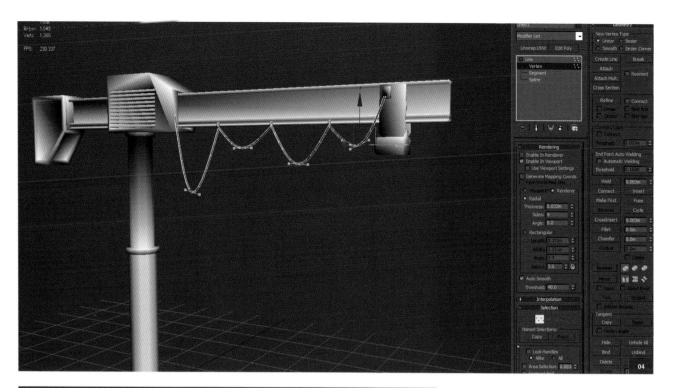

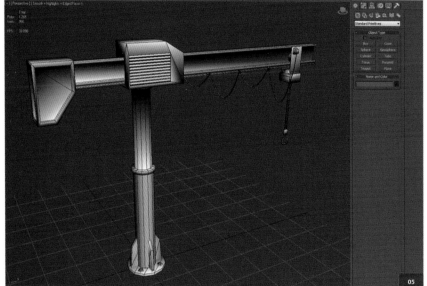

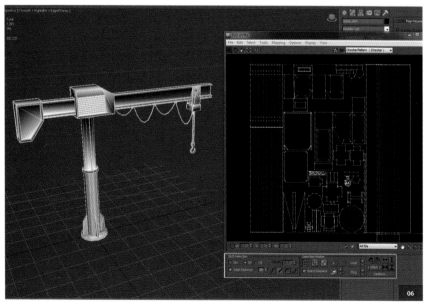

of the crane is made from a cylinder with bevels and extrusions to add little details.

Fig.02 – 03 show the main body of the crane, created from a box primitive, and simple face extrusions and bevels to add some surface detail to the geometry.

To create the wires on the crane, turn on geometry in the viewport and use splines – this gives us 3D geometry that we can attach to our crane model. Use Bevel Curves to create the curves of the wires, so it looks like it is hanging naturally (**Fig.04**).

Fig.05 shows the finished model. As you can see it has very simple geometry due to the time restrictions of this project. You should take more time when creating your assets, so you can show off your best work in your portfolio.

UV-map the whole asset to one UV map and save the UV render, ready to take it into Photoshop for the texturing process (**Fig.06**).

Fig.07 shows the finished Diffuse, Specular and Normal maps, ready to be imported into UDK and applied to the model.

In **Fig.08**, the finished asset with textures applied has been imported into UDK. A material has also been applied to the asset and it is now ready to be placed in our environment.

A barrel can be created in the same way as the crane. Use a simple primitive cylinder, with edges that are chamfered in order to add the detail. Scale-up the looped edges to create lips around the surface of the barrel.

Next, move the vertices slightly in order to create a banged-up, dented look, so the barrel looks used and old. Map the UVs to one texture page ready for texturing.

In **Fig.09 – 12** you can see the process behind the creation of the barrel's geometry.

"The diffuse should have a lot of rust detail, which is also added to the Specular and Normal maps"

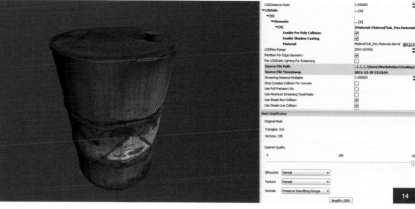

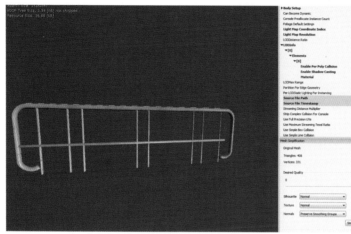

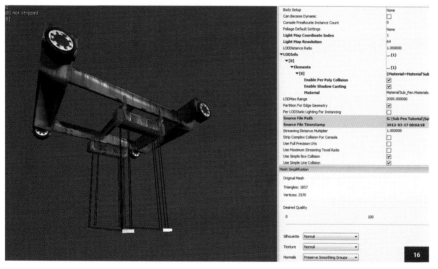

The textures for this barrel are created to further emphasize the banged-up, used-barrel look we want to go for. The diffuse should have a lot of rust detail, which is also added to the Specular and Normal maps. As this is a game barrel asset, it is usually customary for it to be red (**Fig.13**).

In **Fig.14**, you can see the finished barrel asset imported into UDK and ready to be placed in the UDK environment.

I already had two more finished assets that were ready to be placed in our environment: railings and an overhead crane. **Fig.15 – 16** show the completed assets. These can easily be created using the same methods we used for the barrel and original crane.

Once you have these assets, start placing the railing object first, as this is quite an important part of the environment. It will be used a lot and has a lot of influence in the composition of the scene (**Fig.17**).

Start on the left platform and drag a railing asset from the Asset Previewer into position. Use the Translate gizmo to move the asset more accurately into position. Then duplicate the asset all the way along the platform and on the other side (**Fig.18**).

This is just a first pass on the placement; it will continually be tweaked as more objects get placed in the scene, and until we are happy with the final composition of the environment.

"Be sure to rotate these assets so they aren't straight, to give them a more natural placement and the illusion of them being used"

Place a crane near the water's edge and between two railing assets. Also duplicate the asset and place one on the opposite side. Be sure to rotate these assets so they aren't straight, to give them a more natural placement and the illusion of them being used (**Fig.19**).

The overhead crane can be used twice in the environment. Place it along the metal beams that travel across the width of the submarine pen. Make sure the wheels are sitting in the grooves of the beams, so it looks like the crane can easily travel back and forth along the beams. Now place this asset in the other room in the same way (**Fig.20**).

To finish off the placement for this chapter, place the barrels randomly around the environment. Try to group them together and place them in an interesting way, such as on their side. Make sure to rotate each one, so they all look different from one another and are more naturally placed (**Fig.21 – 22**).

"I'm quite happy with the placement at this point, but it can all change as we start to drop in more assets"

Do a draft lighting calculation at this point, using the three temporary lights previously placed – this gives us a rough idea what the finished environment may look like.

Fig.23 – 24 show the finished placement for this chapter. I'm quite happy with the position of the assets at this point, but it can all change as we start to drop in more assets on future passes.

The environment is already starting to come together now it is populated with assets, and by the end of the next chapter it should look very busy and close to the final look we want to achieve.

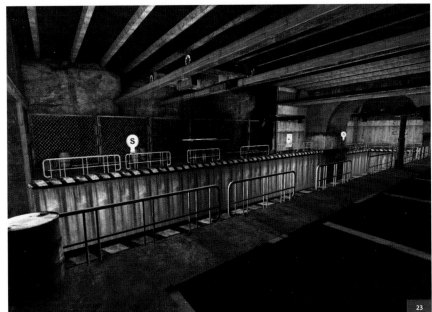

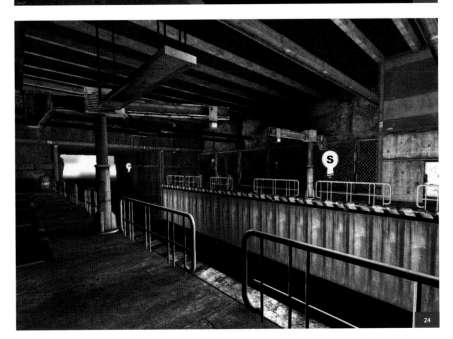

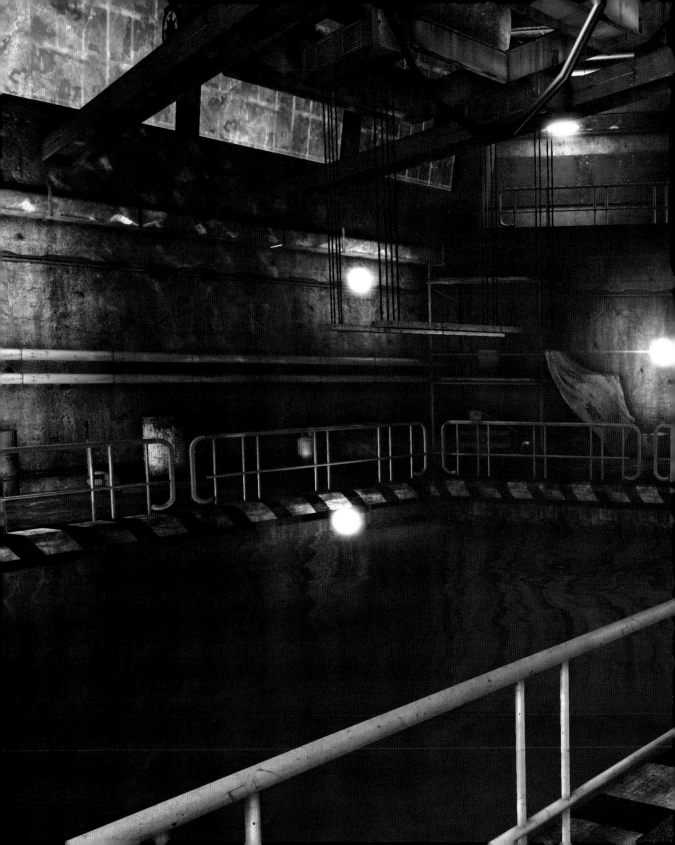

The environment is coming together now with naturally placed assets to add to the realism

SUBMARINE PEN

CHAPTER SIX

FINAL LAYOUT OF ASSETS

Continuing on from the last chapter, you can see the remaining assets I created to populate the environment and finalize the layout in **Fig.01 – 02**. They show the assets – complete with textures and materials applied.

These assets are then placed in the scene and duplicated around the environment, creating points of interest and cover for the player. As this is a game environment, it also needs to be a 'working' environment that can accommodate a player running and jumping around, or getting into fire-fights with enemies. So, using all of the assets we have created, let's start creating some interesting areas.

> **"In order to create a more believable environment, it's important to think about how objects are used and placed in the real world"**

One tip is to try to fill the corners in, so you can't see where the walls and floors meet. Instead of placing a barrel on its own, place it on top of a pallet and finish it by adding an adjacent box. It's simple, but effective, and turns a boring corner into something a little more interesting (**Fig.03**).

Fig.04 shows a corner of the environment that's more complex. To create a more believable environment, it's important to think about how objects are used and placed in the real world.

Place wooden and cardboard boxes under and on top of the scaffolding, so it looks like a used area. There is also a cloth object placed on the scaffolding poles. This asset has an organic, natural shape and is very different from the rest of the assets. It's a bespoke object specifically made to fit this space and hang from the scaffolding.

When we have finished lighting the environment, you should get some nice shadows and highlights on the cloth. It would make a good screenshot for your portfolio. I will go into more detail on how I made this object a little later in this chapter.

Using the same assets, you can fill up the corners in different ways. In **Fig.05**, the space is narrow but tall, so stack the scaffolding on top of each other to fill the space – again placing assets on and around the main structure to make it look like it has been used.

Fig.06 shows a long narrow space. Place the assets along the wall's edge to hide the joining of the wall and floor. Make sure to keep the floor free from obstruction, so the player can't get stuck on assets during gameplay.

When placing duplicate assets next to each other, you should always make sure you rotate them to make them look different from one another and more naturally placed.

During the last chapter, we placed the overhead crane in the environment. In **Fig.07**, you can see I have placed a metal shipping crate on the crane, so it looks like the crane is functional and has a purpose. Do this for both the cranes, one in each room.

Most of the groups of assets we have created have been quite minimal; however, as in **Fig.08**, we can use the shelf assets to fill the wall space. Fill the shelves with lots of boxes and containers to make them look well-used. Remember to rotate and, if possible, scale your assets to create a natural placement.

Also, place wooden crates between the shelves and gas canisters on the end. This creates a more interesting shape, so the assets range from big to small, which keeps your eye moving around the image. This is a good technique to use to create compositions for your screenshots.

The next three images show a few more examples of areas in the environment that we can populate with assets. In **Fig.09**, add the garage door and make sure not to place any assets in front of the door. Later on in this series, we will be adding decals on the floor to provide more interesting details – and objects will get in the way of this.

Also, if we are trying to convince the player that this is a real environment, we need to make sure the paths leading in and out of the doors are kept free from blockage.

As in **Fig.10**, using the same assets but placing them differently, create a dark and dirty corner. When we have final lighting, this area should really come to life, as there are a few different materials that should contrast with each other nicely. There are also plenty of objects and layers to create some interesting shadows.

This completes our placement for now. We can always move things around later, and when we start to add the finishing touches, we can re-configure the placement to get the best-looking results.

Earlier, I talked about how I created a bespoke cloth asset to place on objects in the scene. First, we need to find the place in our environment where we want to place the cloth.

Fig.11 shows the assets selected that we want the cloth to interact with in UDK. With these assets selected, we can export the models from UDK back into 3ds Max. We do this so it keeps the placement and makes it a lot easier to line the cloth up more accurately. With the two scaffolding objects selected, go to File > Export > Selected Only. This will save the selected objects as an OBJ file type that you can then import into 3ds Max.

Fig.12 shows the scaffolding objects in 3ds Max – perfectly placed to match how they sit in UDK.

Create a rectangular object the size we want the cloth to be and then apply a Garment Maker modifier to it (**Fig.13**). This modifier subdivides the mesh in a better way for the cloth simulation to look the most realistic. You can also set the density to something acceptable for the UDK engine.

"There are a lot of settings you can tweak to get different weights on your cloth, depending on what type of material you want to create"

Here we add the Cloth modifier to the cloth. Make the scaffolding objects the collision objects and the rectangle the cloth object. Now, when you run the simulation in the modifier, the cloth will fall and drape over the scaffolding assets, creating realistic-looking cloth.

3ds Max has some good help information on this modifier, so you can look at that to get more information. There are a lot of settings you can tweak to get different weights on your cloth, depending on what type of material you want to create. For this chapter, the default settings work perfectly (**Fig.14**).

You can see the final asset all textured and placed in UDK in **Fig.15**. This is a really quick, simple technique for a great-looking asset.

Fig.16 shows the other cloth assets in our environment. As you can see, you can drape cloth over lots of objects to create some aesthetically pleasing designs.

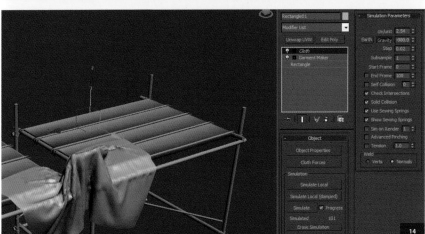

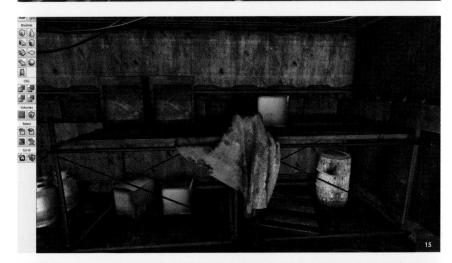

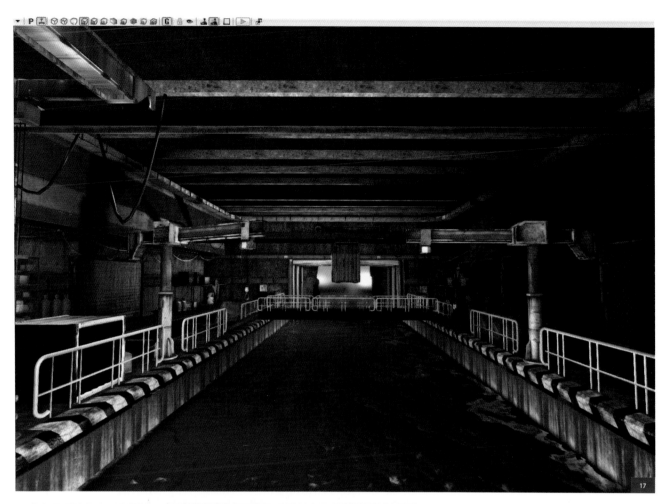

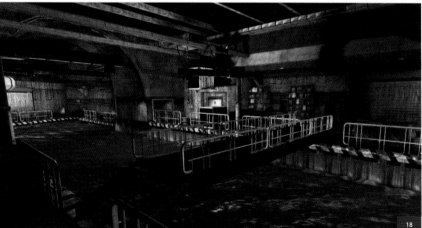

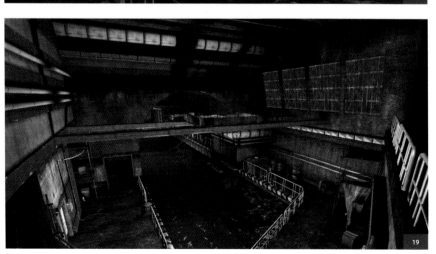

Fig.17 – 19 show the final layout for our submarine pen environment. There may still be some slight moving about when the lighting starts to go in; this is when the environment will spring into life and really start to look like a finished, professional game environment.

> **!** Try to fill the corners in so you can't see where the walls and floors meet.

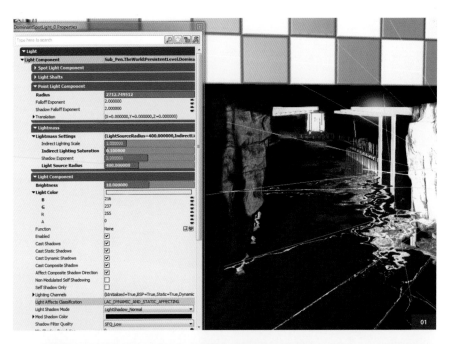

SUBMARINE PEN

CHAPTER SEVEN

DRAFT LIGHTING AND PLACING DECALS

Now that we have finalized the layout of all of our assets within the environment, we are ready to start the draft lighting phase. I will also show you how to place decals to add that extra level of detail to the environment.

So let's start a first pass on the lighting. Delete all of the temporary lights from the scene so we have a blank environment to work with – and no interference from any other light source. We want to start to get a feel for the mood of this environment now, so we will begin with the Sun.

As in **Fig.01**, place a Spot Light outside the sub pen entrance. Aim the light into the cave and slightly to the right. This will make the sunlight enter the sub pen at a more interesting angle and cast light onto many surfaces. You can also see the light settings in this image. Use a Brightness of 10 and a suitable Light Color for the sun. Also make sure the Radius setting is large enough to encompass the surfaces we want the light to hit.

Fig.02 shows a quick light calculation. You can see the light entering the cave entrance to the left, hitting the water and the platform surfaces. The light is also catching the railing which will give us some nice specular highlights.

This image also shows us a problem: the light isn't acting in a natural way. The light enters the cave, but stops once it hits the surfaces. Light doesn't act this way; light usually bounces once it hits a surface and provides indirect illumination, which illuminates the surrounding areas.

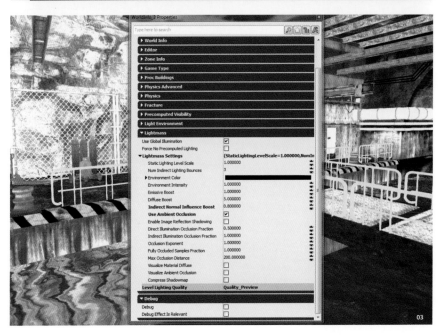

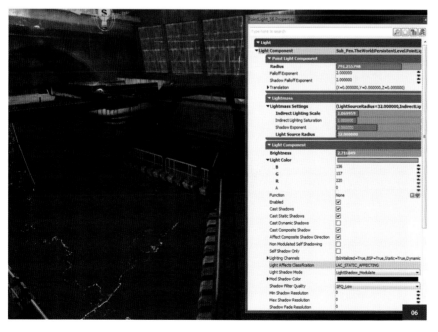

UDK can reproduce this effect quite easily by enabling Global Illumination in the Lightmass settings in the WorldInfo_3 Properties, located in the View menu, shown in **Fig.03**. This will increase the light calculation process by some time, so it is always worth setting your calculations to preview settings as you build up your lighting to make the task a lot easier and quicker to deal with.

"Don't waste time setting up intricate lighting, only to find you don't like the end result"

Fig.04 shows the same view, but with Global Illumination enabled. You can see that without adding extra lights to the scene, there is light filtering down through the dark areas of the environment, from the main Sun light we placed earlier.

Fig.05 shows a close-up shot of the light hitting the platform and railings.

Now we have the natural lighting setup, it's time to add some more interesting interior lighting. So, in the backroom of the sub pen, add a red Omni light as a test, to see if it works as part of the composition. Doing this, don't waste time setting up intricate lighting, only to find you don't like the end result.

Fig.06 shows the red Omni light floating in the backroom of the sub pen; also shown are the settings I used. Make sure the Radius of the light is large enough to hit the areas of the environment we want it to. Keep the Brightness of the light quite dull, so it doesn't overpower the atmosphere of the environment.

Right-click the area you would like the decal to be placed and choose Add DecalActor Here. This will place the decal with the already selected Material we created and applied to the Actor. This DecalActor can now be scaled and positioned in the correct place (**Fig.13**).

Fig.14 – 15 show further examples of how I used decals in the environment. Place yellow painted lines around hazardous areas in the scene, as they would be in real life. This really is a good way of adding details and breaking up repeating textures on floors and walls.

"Keep experimenting with the lighting and try to come up with some more interesting layouts"

Fig.16 –17 show the final scene with all the art placed in its final position. The scene is okay as it is, but we need to add the last bit of polish to make it really stand out. The final lighting stage will add all the interior lights and take this scene to the next level, giving it a more professional look.

Keep experimenting with the lighting and try to come up with some more interesting layouts.

> **!** Placing yellow painted lines around hazardous areas can really break up repeating textures on floors and walls.

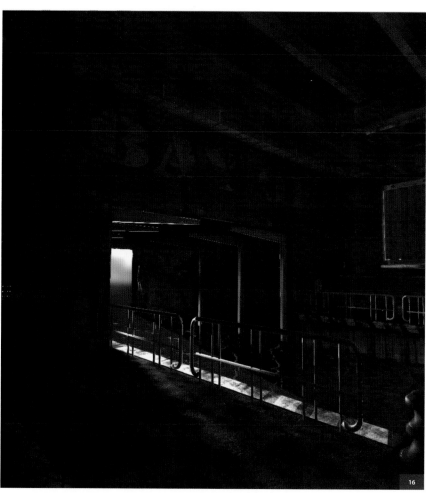

16

17

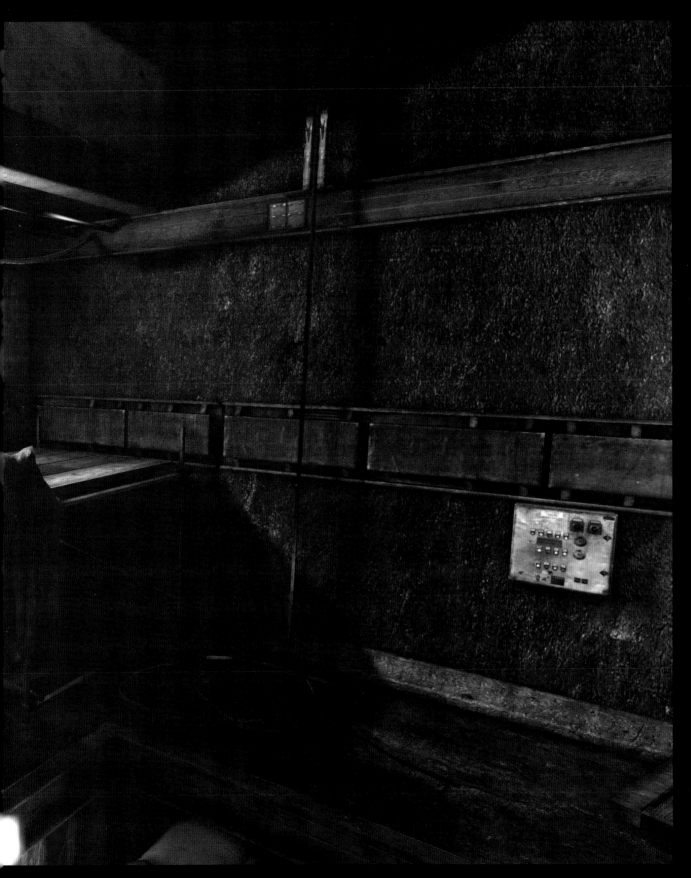

Creating different materials – like this cloth – really accentuates the realism

SUBMARINE PEN

CHAPTER EIGHT

FINALIZING THE LIGHTING

We have completed a first pass of the lighting to give us an idea of the colors we will be using to illuminate our scene. We have also placed decals around the environment to help add that extra level of realism and break up repetition in the textures.

Now we want to continue by adding the smaller details to transition this environment from a mediocre scene to a professional-looking portfolio piece. To achieve this, we will look into adding extra lights to highlight areas of the environment that we want to show off.

As previously mentioned, you should create all of your own assets to be placed in the scene. Due to the time restrictions on this project, I am using assets already available in the UDK library.

Fig.01 shows three assets I have set up in advance and prepared to be placed in the scene. These assets also have an illuminating element, so when they are placed in the scene, each object will emit a small amount of light; however, these alone won't be enough to illuminate the scene so I will later boost this with extra Omni lights.

> ## "Keep it simple when placing lights as you don't want to over-complicate the scene"

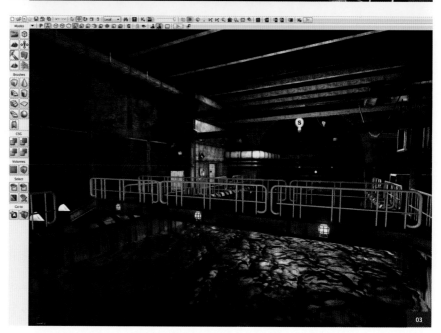

Fig.02 shows the light asset placed in the scene. Try to imagine where lights would be placed in real life and place the objects accordingly; places such as doorways, hazardous spots or walkways are usually most appropriate. It's also best to keep it simple when placing lights as you don't want to over-complicate the scene.

Fig.03 gives an idea of the final lighting scheme in the scene, with all light assets in place. In order to maintain the atmosphere, only place enough assets to light the darker corners and cast some interesting shadows.

You can see I have placed three lights along the bridge in the foreground. I've placed these here as I think it will warn the player of a potential walkway and also indicate the height of the bridge from the submarine's perspective.

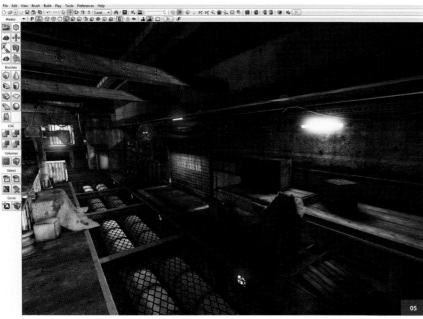

Realistically, a working environment has more than one kind of light. For example, an office has strip lights that flood the room, but also desk lamps or even PC monitors that add small pools of light. The same principle applies for our sub pen environment, as we have sunlight cascading through the entrance and small light assets placed around the scene. We should also add a strip light along the higher parts of the level. This will help create bigger shadows on the floor and lower parts of the level.

In **Fig.04**, you can see the strip light asset in the UDK library as S_L_Light_SM_fluorecent01b.

Fig.05 shows the strip light placed around the scene. Place the strip light assets behind the wire assets in order to highlight the wire and create some interesting silhouettes. It is difficult to see the wire before this light is placed, though now it springs to life and adds some real depth to the composition, which is very important when trying to create a realistic element in your artwork.

The last light we will place in the scene is a floor light that is attached to a wire. **Fig.06** shows this light asset.

Fig.07 shows the light asset placed in the scene.
You can see that I've placed it directly on the
floor and behind the wire mesh fence. I've done
this for the same reasons that I've placed the
strip lighting behind the wire assets. The floor
light will illuminate the scene from behind the
fence, casting some nice shadows and adding
an extra layer of depth to our composition.

Fig.08 shows the scene with all the light
assets placed in the scene and a new light
bake. In my opinion, the environment is now
looking a little bit too warm and over-lit. A
submarine pen is supposed to be a cold and
dangerous environment, but this lighting
setup is contradicting that. To remedy
this, we can select and delete the red and
orange Omni lights as they are no longer
needed. The light assets will provide us with
enough light to illuminate the scene.

Fig.09 gives an impression of the environment
with an updated light bake. The image
now looks a lot darker and colder and fits
with the atmosphere we are aiming for.

The scene is still a little too dark; though this
is easily resolved by boosting the light being
emitted by the light assets and letting the
Lightmass (bounce lighting) calculations
illuminate the darker areas of the environment.
I much prefer the overall impression of this
image when comparing it to **Fig.08**.

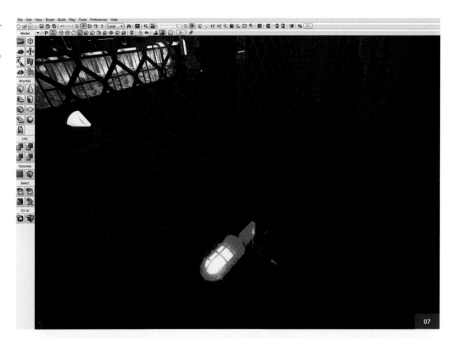

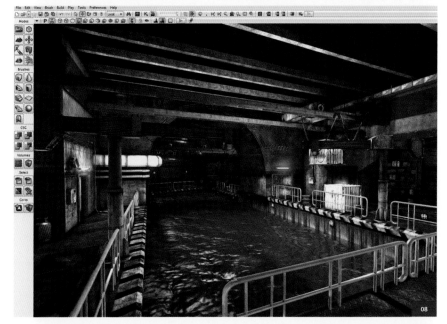

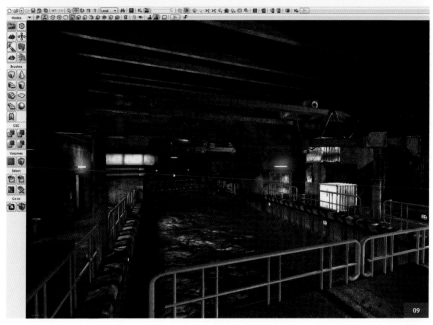

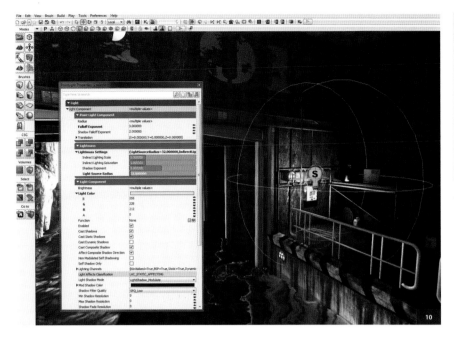

10

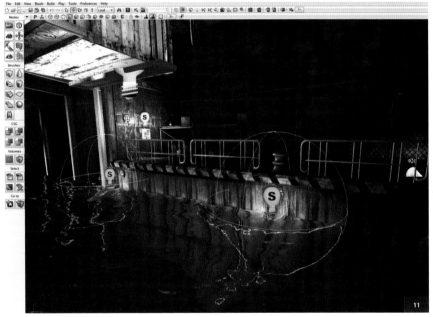

11

12

"The lights on the platform should have a warmer color to distinguish them from the lights placed on the walls"

To boost the light emitted from the light assets, we can place a simple Omni light just in front of the light asset. Shown here in **Fig.10**, the Omni light has a small Radius and a colder, blue coloration. Keep in mind when placing the light that the Lightmass calculation will bounce the emitted light around the nearby area, helping to illuminate the dark corners – so don't worry if the Radius of the Omni light is smaller than you think it should be.

Fig.11 shows how we then continue to place similar-sized Omni lights over the other light assets around the scene. The lights on the platform should have a warmer color to distinguish them from the lights placed on the walls. By keeping the Brightness and Radius settings the same, we ensure that these lights are not too warm, but just warm enough to give the desired effect.

The longer strip lights have a larger surface area of light so this needs to be replicated in the Omni lights we place. Increase the Radius of the Omni lights to accommodate the size of the assets, and also double the Brightness to emulate the power of the light being emitted from florescent tubes. **Fig.12** shows the larger Omni lights placed in the scene.

Fig.13 is the same room that originally contained the large red Omni light that was deleted earlier. We still want this room to have a red hue, to distinguish this area as one of danger, so give the smaller Omni lights a red coloration. Make the Radius of the lights larger as we want them to be more noticeable and have a greater impact on the environment.

To add further interest to the environment, add some lights under the ground. In Fig.14, you can see how I have placed eight small orange Omni lights along the pipes running underground.

Change the color to help distinguish them from the lights placed above the ground. This serves the same purpose as the strip lights, by giving the scene an extra layer of depth that was already present, though not discernible, due to the previous placement of light.

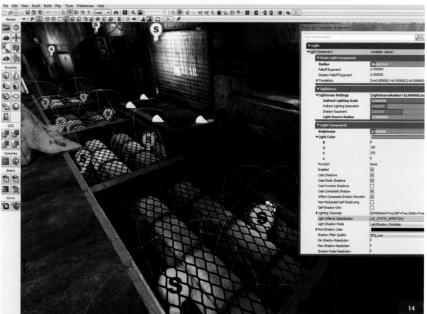

In **Fig.15 – 17**,we can see the final scene with the lighting now complete.

This scene is still not complete, as we will add finishing touches such as LensFlares, color balancing and depth of field, to add that extra level of realism. Try experimenting with different lighting setups and see how changing a few settings can really change the mood of your environment.

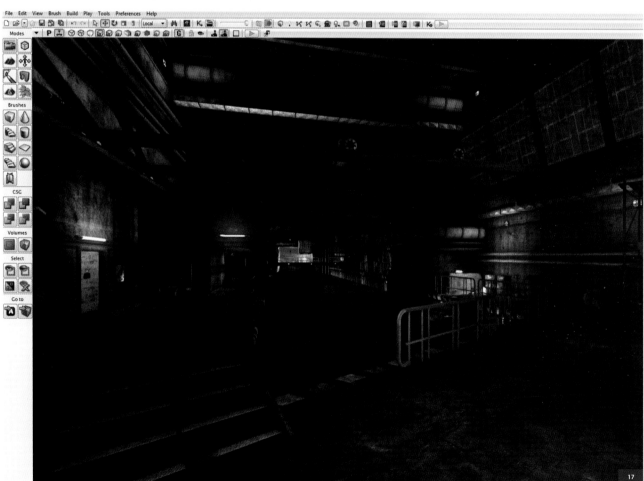

SUBMARINE PEN

CHAPTER NINE

FINAL POLISH STAGE AND COMPLETION

In the last chapter, we finished the lighting pass and have now almost completed the project. All that is left to do now is to add the final polish elements that will really bring the scene to life and make it look professional and complete.

These final polish elements will include adding LensFlares and color balancing. You will notice a dramatic change in the appearance of the environment after this phase which just shows how important it is.

As this is a gaming environment, the player will be running around the level in real-time, and so to mimic reality, the environment will need to move while the player is in it. This will entail creating swaying wires or rippling cloth.

> ## "We can also make those water reflections ripple realistically with a simple material setup in UDK"

As there is water in our environment, it would be a good idea to add light reflecting off the water and bouncing off the walls and ceiling. We can also make those water reflections ripple realistically with a simple material setup in UDK.

Fig.01 shows how I've set up two material elements working together to create the animated effect for the material in UDK. First, start by adding two Rotator nodes and place them in the same way I have shown in the image. The bottom Rotator node should use these settings:

Center X = 1.0, Center Y = 0.5 and Speed = 0.1.

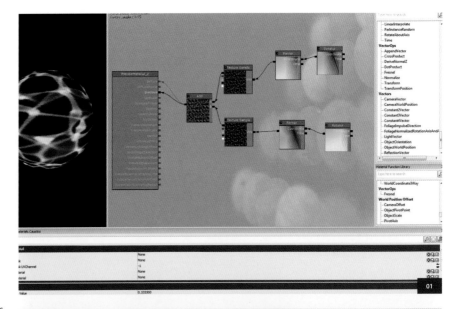

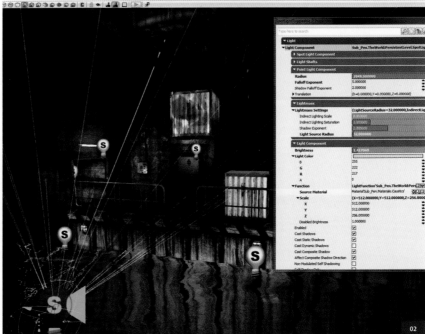

The top Rotator node should use these settings: Center X = 0.3, Center Y = 0.5 and Speed = 0.1.

This rotates the water caustics texture at different speeds, which in turn gives us the animated look we are after.

Next, add two Panner nodes and place them either side of the Rotator node (you can follow **Fig.01** for the layout).

The bottom node uses these settings: Speed X = -0.01 and Speed Y = -0.01.

The top node uses these settings: Speed X = 0.1 and Speed Y = 0.1.

This makes the water caustic texture pan in different directions, so when

combined with the Rotator data we get an animated ripple effect.

We now need to plug these nodes into our texture. Drop two Texture Sample nodes into the material and apply any water caustics texture. Follow my original layout in **Fig.01**, and link the nodes to the texture UVs of the texture samples.

In order to get the two strands working together, we need to drop an Add node to the material, and link the top and bottom strands to A and B. You can now connect the Add node to the Diffuse and Emissive slots of our material.

Our created material can be added to a spot light within the scene and be projected as light onto any surface you point the light at.

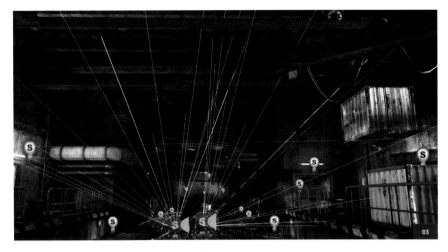

03

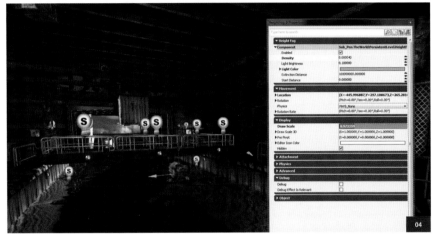

04

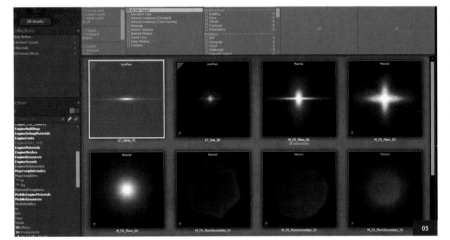

05

06

Fig.02 shows a Spot Light I have placed in the scene and the settings used to create it. In the Light Component tab of the light settings window, move to the Function section and drop our material into the Source Material slot. This Spot Light is now linked to the material we created and is now able to be projected into our scene.

You can also increase the Brightness and change the color as if it were a normal light. This type of light can be quite expensive to use in real-time, so it's best to use them sparingly. For our portfolio piece, however, they are perfect. Duplicate the lights around the scene and position them pointing upwards to give the illusion of light bouncing off the water surface and hitting the walls (**Fig.03**).

At the moment, the environment is looking a little flat and lacking any atmosphere. As you look into the distance, color fades and you can see less detail due to the atmosphere and environmental effects, such as fog and mist. If you look from one end of our map to the other, it has the same color values and saturation values from the beginning to the end. We can fix this by adding a Fog actor to our scene to give us the subtle effect of an atmosphere.

Fig.04 shows the actor in the scene and the settings we will use to get the effect we want; for example, giving the fog a bluish tint to exemplify the coldness of our environment.

We want to add some lens effects to some of the lights in our scene. UDK has some pre-made LensFlares, found in the Asset browser shown in **Fig.05**. Choose the asset LF_Lamp_01 and just drag this into our environment.

We don't want to place LensFlares over every light asset in the scene, as this will look ridiculous, so choose specific lights that you think will have the most impact. These are mainly the Spot Lights on the bridge and either side of the garage doors (**Fig.06**).

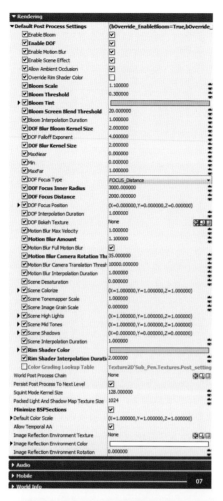

We want to add some depth of field to the camera. This can easily be done in the WorldInfo Properties. **Fig.07** shows all the settings used to affect the camera. Enable Bloom so we get some blooming effects from the bright Spot Lights, and adjust the settings so the effect isn't too overpowering. Like most of the settings, try to keep the effects low-key so they don't take over the image.

Most importantly, enable DOF. We don't want the environment to be out-of-focus because that would be unrealistic, but we do want the exterior of the cave to be blurred so the player won't be able to focus on this area. Play around with these settings until you get the look you want in your scene.

You can also color-balance in these properties, but I don't like to use this technique to do that. I much prefer to make my changes in Photoshop, bring the data into UDK and apply it to my camera. To do this we can use the Look Up Table (LUT).

To do the color grading and adjustments in Photoshop, we first need to take a screenshot of our environment and paste it into Photoshop. UDK provides a small,

color-graded bar PNG on their website (search for 'look up table') (**www.udn.epicgames. com/three/colorgrading.html**). To make it a little easier, I have also added it to the downloadable media for this tutorial.

Drop this .PNG onto a new layer in Photoshop and place it somewhere that does not obscure the view. Now, add Adjustment layers so we can change different settings without destroying any data. These layers allow us to go back and continue to make changes. I normally just use four Adjustment layers: Levels, Color Balance, Hue/Saturation and Brightness/Contrast.

Fig.08 shows my setup in Photoshop before I make any adjustments. Make sure the color-grading bar is underneath the Adjustment layers so they can influence the texture. All you need to do now is adjust each Adjustment layer to get your desired effect.

Start by adjusting the settings to ensure that the dark and light areas, color balance and saturation all appear correct. You can make some drastic changes to the way your environment looks here, but try to keep it simple and color-balance to subtly enhance the atmosphere of the environment.

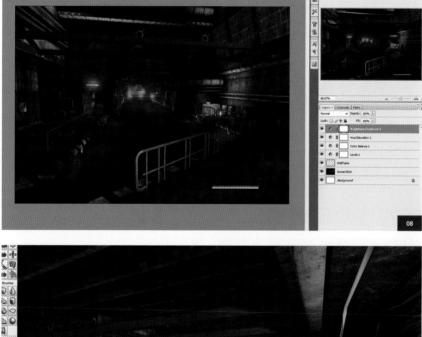

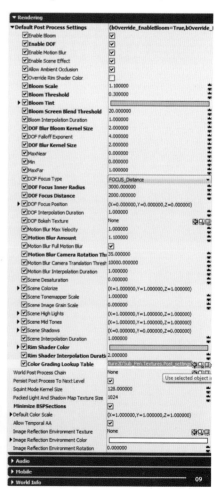

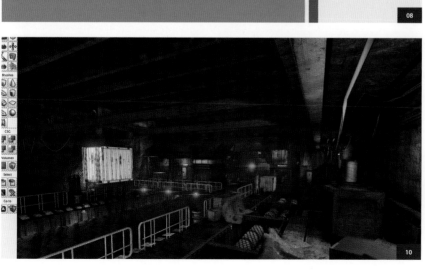

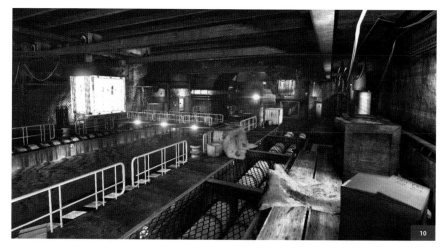

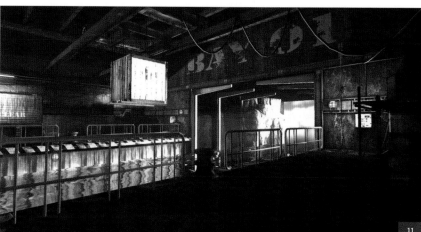

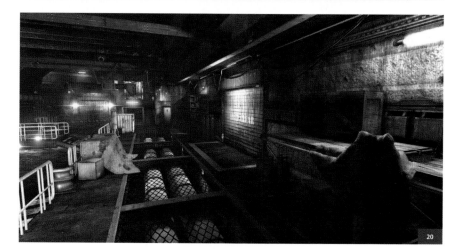

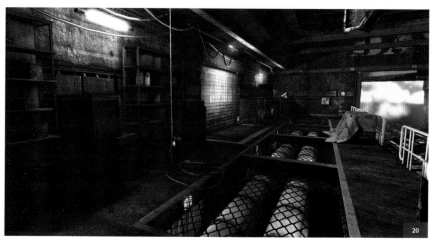

When you are happy with your adjustments, hold Ctrl and left-click on the RGB Table layer. This will select all of the pixels in this layer. Then select Edit > Copy Merged and create a new document. Paste this copied layer into the new document. This will contain all your adjustments, so save it to a separate file so we can import it into UDK.

Once you have imported the new RGB Table into your UDK package, apply it to the Color Grading Lookup Table in the WorldInfo panel (Fig.09).

Fig.10 –11 show an image of our environment with the LUT off and on, respectively. As you can see, it makes a dramatic difference to the look and feel of our environment.

Our white areas stand out nicely and the dark, shadowed areas are suitably deep. Overall, the colors are well-balanced and everything seems to work together a lot better now.

You should find interesting angles that best show off your assets and environment. Experiment with different angles and create some dynamic screenshots that you can add to your portfolio.

Fig.12 – 14 show sample screenshots of our finished scene. Also create a standalone EXE file that can be distributed to studios so they can install and explore your game scene.

VEHICLE DESIGN
BUS

In this section, we will cover the process of creating a vehicle that we can then place in our environment in the zombie town section. The vehicle that we will create is a New York City-style bus. This asset will be used as a set-dressing asset; it is not a vehicle that is designed to be driven by the player. You have to think ahead about how the asset you are making is going to be used.

The zombie town section will be a third-person style environment, with the camera positioned further away, so not as much texture or detail will need to be modeled onto the asset. However, with the lighting effects we will apply, it will still look amazing.

CHAPTER ONE
MODELING

You will need to find a vehicle blueprint from the internet. This is easy to do as there are specialist websites for this. They are well worth finding to get an accurately finished asset. We can use Photoshop to make sure the front, back, left and right blueprints are of equal size and measurements. Then we save them out into separate images.

In 3ds Max, create four planes and assign the images to each corresponding plane. Scale the planes to make sure each image is aligned correctly and to the correct size (**Fig.01**).

Switch the viewport to the left view, so we are looking at the bus from the side.

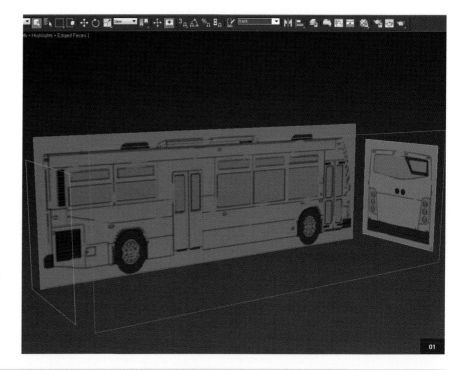

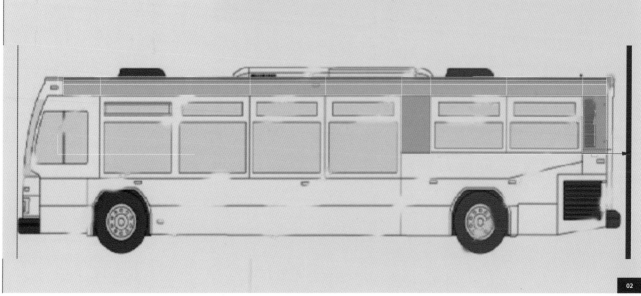

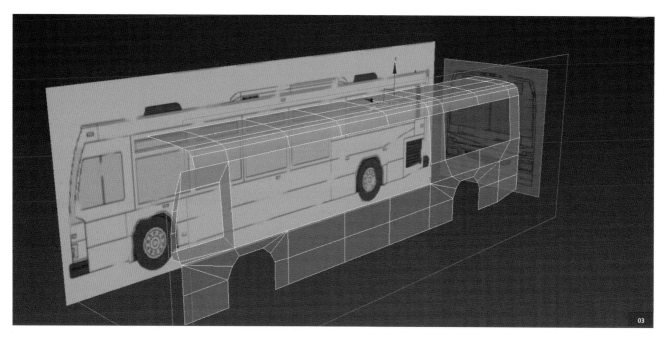

03

04

"Temporarily add a symmetry modifier in 3ds Max, just to get a feel for how the hull of the bus is looking"

Start to model the bus using a simple plane and convert it to an editable mesh. Concentrate on one area of the bus, extruding edges and moving vertices to get the desired shape (**Fig.02**).

You can model most of the right-hand-side of the bus relatively easily by just extruding edges and moving vertices to line up with the blueprint.

To model the roof, extrude the top row of edges in the top viewport until they are roughly halfway across the width of the bus. Switch between the top and front viewports to cut the edges and move the vertices into position (**Fig.03**).

Temporarily add a Symmetry Modifier in 3ds Max, just to get a feel for how the hull of the bus is looking – once we have finished viewing it, we can remove it (**Fig.04**).

Model the front-wheel arch, using the same method of modeling, then duplicate it to the back of the bus (**Fig.05**).

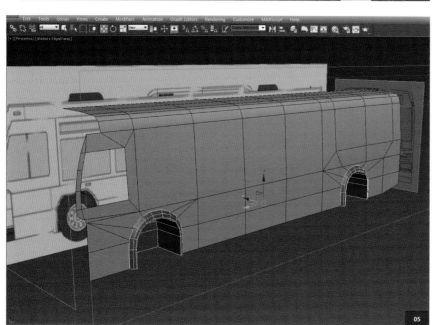

05

Fig.06 – 07 show the front of the bus. Model in the headlights, the grill and the bumper. Again, add a Symmetry Modifier to give a feel for how the bus is looking.

For the wheels, start off with a simple cylinder created to the rough dimensions of the wheels in the blueprint. This time, use the Bevel tool to create the details of the wheel, such as the grip and the hubcap. Duplicate the wheel and position it at the rear of the bus (**Fig.08 – 10**).

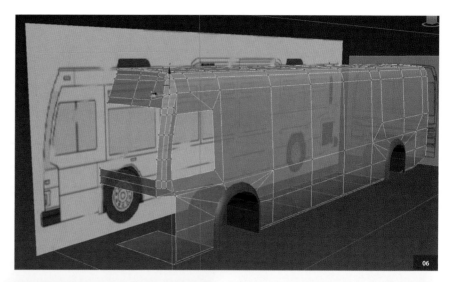

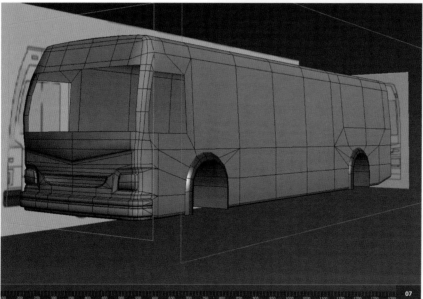

> **"For the wheels, start off with a simple cylinder created to the rough dimensions of the wheels in the blueprint"**

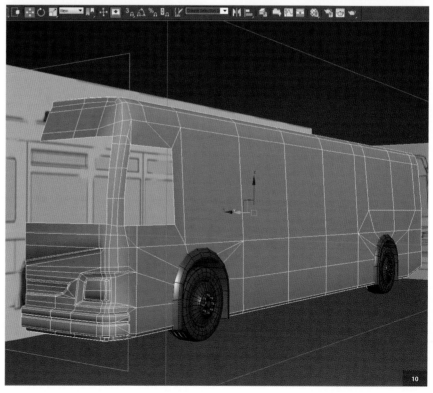

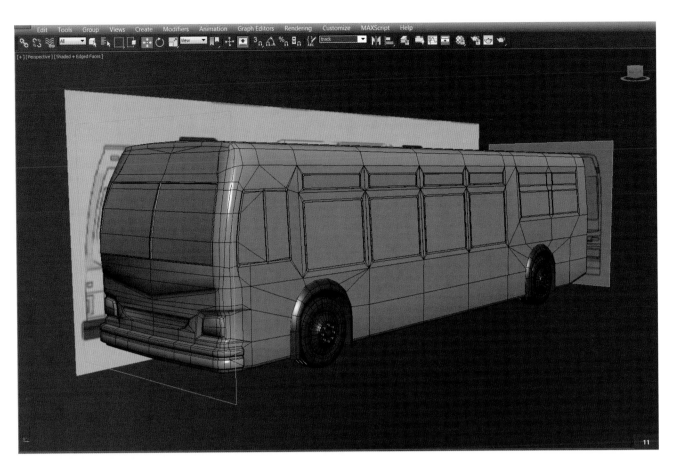

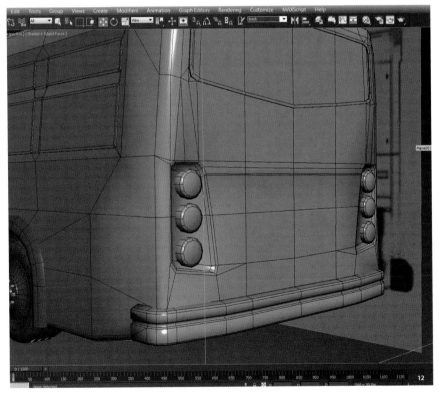

"It's simple modeling, but it's all we need for an asset like this!"

Using the large polygons that cover the space for the windows, use the Bevel tool to add the detail of the window frames – it's simple modeling, but it's all we need for an asset like this (Fig.11).

Fig.12 shows the back of the bus with the rear lights modeled using simple cylinders and chamfering to round them off at the ends. This completes the main hull of the vehicle now. It's looking pretty solid – and looks like a bus, which is great!

Only model one-half of the doors to save time doing duplicate work, as you can mirror them. Once the doors are complete, place them into position along the side of the bus. Cut into the main hull around the doors and delete the polygons where the doors would be. Inset the doors so they don't sit flush with the side.

Finally, for the door frames, chamfer the edges to make them more rounded and close any gaps between the doors and the main hull of the bus (**Fig.13 – 15**).

> "Only model one-half of the doors to save time doing duplicate work, as you can mirror them"

15

14

> You have to step back and look at the bigger picture, especially when working on a professional project with deadlines and budgets to work towards.

VEHICLE DESIGN BUS

CHAPTER TWO
MODELING FINALIZATION AND UV-MAPPING

With the main body of the vehicle now complete, it's time to add the little details to finish off the modeling process for the bus.

Place simple boxes with chamfered edges on the roof of the bus, which you tend to see on most buses. I'm not quite sure what they are needed for, but they break up the silhouette of the bus and add detail. The wing mirrors are different on each side of the bus, so we have to model each separately (**Fig.01**).

This now completes the modeling stage of the vehicle. It's very simple, but this is all we need because it's a set-dressing asset. There is no need to go overboard with the detail, especially as we will be using this asset in an environment that is set at night, so most of the details will be lost. You do have to think ahead when modeling

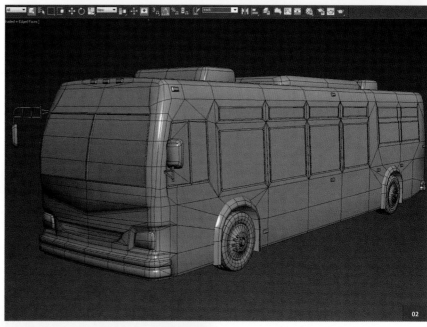

your assets – you don't want to waste time doing work that won't ever be seen when in the game (**Fig.02 – 03**).

The next stage is to begin creating the UV for the wheels – selecting the polygons and using Planar mappings to flatten them out. Use the Relax tool to spread out the UVs and minimize any stretching or warping that may occur. For the tread of the wheel, use cylindrical mapping and lay it out at the top of the UV window.

Here, we can place a repeatable texture to seamlessly wrap around the wheel. Place the UV islands in suitable positions in the UV window and give more space to the polygons that will be most visible – such as the hubcap area.

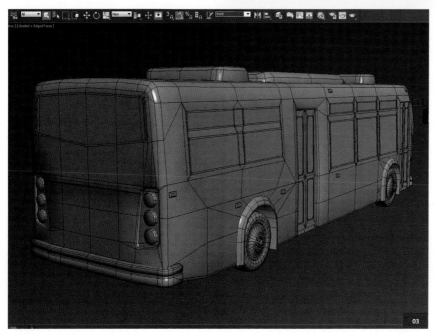

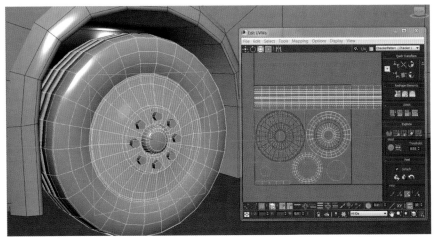

"The checkerboard material shows up any errors with the mapping that we can easily fix before we start texturing in Photoshop"

Once we have finished the UV on an asset, it is good practise to apply a checkerboard material (**Fig.04 – 05**). The checkerboard material shows up any errors with the mapping that we can easily fix before we start texturing in Photoshop.

Moving on to the main hull of the bus, map all four sides and the roof, using Planar mapping and the Relax tool – again adding the checkerboard material to show up any errors (**Fig.06 – 08**).

The bus will have to be split into two textures because we need the pixel resolution on the main bus hull. Adding the wheels and trims will reduce the pixel density, so splitting it will maintain a good resolution when in the game.

"You can get some weird results in your final texture if you don't maintain the scaling across the whole asset"

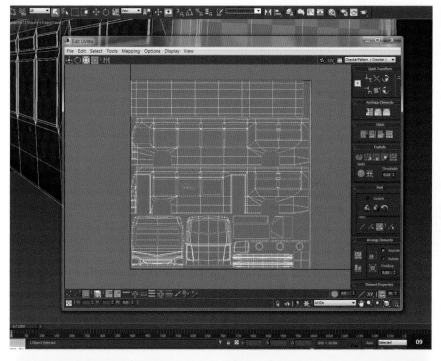

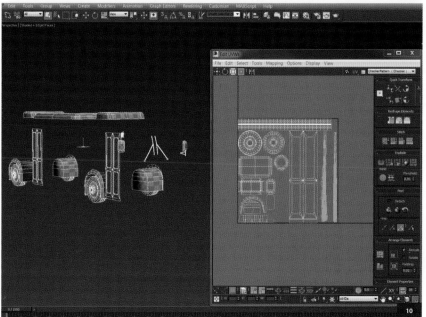

Move the UV islands of the bus into position in the UV window, being sure to maintain the same scaling. When I need to scale a UV island like this, I usually grab them all and scale them all down rather than do it individually. You can get some weird results in your final texture if you don't maintain the scaling across the whole asset (**Fig.09**).

Do the same for the wheels and trims. The UV process is now complete and you should be left with a bus that has an almost perfect, square checkerboard material applied to it (**Fig.10 –11**).

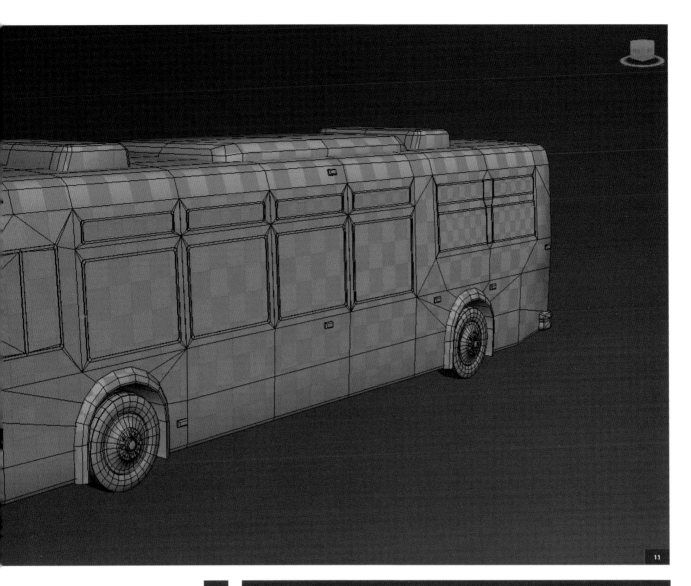

11

Once I have finished UV-ing an
asset I like to apply a checkerboard
material; this will show up any
errors with the mapping that can
be easily fixed before starting
to texture in Photoshop.

VEHICLE DESIGN BUS

CHAPTER THREE
TEXTURE CREATION

Before we begin texturing in Photoshop, we need to use one more tool in 3ds Max to render out the UVs to a texture, to use as a guide when creating the final texture for the bus.

In 3ds Max, and with the bus selected, apply an Unwrap UVW Modifier. In the tools menu, select the Render UV window – this should pop up a dialog box. Leave most of the settings as default but change the dimensions to 2,048 x 2,048 as this will be the size of our final texture.

Click Render and a new window will appear with the UVs rendered out – save this to the location you're working in (**Fig.01**).

Open the rendered UVs in Photoshop and begin painting our Diffuse texture. Collect reference images from the internet to get some idea of what sort of designs you can put on the bus, and what looks good.

Start with a white background, as this is the main color of the bus. Then start to add different shades of blue decals onto each side of the bus (**Fig.02**).

While working, continually save the texture and apply it to the model in 3ds Max, to see if things are lining up correctly and looking good.

Continue to block-in the main details, like the lights and various other trims and logos – most of these details are sourced from photos I have gathered from the internet. Also paint thin black lines around the body of the bus – these are to represent the paneling that the shell of the bus is made up of. Use the UV render image as a guide to show the most suitable place for the panels (**Fig.03**).

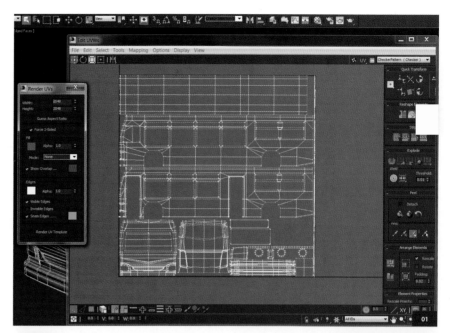

"The final pass of the Diffuse texture is to add the Ambient Occlusion map, which you can render out in 3ds Max's Render to Texture tool"

Buses are usually quite dirty from driving around the city all day, so add bits of dirt and spray off the wheels to give the bus a bit more life (**Fig.04**).

The final pass of the Diffuse texture is to add the Ambient Occlusion map, which you can render out in 3ds Max's Render to Texture tool – which I have shown in previous chapters.

Place the AO in Photoshop and set its layer to Multiply – this will make all the little details on the bus 'pop'. The geometry that sits on top of the other geometry will bed down a lot nicer now (**Fig.05**).

That completes the Diffuse texture for the main body of the bus. Using these same texturing techniques, you can finish making the second Diffuse texture for the trims (**Fig.06**).

VEHICLE DESIGN BUS

CHAPTER FOUR

TEXTURE FINALIZATION AND PORTFOLIO PRESENTATION

With the Diffuse textures now complete, we can move on to creating the Normal and Specular maps for the asset. In addition, we will create a Self-illumination map, because this bus will be set in a night-time environment and we want the headlights to be working.

For the Normal map, duplicate all the Diffuse layers in Photoshop and put them in a new group, so that we can work on them easily without interfering with the Diffuse texture.

Hide all the dirt layers, logos and any other details we don't want to be included in the Normal map. Make sure all the new layers are black-and-white because we will use this map as a Height map in CrazyBump to generate the Normal map.

Open this map up in CrazyBump as a Height map and turn all the larger details down low to about 10. I tend to keep the fine details up high, so it picks up the fine lines of the paneling and vents. You should be left with a good Normal map that looks like **Fig.01**.

Duplicate the new group created for the Height map. This time, turn on all the dirt layers, as we don't want the dirt to be affected by the lighting and reflection once it is in the environment.

Turn up the lights, windows and decals nearly to white so that they stand out more from the rest of the bus. Lastly, make the background color a light gray instead of a bright white. This is to dull it down a little and help to boost the Specular on the white areas of the texture. The shell of the bus shouldn't be as

reflective as the windows or glass headlights, so shouldn't be as brightly highlighted as the more reflective surfaces (**Fig.02**).

Finally, on to the Self-illumination map. This is a really simple texture, but will add so much life to the asset when it is in the game.

Keeping on the headlights, rear brake lights and side lights, you should make all of the other details black. On the remaining lights, use Levels in Photoshop to add more white to the textures. This will aid us in making the lights look more realistic when setting up the material in UDK.

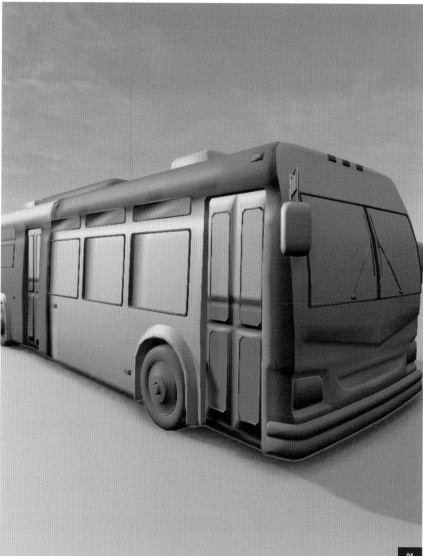

The finished Self-illumination map should look something like **Fig.03**. Repeat this process for the trims texture, creating the Specular and Normal maps. This will finish the texturing process for this asset.

It's time to get it in the game with the materials set up and working correctly, ready to be placed in our environment.

Back in 3ds Max, ensure the whole of the bus is one object; this includes the wheels, trims and the main body of the bus. Apply a Multi/Sub-Object material to the bus and assign the first ID to the body and the second ID to the trims – this will allow us to apply two materials in UDK.

With the bus selected, you can center it to the world and go to File > Export > Export Selected, then choose the ASCII Scene Export (*.ASE) exporter and export it.

A new dialog box will appear; I usually keep these settings as default, but make sure you have Export Mesh Normals and Mapping Coordinates selected. This should create an ASE file which we then import into UDK.

We are now ready to get this asset into the game, so open up UDK and start with a new scene. Import the mesh and all of the textures into a new package. Drag and drop the bus into the environment (**Fig.04**).

Create a new material and name it 'trims', then drop the three textures into the material and link them to their relevant slots (**Fig.05**).

Repeat this step for the other material and name it 'Body'. This material is a little more complex than the first material because we want to add self-illumination and reflection.

The self-illumination is linked to a Multiply node and a Constant node. The Constant node will allow us to increase the power of the illumination – a power of 10 works well. Finally, link the Multiply to the Emissive slot of the material.

To add the reflection, add a Reflection Vector and Vector Transform, then link them together. These nodes are then linked to a texture sample. This is a Cube map, which can be found in the UDK library. Use T_BlurredReflection_ Cube, as this texture resembles a cityscape environment, which works well.

Link all of this to an Add node in slot A. In slot B, link the Diffuse texture of the body of the bus. Finally, link this to the Diffuse slot of the material (**Fig.06**).

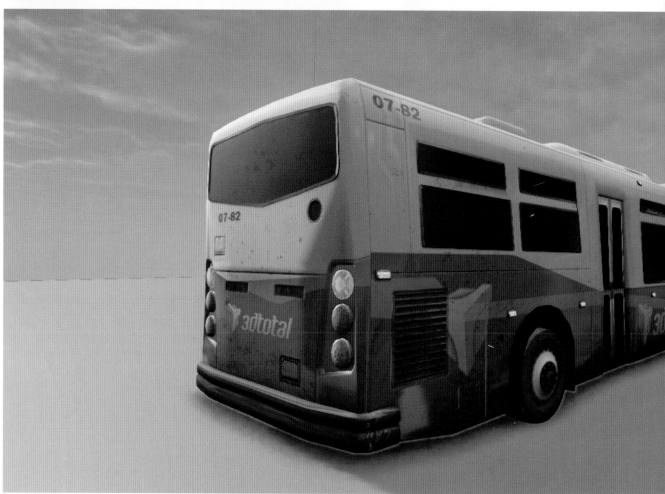

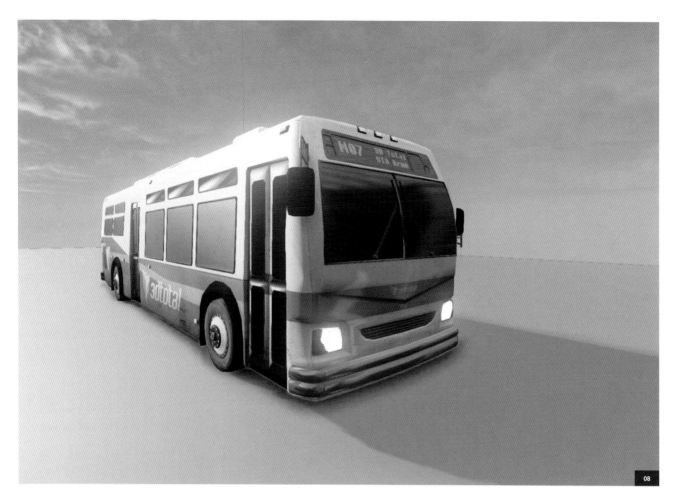

08

"Sometimes you don't need to add huge amounts of detail to an asset for it to be usable"

With the two materials now set up, it's time to apply them to the material slots in the Static Mesh properties you have done. The bus should look something like **Fig.07 – 08**.

This completes the New York City bus asset and it is now ready to be used in the final environment section of this book.

This section has shown you that sometimes you don't need to add huge amounts of detail to an asset for it to be usable; you have to step back and look at the bigger picture, especially when working on a professional project with deadlines and budgets to work towards.

07

LIGHTING UDK

Lighting is a very important part of creating environments and also smaller assets. If you have a poor lighting setup it can ruin your models and destroy all the hard work you have put into creating them. Lighting is my favorite part of games development; it gives you so much control over the feel of it – you can create a lot of emotion. It's not all about placing lights in your scene, it's about correctly setting up your materials and shaders to react naturally with the light, and balancing textures and post effects such as color grading. It's all part of the lighting process.

In the following chapters, I will cover the process of lighting the same scene with five different lighting solutions to demonstrate the power that lighting has over your images, and how quickly you can change the atmosphere, mood and style of your artwork.

CHAPTER ONE
MIDDAY

In this chapter, we will be creating a midday lighting scenario. We will see that the sunlight is very strong and casts narrow shadows. The sky is bright blue with a little cloud cover to add some interest. We will also add a slight haze to the environment; this creates depth and the blue hue adds to the effect of a midday scene.

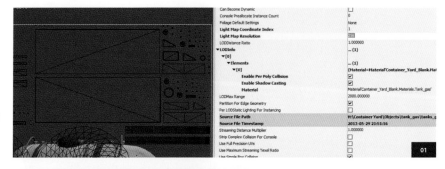

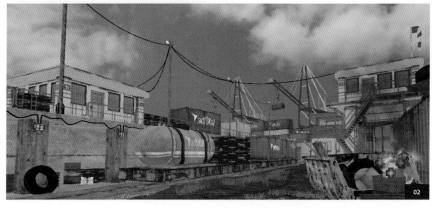

Before we begin lighting the scene, we need to make sure the object will behave correctly when being lit. In UDK, assets require two sets of UVs. The first set obviously maps the object to the maps you apply, such as the Diffuse, Specular and Normal maps.

The second mapping channel needs to be mapped to the UV space, except no polygons can overlap the UV space, otherwise they will receive incorrect lighting. The polygons must also have their own space within the UV square. If the polygons were to overlap then they would also receive incorrect lighting.

This is because when you bake the lighting in UDK, each asset renders out lighting maps according to the second set of UVs. If polygons were to share UV spaces then you could potentially have light and shadows in inappropriate areas.

Fig.01 shows the gas tank asset. Overlaying the asset is the second set of UVs. As you can see, the polygons all have their own place in the UV space and are unwrapped correctly. This means the asset shouldn't

have any lighting errors when the lighting and baking process is complete.

I have also highlighted the Light Map Resolution settings in the properties setup. I have given a size of 256 x 256; this setting determines the Light Map image resolution that UDK bakes out. If the size is too low the resolution will not give good results; too high and the baking process will take a very long time to complete and may not offer that much difference in terms of quality. So you need to be careful when adjusting this setting. Think about the size of the asset and if the asset will have shadows cast on it. If the asset is always in sun or always in complete shadow

then the resolution doesn't need to be high. If the asset has detailed shadows cast over it, then the resolution needs to be higher in order to get the shadow's definition.

I feel 256 x 256 is a good enough resolution for this asset; due to the size of our scene we can get away with having higher resolution bakes.

So let's begin with our unlit scene (**Fig.02**). Nothing exists in this scene except the assets and one particle effect (PFX) for the fire in the barrel. The scene is very flat, uninteresting and void of any detail. This shows just how important lighting is in the process of creating game art – or any art for that matter.

03

04

"Already, after placing this one light and using the default settings, the scene springs into life"

You should always start by adding the Sun light; it is the dominant source of light in this scene and so should be placed first. Using the Actor Classes browser, locate the DominantDirectionalLight in the Lights section.

It doesn't matter where you place this light; as it is a directional light the position is irrelevant. However, I like to place it in the middle of the scene so it can be easily found and edited in the future. Rotate the light until you are happy how the Sun light is affecting the scene.

You can judge the rotation by watching the shadows being cast. Already, after placing this one light and using the default settings, the scene springs into life (**Fig.03**).

With the light selected, press F4 – or double-click the light – and its properties window will appear. Change the Brightness to 4.0 and the Light color to a light orange/yellow in order to mimic the sun (**Fig.04**).

There is only one other light source in this scene and that is the fire in the barrel. As there are assets close to the fire they will pick up some of the fire's light. Place a Point Light, which can be found in the Lights rollout of the Actor Classes. Position it just above the fire PFX (**Fig.05**).

The settings used for this Point Light are similar to the Sun's Brightness of 4.0, but this time use a darker orange color. As this is a Point Light, we can now adjust the range of the light's effect in the scene using the Radius setting. Give a Radius of 180. This is large enough to influence the nearby objects, but not anything outside of the fire's range (**Fig.06**).

With the lights now placed, click Bake Lighting and set it to Production. This takes a little time to complete and the result is close to our final lighting.

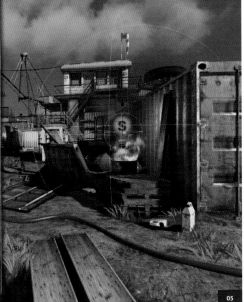

05

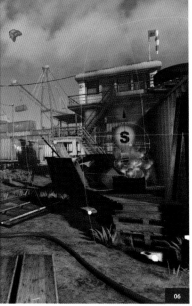

06

I can't see any lighting errors; all the objects are casting and receiving shadows correctly. The Lightmass is calculating the bounce light to fill the darker areas in a natural way. I'm happy with the way this image is being lit and it is now ready for the finishing touches, like fogging and color grading, to give the scene a professional look (**Fig.07**).

In the Actor Classes Tab there is a Fog section. Expand it and select Height Fog. Place the fog in the middle of the scene.

As this is height-based fog, the amount of 'fogging' you see is dependent on the height that the fog is placed at. The higher it's placed, the more fog that is visible. This also stops the fog from overpowering the scene and affecting it on a whole.

The sky shouldn't have any fogging higher up, only on the lower horizon, as it acts like a haze rather than a fog. So raise the fog icon until you get a result you're happy with (**Fig.08**).

Pressing F4 shows the settings window for the Height Fog. Change the Density to a very low setting of 0.000006 and the Light Brightness to 6.0. Use a sky-blue color so it blends nicely with the sky (**Fig.09**).

In order to get the best possible light bake we need to change a few settings. In the WorldInfo Properties there is a tab called Lightmass – expand this to show the settings. Make sure Use Global Illumination and Use Ambient Occlusion is enabled.

These settings ensure we have the bounce light from the lights we placed calculated and used in the bake. The Ambient Occlusion is also very important as it grounds objects in the scene; without these settings the scene will look a whole lot flatter.

Another important setting I change is Indirect Normal Influence Boost. I change this setting to 0.75. This boosts the effect of the Normals applied in the materials, enhancing the detail in the scene that may get washed out with the lighting bakes (**Fig.10**).

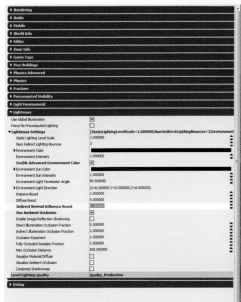

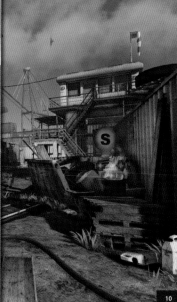

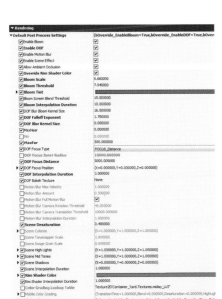

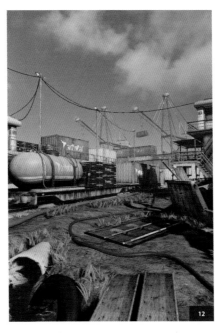

11

12

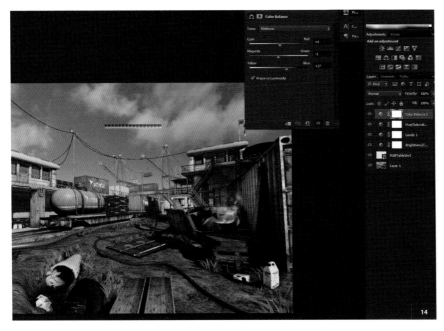

13

14

Continuing in the WorldInfo Properties window, expand the Rendering settings. Here we can add post effects to the scene such as color grading, DOF and Bloom. Enable Ambient Occlusion in the Lightmass settings. You can also switch it on and off in the render settings; just make sure it is enabled.

Follow the settings I have shown in **Fig.11**; I found them to give me the best results. Add DOF to blur out the far distance only slightly. Also add a slight Bloom to make the specular highlights stand out a little more.

Desaturate the scene by 0.4, which adds to the realism effect we want to achieve. Too much color would make the scene cartoony and this isn't the look we want. It is best to be subtle with these settings because you run the risk of becoming too stylized – unless that is what you want.

Set the lighting to bake at Production quality. **Fig.12** is the final result in UDK. I'm happy with how this scene is looking; now the only thing left to do is the color grading.

Color grading is a very important step and can drastically change the way the scene looks. This is one of my favorite processes in creating environments, as it adds the next level of polish and transforms images into something that looks more professional.

I use Photoshop to create the edits for this process and you do this using something called Look Up Tables, or LUT for short. This is a texture that you plug in to UDK; any edits you make to this texture get filtered through to the UDK scene.

The texture is a small multi-colored texture. Start by taking a screenshot of your scene and pasting it into Photoshop. Then import the LUT texture as a new layer and position it somewhere out of the way to not obscure the image.

Then, in Photoshop, add four Adjustment layers: Brightness/Contrast, Levels, Hue/Saturation and Color Balance. Make sure the LUT is below the Adjustment layers so any edits we make will also edit the LUT, as shown in **Fig.13**.

You can see the Photoshop image after adjusting the layers in **Fig.14**.

"The Ambient Occlusion is also very important as it grounds objects in the scene; without these settings the scene will look a whole lot flatter"

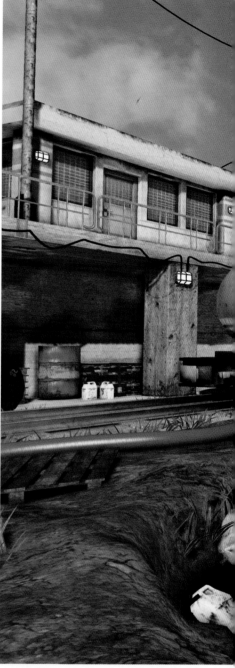

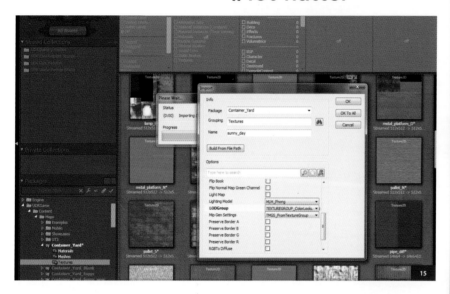

To get this LUT into UDK you need to save the LUT layer in Photoshop as a new texture. In Photoshop, hold Ctrl and click on the LUT layer. Then click Edit > Copy Merged. This copies all the edits in the Adjustment layers.

Create a new document and paste the LUT into it. It should automatically be the correct dimensions and the LUT should fit perfectly. Save this image out as a TGA and name it 'Midday_LUT' so it's easy to find.

In UDK now, import the texture into the Textures group of the package – but before you click OK you will need to change a setting so the LUT works correctly. Scroll down the options to find the LOD group and find from the drop-down list TEXTUREGROUP_ ColorLookUpTable, then click OK (**Fig.15**).

To use the LUT, open up the WorldInfo Properties > Render Tab and scroll to the bottom. Enable the Color Grading Lookup Table. Make sure the LUT texture is still selected in the Asset browser and apply it to this option. You will notice the changes filter through your scene and the edits we made in Photoshop are now visible in UDK (**Fig.16**).

This completes our midday scenario (**Fig.17**). The scene now looks and feels like a hot, sunny day. The techniques we have learned in this chapter are the same techniques we will use in the next chapters, and we will see how easy it is to create different lighting scenarios quickly and to a high, professional quality.

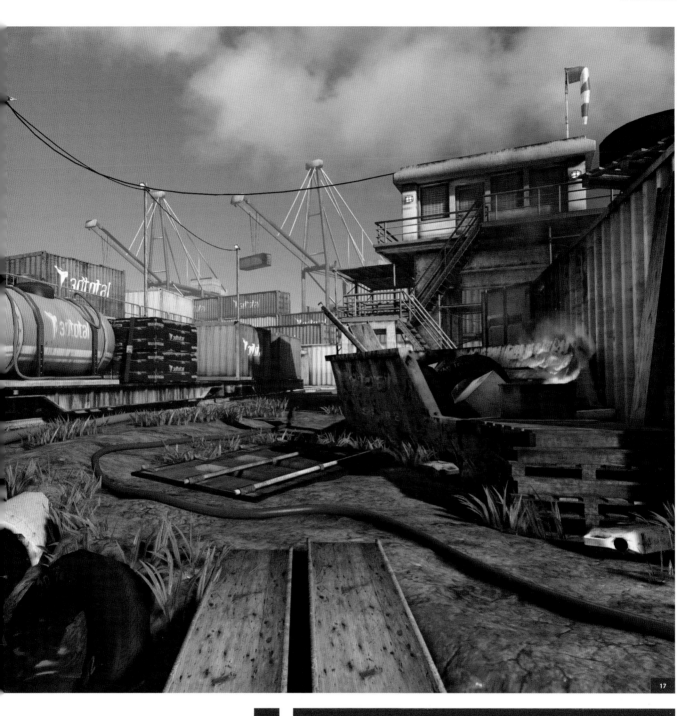

A Light map that is too low
in size and resolution won't
give good results. A resolution
which is too high, however, will
take a very long time to bake.

LIGHTING
UDK
CHAPTER TWO
NIGHT

In this chapter I will be guiding you through the process of turning the scene into a night-time lighting scenario.

The sky is changed to a clear night sky containing a few stars and the moon to add some interest. Because there is not a strong direct light (the Sun), this scene will rely on synthetic lighting such as street lamps and spotlights. This will create a very interesting scene; small pockets of intense light will draw the viewer's eye and really boost the details in our assets.

We have a lot of freedom with a scene like this; if we want an area to be lit we can just place some free-standing lights. In the midday scene we were a little more restricted by the lights affecting the scene. With the intense lights in this scene though, we can add LensFlares to the light sources, which will make this scene more dramatic and visually pleasing.

Starting with the unlit scene, just like in the last chapter, place a Dominant Directional light to act as the moon light and point it in the rough direction of the moon. Give the light a low power of 1.5 and a slightly darker blue (**Fig.01**).

The fire in this scene has slightly more range in its light because it is night time, so the Point Light can have a higher Radius at 230.0. For the Brightness, use 4.0 and give it a bright orange color (**Fig.02**).

I have placed many lamps around the scene – mainly on the pillars and huts. We can place these lamps anywhere we want to if it helps us create a visually interesting scene. But it is also good practise to place the lamps as if this was a working environment, so

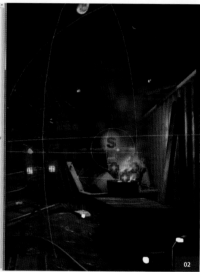

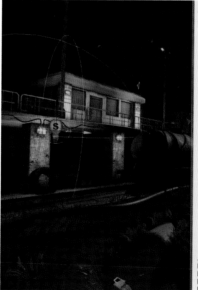

placing them near to the doors and walkways will help convince the viewer that this is a believable and realistic environment.

Using Point Lights, place a light just in front of your lamps. Use a Radius of 230 and a Brightness of 3, and for the color use a

pale yellow to match the self-illuminating Diffuse map of the lamp, shown in **Fig.03**.

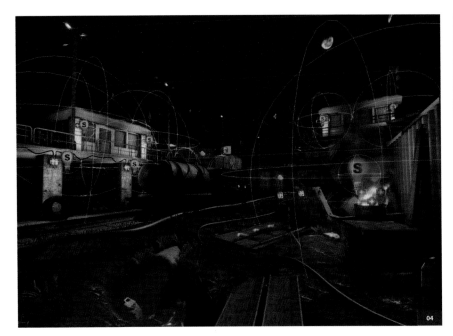

04

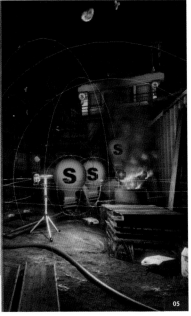

05

"A strong light in the foreground will help grab the attention of the viewer"

Duplicate the Point light and place it in front of all of the lamps and do a Medium bake of the scene (**Fig.04**). This gives us a rough idea of how the scene is going. So far I think it works quite well, but there is still something missing.

I think a strong light in the foreground will help grab the attention of the viewer. Place a free-standing light asset with two lamps facing the shipping container. This should cast some very interesting light over these assets.

Place two Point Lights with a high intensity and pale blue color. Give the lights a big enough Radius to affect the assets and the floor in a natural way (**Fig.05**).

In the middle of the scene we have a very interesting asset: the train carriages carrying cargo. At the moment, these assets fade into the darkness and become invisible. We need to show off the assets and in turn make the composition of this scene a whole lot more impressive.

Place another free-standing light in front of the gas tanker and copy the two Point lights we just created and position them close enough to light up the gas tank (**Fig.06**).

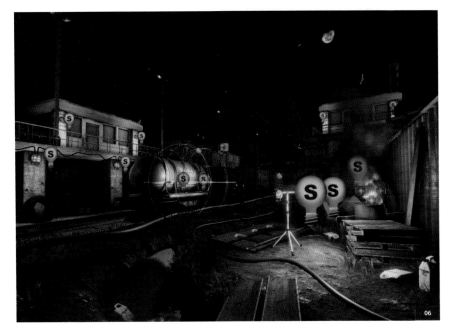

06

I think this now completes our placement of lights. We can always add more later on, but for now I think this is giving us a really good result.

You will notice I never added any Spot Lights coming from the street lamps on the upper-left platform. This is because I felt the light would pollute the lower terrain and wash out all the detail we had created with the lamp lights. Also, the street lights would mainly only affect the upper platform, so it doesn't look odd if we don't place any additional Spot Lights.

The next stage is to place the Height Fog, as we did in the first chapter. We want the Height Fog to stay low to the horizon. Place a Height Fog Actor in the center of the scene and raise it slightly off the terrain. Use a low Density of 0.00004 and a Brightness of 3.0.

Give the Fog a dirty orange color. This will give the illusion of dirt and dust being kicked up from the dry dirt terrain and the high intensity of the Spot Lights will illuminate the dust particles. This really adds a lot of life and atmosphere to the scene (**Fig.07**).

Now we can place the LensFlares. In the Content browser, select UDK Game in the Packages section. Then type 'Lens Flare' in the search bar. This will display all of the LensFlares available in the UDK library. Select LF_Lamp_01 and place the LensFlare in front of the Lamp objects (**Fig.08**).

You can change the appearance of the LensFlare if you double-click the asset in the Content browser – I won't go into this now but you can edit the color and power to suit your needs if you want to. I went for a blue hue and lowered the opacity, as I felt the original asset was too overpowering in the scene when placed multiple times.

Make a duplicate of this LensFlare and give it a bright red color and intense power. This would be the warning lights for the cranes in the background, adding some points of interest in the distance (**Fig.09**).

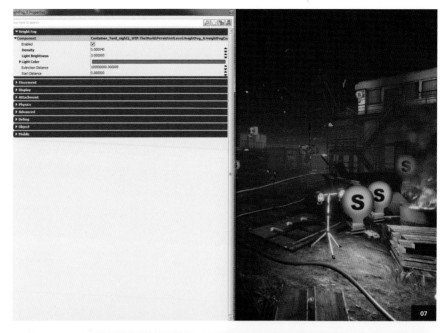

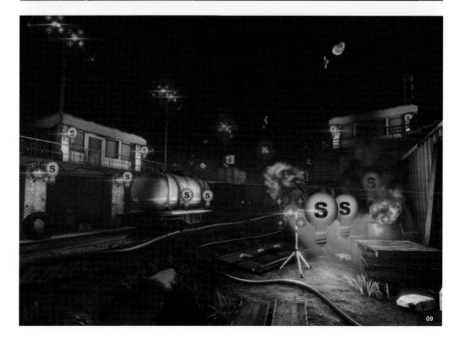

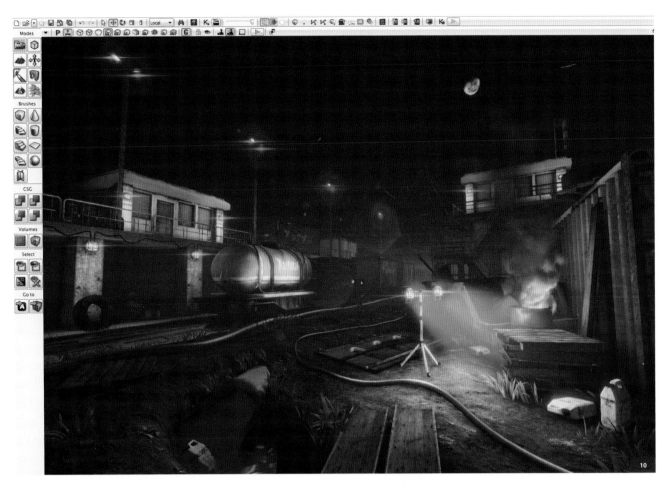

Place one last LensFlare, LF_Sun_02, and position it near the moon. This LensFlare produces larger hexagonal shapes and cascades them across the screen further, increasing the illusion of looking through a camera (**Fig.10**).

The last phase of this tutorial is the Look Up Tables (LUT). Just as we did in the first chapter, take a screenshot of the scene and set it up in Photoshop with the Adjustment layers. Give this LUT a bluer tone to emphasize the coldness and darkness of the night. Save the LUT layer out to a new document and call it 'Night_LUT' (**Fig.11**).

In UDK, import the texture into the Textures group of the package – but before clicking OK, once again ensure you change the setting so the LUT works correctly. Scroll down the options to find the LOD group and find from the drop-down list the TEXTUREGROUP_ ColourLookUpTable, and then click OK.

To use the LUT, open up the WorldInfo Properties > Render tab and scroll down to the bottom. Enable the Color Grading Lookup Table. Make sure the LUT texture is still selected in the Asset browser and apply it to this option. You will notice the changes filter through to your scene and the edits we made in Photoshop are now visible in UDK (**Fig.12**).

This completes the night lighting scenario. I think we have successfully created an interesting night scene with a good atmosphere very quickly and easily – one that is drastically different from the midday lighting setup, and with minimum effort (**Fig.13**).

"We have successfully created an interesting night scene with a good atmosphere very quickly and easily"

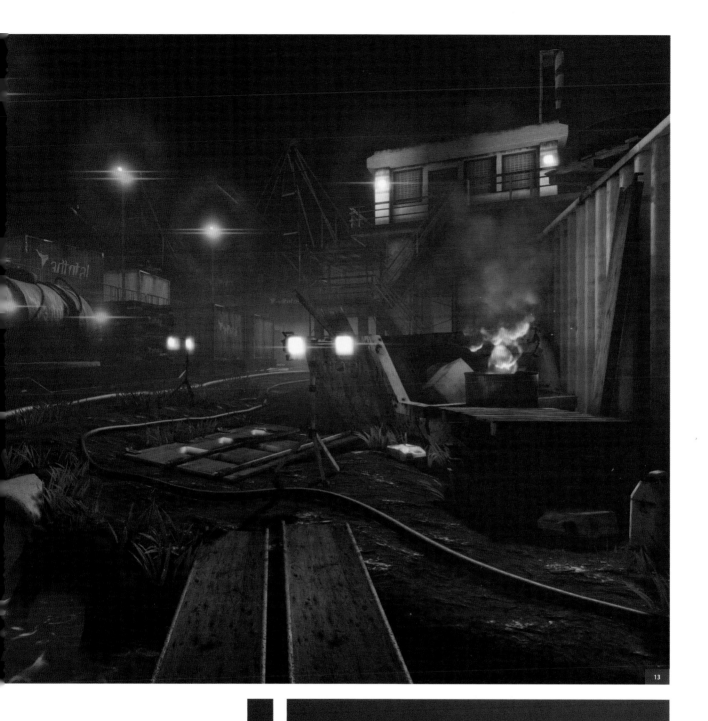

Without a strong direct light (the Sun), the scene will rely on synthetic lighting such as street lamps and Spot Lights.

LIGHTING
UDK

CHAPTER THREE
FOGGY

This chapter will use the night lighting scenario we have just finished creating and convert it to a different weather condition. A foggy scene can be quite interesting to look at, even though most of the scene's visibility will be washed out. We will use the light sources to add shafts of light and shadow across the scene to add a huge sense of atmosphere and mystery.

Instead of using the unlit scene to start with, use the night-time lighting setup and adapt it. The only thing we will change in this scene is the sky texture. The night sky used a starlit clear sky and this would look really odd if we had a foggy atmosphere and a clear night sky. So apply a cloudy texture to the sky (**Fig.01**).

Select the main source of light (moon light) in the center of the scene and press F4 to open up the setting for the Directional Light.

Slightly increase the Brightness because the cloudy and foggy atmosphere will disperse the light more and generally make the environment brighter; increasing the Brightness will lift the scene enough to give this effect. Also make the color of the light a more desaturated blue (**Fig.02**).

"These settings make the fog appear thicker and disperse the light being emitted in the scene"

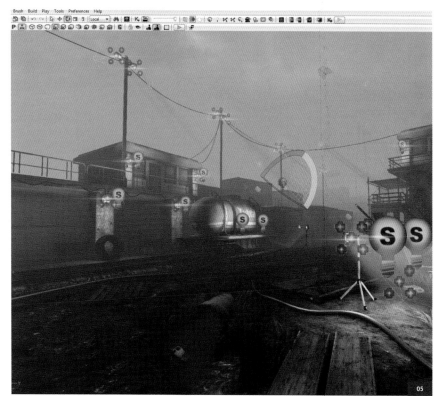

The most important part of this scenario is the Height Fog actor. Select it and Press F4 to open the settings window. The night fog was low-lying to emulate dust rising from the terrain, but a foggy scene will affect everything, so the actor needs to be positioned higher for it to encompass the whole environment, including the sky.

Increase the Density to 0.004 and the Brightness to a value of 0.7. These settings make the fog appear thicker and disperse the light being emitted in the scene. Give it a blue color to match the main light source and blend in with the sky texture (**Fig.03**).

When you have a foggy atmosphere, or any environment where there are small particles in the air, you will get an interesting effect from the light. Shafts of light and shadow appear. This is because the light normally travels in a straight direction and when it hits an object it stops and creates a shadow.

The particles expose these shadows in the atmosphere rather than just on a surface. How thick the atmosphere is will determine how strong this effect is.

We can reproduce this effect in UDK. Select the main light source and press F4. In the options, find the Light Shafts tab and open it

up. Enable Render Light Shafts and you will see these shafts of light appear in the scene following the direction of the Directional Light (main light source) (**Fig.04**).

Originally, this light was placed in the night lighting scenario for a clear sky. Now we have fog and light shafts enabled, the direction

of the light might not look as good as it can for the scene. So with the light still selected, rotate the light until you get a good result.

Personally, I find that you can get the best results by pointing the light from left to right to show the light shaft emitting from the lamp posts (**Fig.05**).

"It was really
simple to use
an already
existing lighting
setup and with
a few tweaks
of the settings,
we can create
a scene with
a completely
different weather
condition"

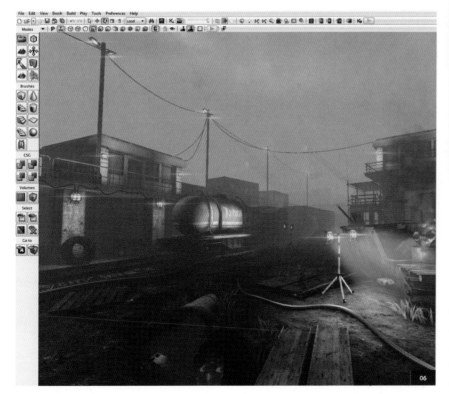

The LUT we created for the night lighting
scenario will work well with this foggy
scenario, so there is no need to make
another one – just make sure the Color
Grading LUT in the WorldInfo Properties
is pointing to the Night_LUT (**Fig.06**).

This now concludes the foggy lighting
tutorial. It was really simple to use an already
existing lighting setup and with a few tweaks
of the settings, we can create a scene with a
completely different weather condition (**Fig.07**).

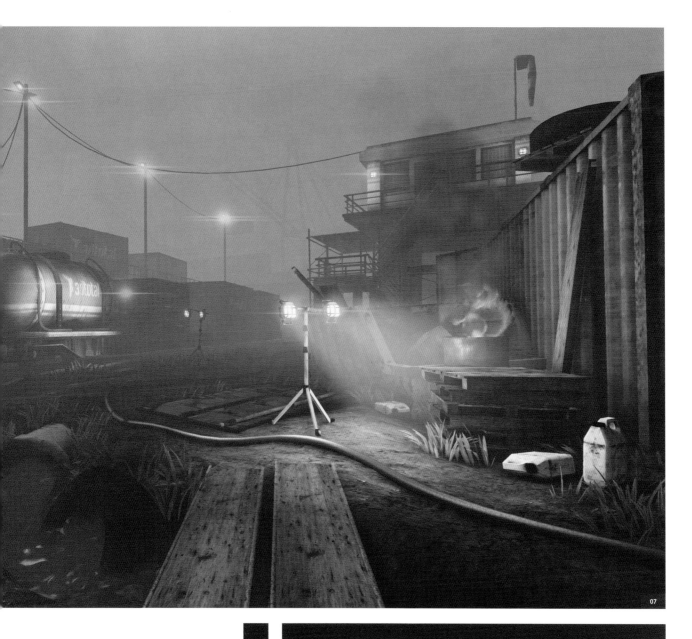

07

Using light sources to add shafts of light and shadows across the scene adds a huge sense of atmosphere and mystery.

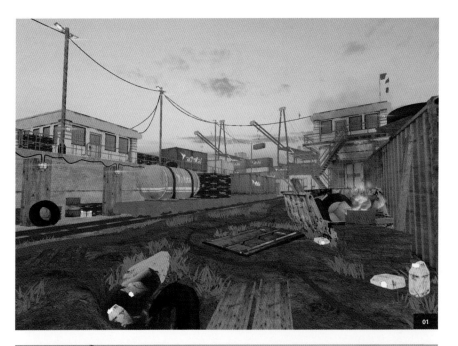

LIGHTING
UDK

CHAPTER FOUR
SUNSET

Sunsets are really interesting to work on as they are colorful and dramatic. They also give you the chance to have a little artistic freedom. The low-angled sun will help us add detail to our surfaces such as Specular and Normals; they should really pop out.

Because the Sun's brightness can be low, we can get away with having the street lights and lamps switched on at the same time and not make it look weird. We also have some freedom with the clouds; you can go dark or bright in color.

"Dark clouds add spots of interest and break up the large area of plain sky in the scene"

In my scene, I decided to go with dark clouds, but if you do a search for sunsets you will come across clouds that look self-illuminated, because the low-angled orange sunlight disperses in the cloud from a low angle and not from directly above, like in the day time.

Starting with the unlit scene, change the sky dome texture to a sunset. I have an orange-yellow horizon that blends quite quickly to a lighter bluish-purple color. The dark clouds add spots of interest and break up the large area of plain sky in the scene. Everything else is the same as all the other lighting chapters (**Fig.01**).

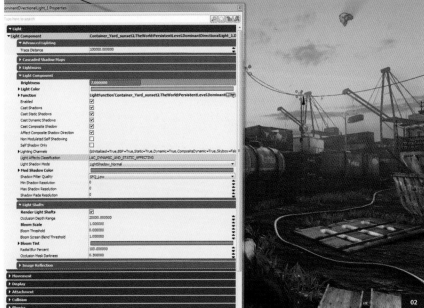

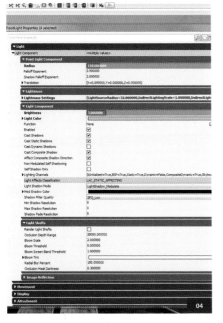

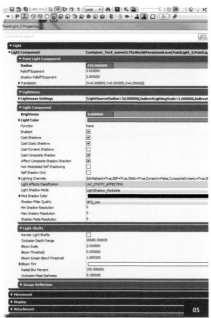

Place a Direction Light in the center of the scene and point it in the correct position according to the Sky Dome texture. Give this light a power of 7 and a deep orange color. Make sure Render Light Shafts is enabled as this adds the 'god rays' to the scene making for a more atmospheric mood (**Fig.02**).

For the fog, position it a little higher so it doesn't look like dust kicking up off the terrain, but more like atmospheric haze from the sunset. Change Density to 0.000006 with a Brightness of 4.13. Match the color of the Sun to a deep orange (**Fig.03**).

"The fire will also be giving off some light... so place another Point light hovering above the fire PFX emitter"

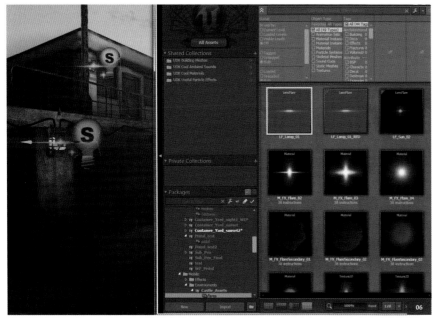

Because the Sun's influence is quite low, the lamps on the buildings will have some influence in the scene, so place Point lights in front of the lamps. They should have a low Radius of 110 and a Brightness of 3.0. Give them an off-white color (**Fig.04**).

The fire will also be giving off some light in our scene, so place another Point light hovering above the fire PFX emitter – this time with a higher Radius of 210 and a Brightness of 4.0. To match the color of the fire, tint the light with orange (**Fig.05**).

Just like in the night-time scene, place LensFlares in front of the lamps. Search in the asset browser for LF_Lamp_01; which is the asset I'm using in my scene (**Fig.06**).

You could just copy and paste the LensFlares from the night-time scene. If you open that scene up in a second UDK application, simply select all the LensFlare emitters, press Ctrl+C, then switch back to our sunset UDK scene and press Ctrl+V to paste them in (**Fig.07**).

The last phase of this chapter is the LUT. Just as we did in the first chapter, take a screenshot of the scene and set it up in Photoshop with the Adjustment layers. Give this LUT an orange-red tone to emphasize the sunset's dominant colors. Save the LUT layer out to a new document and call it 'sunset_LUT' (Fig.08).

In UDK, as before, import the texture into the Textures group of the package, ensuring you change the LUT setting. Scroll down the options to find the LOD group and find TEXTUREGROUP_ColorLookUpTable from the drop-down list and then click OK.

To use the LUT open up the WorldInfo Properties > Render tab, scroll down to near the bottom and enable the Color Grading Lookup Table. Make sure the LUT texture is still selected in the Asset browser and apply it to this option.

The changes will filter through to your scene and the edits we made in Photoshop are now visible in UDK (Fig.09 –10).

This completes the sunset lighting scenario. Again, it shows just how easy it is to make a completely different atmosphere and mood in your scene in no time at all. It also demonstrates how powerful and versatile the UDK engine really is (Fig.11).

"It shows just how easy it is to make a completely different atmosphere and mood in your scene in no time at all"

A low-angled sun helps to add detail to your surfaces, such as specular and normals. They should really 'pop' out!

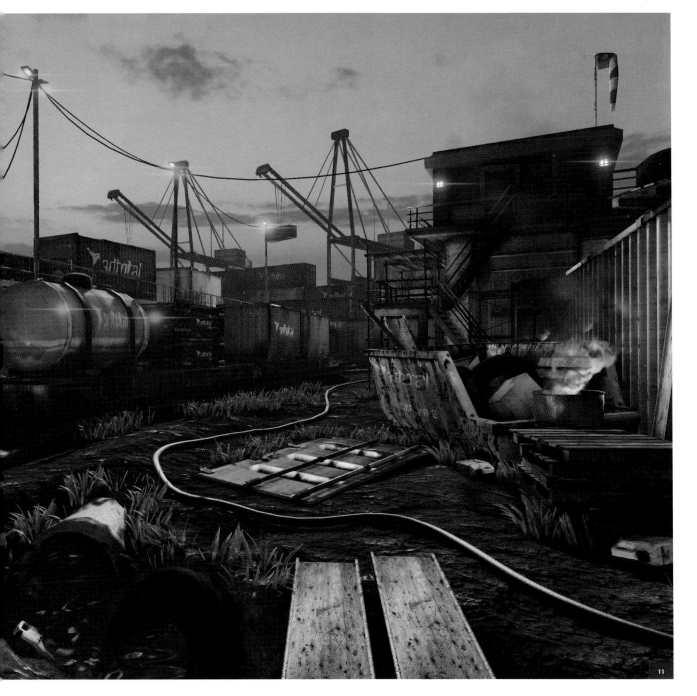

11

01

LIGHTING
UDK

CHAPTER FIVE
RAIN

To make a convincing rainy environment
we will have to make big changes to our
materials. We will dramatically increase the
specular values, but most importantly we
will add reflection. These changes will give
us the wet surface look we need to make
this scene realistic. This will have to be done
for every surface in the environment.

We will also add a rain environment effect to
the scene and splashes from the raindrops,
further enhancing the illusion of rain.
The lighting setup is exactly the same as
the night tutorial. We will use the foggy
cloudy sky from the earlier chapter, too.

Tweak the fog a little to better suit a rainy
scene. The Density should be changed to
0.00002 and the Brightness to 3.0. Give
the fog a blue color. Move the fog Actor
higher so it influences the clouds and
the higher geometry in the scene.

These settings help fill the atmosphere with
moisture, giving the illusion of more rain in
the scene than there actually is (**Fig.01**).

To create the Reflection map that we will
use on all of our materials, we need to
create a Cube map. UDK can create this
for us from inside our scene. To do that,
go to the Actor Classes browser and find
SceneCaptureCubeMapActor – drag this Actor
into the scene; a black sphere should appear.

Position this sphere slightly off the ground
and somewhere near the center of our
environment based on the camera angle we
have used throughout this tutorial (**Fig.02**).

02

03

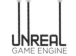

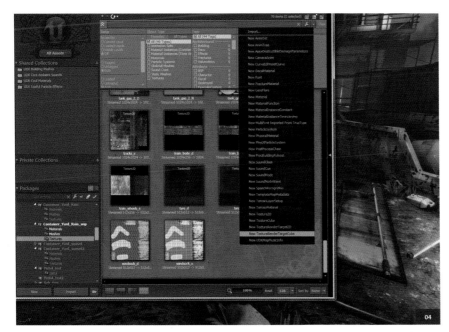

We need to make sure this sphere picks up our environment correctly so it can render the entire environment for the Cube map. With the Sphere still selected, press F4 to access the settings. The default settings will have a Far Plane, which hides most of the scene. Change this to a very high number to make sure it encompasses all of the assets in the scene (**Fig.03**).

Navigate to the Textures folder in the Content browser and right-click in an empty space, and then select New TextureRenderTargetCube. This will be the texture that the Cube Map Actor renders to (**Fig.04**).

You will be presented with an options box; all you change here is the size of the texture to be created. I chose a 512 texture and left all the other settings as default (**Fig.05**).

With the new texture still selected in the Asset browser, select the sphere and press F4 to bring up its options again. In the Capture tab there is a Texture Target slot; assign the new texture to this slot and you will see the Sphere instantly reflecting the entire environment, like a mirrored ball (**Fig.06**).

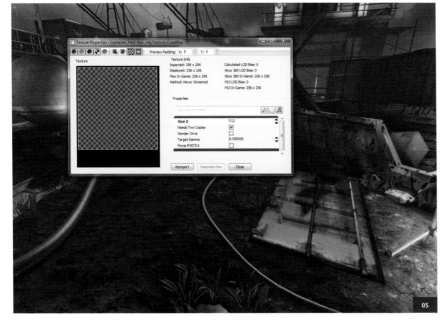

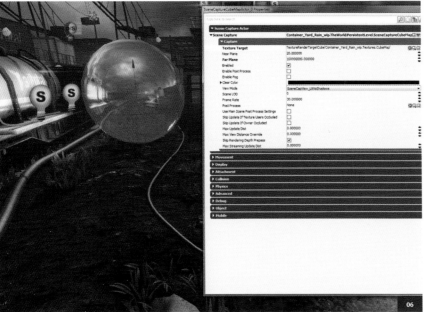

All that is left now is to render out the Cube map from this Sphere. Go back to the Asset browser and locate the new texture we created; right-click on it and select Create New Static Texture. UDK will now render individual maps for the cube and compile them together to form the Cube map, which we can then assign to our materials (**Fig.07 – 08**).

"A lot of the materials have metal properties and we can replicate the effect in our material easily"

The next step can be a bit complicated, but it is essential to get the look we need. So far we have only used basic materials, which has been okay for our needs, but in order to get the wet look on the surfaces, we need to do something a bit more advanced...

Fig.09 shows the material in a complete state. Starting from the far right, add a Reflection Vector node and link it to a Vector Transform node. With the Vector Transform selected, make sure the Source is set to Tangent and the Destination to World. This makes sure that when we move around the world, the Cube map acts in the correct way on the assets in our location.

Link these two nodes to a Texture Sample Node, which contains the Cube map we created earlier. Add a Multiply node and link the Texture sample to the B slot; this completes the reflection part of this material. A lot of the materials have metal properties and we can replicate this effect in our material easily by adding a Fresnel node with a value of -1.0. Link this node into the B slot of a new Multiply node.

To help control this effect, add a Constant node with a value of 0.1 and apply this to the A slot of the Multiply node. Finally, link this Multiply node to the first one we created in the A slot.

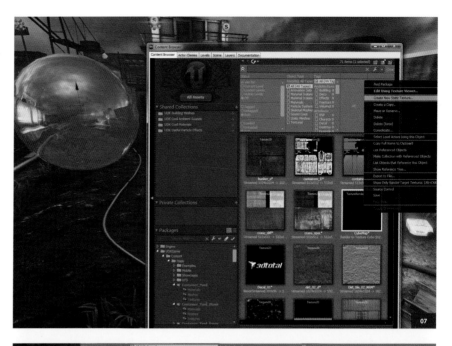

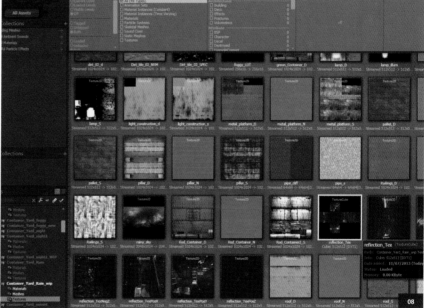

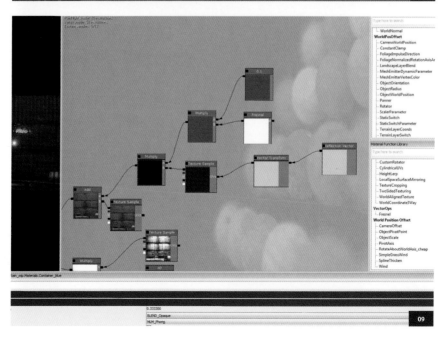

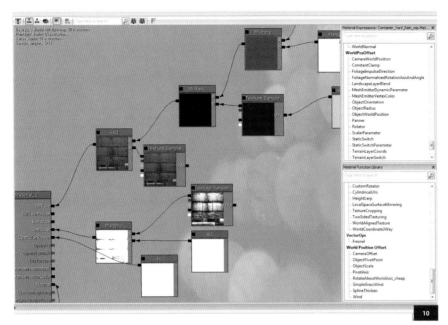

10

We now need to blend the reflection and metal setup with the original texture of the asset we are working on. Create an Add node and place it in front of the original Texture Sample containing the Diffuse texture of the asset. Link the Texture Sample into the B slot and then link the last Multiply node we created to the A slot of the Add node.

Finally, link the Add node to the Diffuse slot of the material. If you compile the material you will now see the reflection being rendered on the surface of the assets.

A wet surface is very reflective and shiny. We've sorted out the reflection side of things, so now we need to give it some punch with a high specular. Add a Constant Node and link it to the Specular Power slot of the material; with a value of 50 this will give us a very tight, glossy specular.

We already have a Specular texture in this material, but it is no longer powerful enough to mimic a wet surface, so link the Specular Texture Sample into the A slot of a Multiply node. In slot B, add a Constant node with a value of 40 (**Fig.10**).

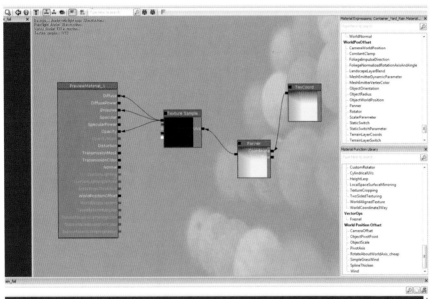

11

This completes the material setup for the asset. You can copy and paste from material to material to make the process quicker and link up the new Texture Sample nodes for the assets. Once you have completed this task you will notice the whole scene now looks wet and shiny. But this alone is not enough to convince the viewer they are seeing a rainy scene...

To add rain to the scene, use a method of placing planes in front of the camera with an animated scrolling texture. Place a couple of these planes in the scene to represent raindrops at different distances.

To create the animated scrolling texture, create a new material with a Blend mode set to Blend_AlphaComposite and add a raindrops texture to a Texture Sample node and apply it to the Diffuse, Emissive and Opacity slots of the material.

Add a TexCoord node with the values for Utiling -2.1 and Vtiling -2.0. This increases the amount the texture is repeated on the plane. Link this node to the Co-ordinate slot of a Panner Node. Set the values of this node to Speed X 0.0 and Speed Y -1.0. This scrolls the texture vertically towards the floor.

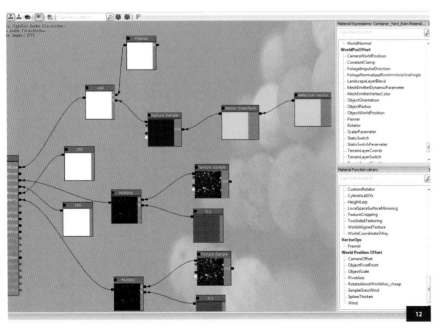

12

173

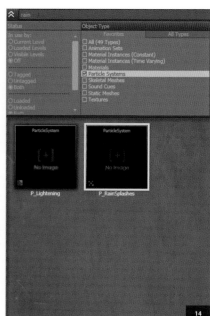

You can adjust these settings to get the correct speed of rainfall you desire. Finally, link this node to the UV slot of the raindrops Texture Sample (**Fig.11**).

"UDK comes with a PFX of raindrops bouncing up from the terrain"

Similar to the rainfall planes, add a new plane even closer to the camera. The texture on this plane will be like raindrops hitting the lens of the camera. You can create this material using the same techniques outlined in (**Fig.12**).

Fig.13 shows these planes arranged in the scene. Draw around them to show them off better. You can see the layered effect we are trying to create in front of the camera.

To add the final polish to the scene and make this scene more believable we need to show the rain hitting the floor. UDK comes with a PFX of raindrops bouncing up from the terrain. In the Content browser type Rain in the search bar and select Particle systems. Select the PFX P_Rain_Splashes (**Fig.14**).

Drop the PFX into the scene and place them around the floor near the camera. This PFX only works if it collides with objects, so you must make sure the object you want to emit rain splashes have collision.

This now completes the rainy scene (**Fig.15**). You can get some really nice results from making more complex materials. These reflective materials don't have to be just for wet materials; you can add the reflection qualities to the other lighting scenarios, they will help to bring out the light and make the scene more realistic.

This section has shown that you can easily create any type of lighting scenario quickly and easily. The freedom and power of UDK makes this possible to do, and with it being so user-friendly it is not over-complicated either.

> **You can add a Constant node and link it to the Specular Power slot of a material to make it reflective and shiny – simulating a wet surface.**

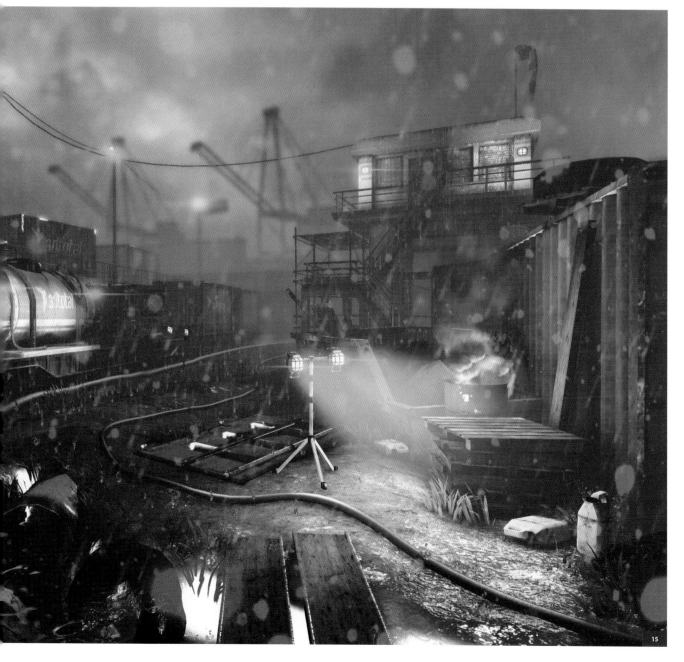

15

175

ZOMBIE TOWN
LEVEL CREATION

INSPIRATION

In this final section, I will guide you through the process of putting together a level in the art style of a side-scrolling platform game. A very good example of a game that uses this type of environment is *Deadlight*, a game created by Tequila Works. If you haven't played this game already, you should try it!

Fig.01 is a screenshot from *Deadlight,* which is an excellent example of lighting an area of interest and gameplay elements for the player to look at. The player's path is clearly visible by the lighting, so they instantly know where they have to try and get to. There is also a red light near a control panel, which indicates some sort of game function.

The exit of this little area is also clearly visible on the right; a window is boarded up but allows light to come through, telling the player that you are able to get through here with the right tools. The desaturated background keeps the player focus on the foreground and the action.

In this outdoor shot (**Fig.02**), you can clearly see the silhouette of the assets and the

> **"The sky is lovely and provides the image with an injection of color, also silhouetting the foreground and giving the illusion of more detail than is actually there"**

DEADLIGHT © 2011 *Tequila Works* 01

DEADLIGHT © 2011 *Tequila Works* 02

ground surface facing the camera. This is an important part of the art direction, as it gives some perspective to the player and is something to replicate in our environment.

In **Fig.03**, I like the way the telephone wires in the foreground and background really help tie the scene together and provide horizontal detail.

Fig.04 is interesting because it shows that the player is alone in this vast city that is falling apart in front of him, as the zombies take over. The sky is lovely and provides the image with an injection of color, also silhouetting the foreground and giving the illusion of more detail than is actually there.

DEADLIGHT © 2011 Tequila Works

03

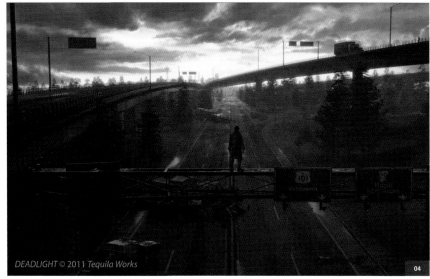

DEADLIGHT © 2011 Tequila Works

04

There are cars abandoned in the road in the distance – these provide good blocking assets. We will add assets like this in our environment to block the player's view and aid the story, to further immerse the player.

As this is the final section, I expect you to be able to follow the steps easily, without going into too much detail. If I come across a topic I haven't discussed already, I will explain it more. In the zombie town environment, the camera will be fixed on one axis and pointed in one direction. This gives us a great opportunity to focus our efforts in one area. It's important to create depth in this style of environment. Because of the fixed camera angles, we risk the environment looking flat. To combat this, we will create layers and parallax to give the illusion of distance between our layers of detail. For example, we will have objects near the camera and blacked-out, just so we can see the silhouette. Foreground objects will be where the player is located in the world. For mid-distance, we will add a near background, and for far distance, we'll create a backdrop and make the most of the parallax effect.

As the camera pans across the level, these layers will combine together at different movement speeds, to give the illusion of distant life outside of the playing environment.

ZOMBIE TOWN
LEVEL CREATION

CHAPTER ONE
UDK ASSET REVIEW

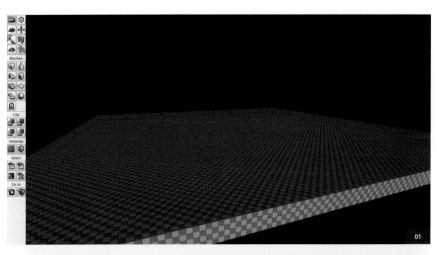

I like to start any new environment by creating a large BSP as a base, so I have plenty of room to start building on. We should create a library of assets for the scene, to quickly grab them and look at them. I find this easier to work with for small environments, rather than the Asset browser. This would be impractical for a large environment, but for what we are doing here, it is very useful (**Fig.01**).

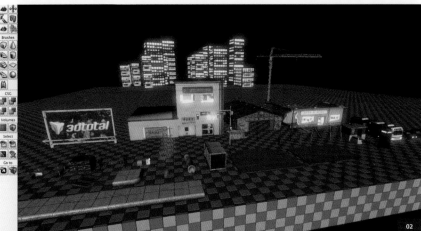

In **Fig.02**, you can see the scene with all of the assets imported into the Content browser and placed in rows within the environment.

Take a closer look at the assets I have in the scene. For the pavement, I have a straight piece and a corner piece; these modular assets are all we need to create the whole of the paved area in the map.

They fit together seamlessly. The geometry is simple, as is the texture, but it's all we need because of the third-person camera position. Small details will be lost, so there is no point using valuable time putting it into this asset.

It's also important to note that the assets won't look their best at the moment, because there is no lighting in the scene. They will all look flat – we just have to look past that for now (**Fig.03**).

For the road modular pieces, use a straight section and a T-junction piece. The texture is a bit more detailed this time, and more attention has been paid to the Specular and Normal maps because we want the lights in the scene to reflect well in the road surface. You can't see that at the moment, in this screenshot, as there aren't any lights in the scene yet (**Fig.04**).

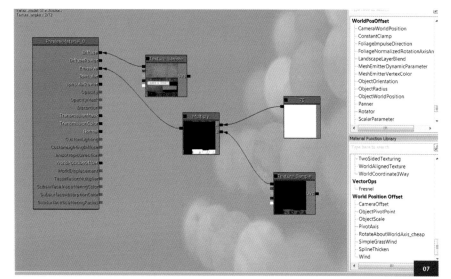

Parallax gives the illusion of distance between our layers of detail.

The NYC bus from the vehicle tutorial will serve as a focal point in the scene (**Fig.05**).

Fig.06 is an example of a building. Note the hole in the side of the building, which will tie together with the bus. The windows are Emissive – this will really help the scene come to life and be aesthetically pleasing when combined with the lighting.

To get a good Emissive material on the building's windows, add a Constant node to the material and plug this into a Multiply node, along with the Self-illumination texture – this is then plugged into the Emissive slot.

The Constant node is able to boost the output of the illumination. Add a value of 75, which is strong enough to have influence in the Bloom post-effect we will add later. This material will be quite bright and will suit the foreground. However, the background – if kept at the same intensity – will look odd. To combat this, we can copy the material and reduce the power of the Constant node to dull down the effect (**Fig.07**).

The crane in this screenshot is a little different; it's just a simple plane with an Alpha texture on it. It will be a mid-to-background asset, so the player won't be able to get anywhere near it. We can get away with it being just a 2D plane in the world. This will also give us some parallax movement I was talking about earlier, bridging the gap between the middle-ground and the background (**Fig.08**).

ZOMBIE TOWN
LEVEL CREATION
CHAPTER TWO
LAYOUT

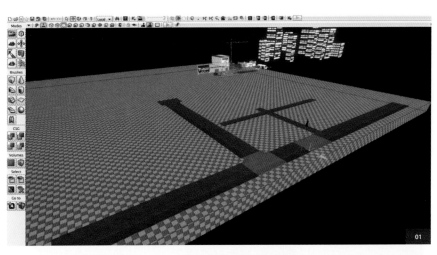

It's now time to start placing the assets and making our final environment. First of all, we need to move the assets out of the way, so push them to the back of the work area.

Selecting the two road modular pieces, start to move them into position and form the blueprint which the other assets will be placed along. At this stage it's all about realizing the space; we can always edit the layout if it turns out it's not working – that's the good thing about creating modular pieces (**Fig.01**).

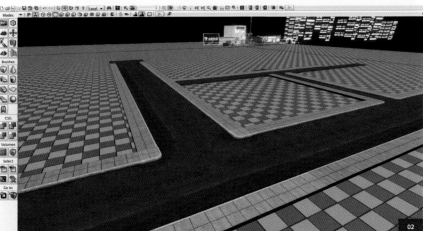

> ## "An important part of creating any playable environment is to block the player from escaping"

With the road now placed, we can begin to lay down the pavement assets (**Fig.02**).

Roughly place the large building assets – the shape and form is starting to come together now, and we can begin to think about where the other assets will be best placed (**Fig.03**). An important part of creating any playable environment is to block the player from escaping. So, we need to place a blocker asset – here we can use a security hut with the arm down.

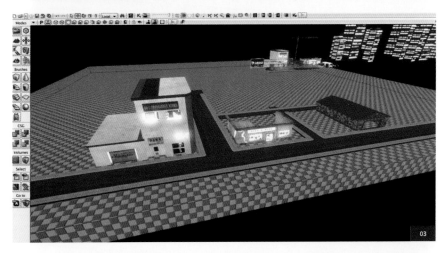

This has a good visual language to give the player enough information to realize that they cannot pass. Place this asset at both ends of the playable environment (**Fig.04**).

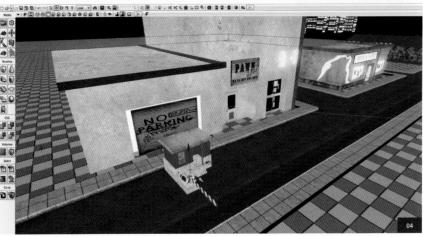

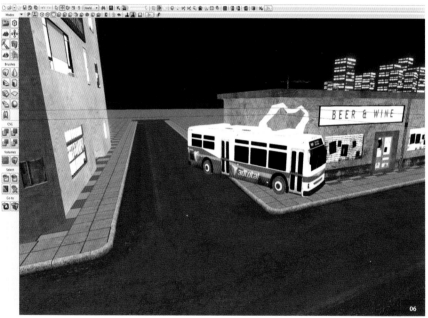

With the security hut placed, there is still some gaps around it that may cause some players to think they can still go this way. It's important to get the player to realize that this is not where they should be going. So, use the barbed-wire and concrete bollard assets to really block this area off (**Fig.05**).

The NYC bus is a key feature of this environment and it ties in with the middle building. We want it to look like the bus has crashed into the building and has knocked a hole in the wall. So place the bus up against the building, crossing over the pavement (**Fig.06**).

Still focusing on the bus area, we want to build the detail up in this area and make it as interesting as possible.

Add two cars in the foreground that have also crashed, as well as a set of traffic lights. These will do a couple of things for us: the broken signs and wires from the traffic lights will show that this is an area where bad things have happened, such as a zombie attack; secondly, because they are traffic lights, it will give us the opportunity to place interesting lights around the area, such as green and red. This will make for an interesting composition when it is finished.

Also place an additional car in the background to add life beyond the playable area. This is important and makes the scene that more believable. We can also add a billboard on top of the building to give some vertical detail (**Fig.07**).

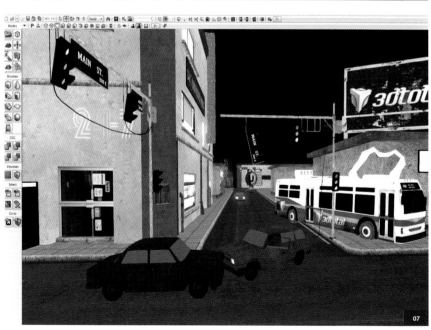

For the far background, add some high-rise buildings – these buildings have an illuminated texture applied to give the illusion of office lights being left on. This adds a huge amount of life outside the playable area and convinces the player there is a world beyond what they are playing in.

These assets are very important for the parallax movement I have previously mentioned. They also play a big part in scaling the environment. They look nice in the distance too (**Fig.14**).

In addition to the distant lit buildings, UDK has a high-rise building set with no self-illumination. Use this to break up the previous asset – they give a good silhouette in the distance as well (**Fig.15**).

With the larger assets now placed, it is time to start placing the smaller details – things that break up boring walls and harsh edges, adding that extra layer of detail.

Add pipes and support beams to the main walls. Also, where the building meets the floor, place rubbish bags, boxes and pallets – this helps buildings sit better in the world and break up uninteresting areas (**Fig.16**).

"Where the building meets the floor, place rubbish bags, boxes and pallets – this helps buildings sit better in the world and break up uninteresting areas"

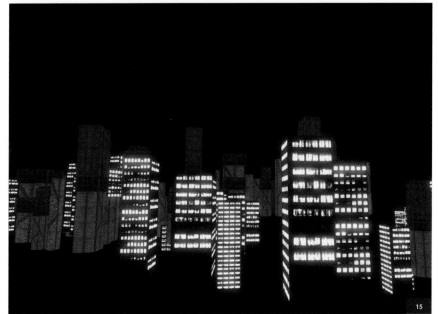

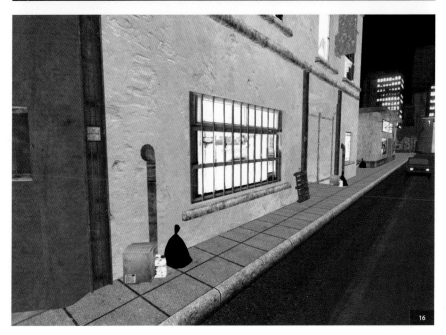

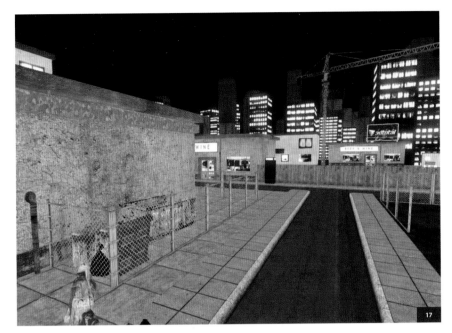

Use a combination of the smaller set-dressing assets and the mesh-fence to add extra areas of interest, like this storage and waste area (**Fig.17**).

Instead of leaving a big hole in the doorway of the large building, add a gate using the mesh-fence asset, scaling it in one axis, adding yet further detail to the building's geometry (**Fig.18**).

The motorway didn't have any supports modeled into the geometry, so it's floating at the moment. UDK has some nice pillar assets that we can use here to prop it up. This will also give us the opportunity to place assets against the pillars, as well as lights, making this area a focal point for the player (**Fig.19**).

"Place assets against the pillars, as well as lights, making this area a focal point for the player"

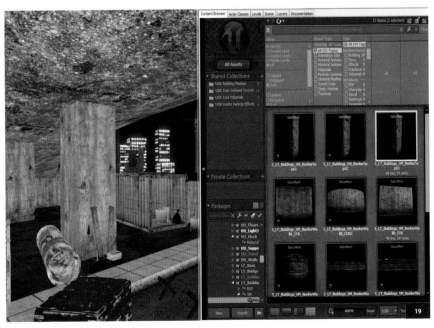

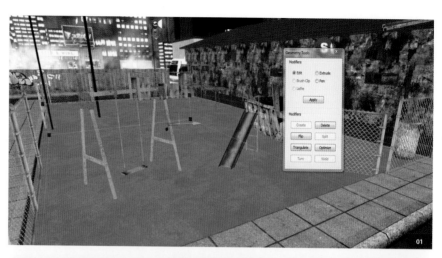

ZOMBIE TOWN
LEVEL CREATION

CHAPTER THREE
BSP AND TREE PLACEMENT

The pavement is slightly higher than the road, so we need to fill in the terrain in order for the other assets and buildings to sit on the floor. Add a simple BSP cube and make sure it sits flush with the top of the pavement.

We don't need to worry about the rear of the area because it will be hidden, just make sure there is enough room for the assets to sit on. For this area, apply a dirt material which can be found in the UDK library (**Fig.01**).

Repeat this process for under the shop buildings – only this time, add a slab texture that matches the pavement (**Fig.02**).

> ## "Trees are a very good asset; they give lots of interesting details, catch the light and cast detailed shadows"

Even though this is a town environment you will still see vegetation. So, in the playground area, give it an overgrown look. Using the UDK library, search for a grass Static Mesh and place it around the playground area (**Fig.03**).

Trees are a very good asset; they give lots of interesting details, catch the light and cast detailed shadows. They are good for filling large areas that are looking sparse and you can scale them to fill as much space as you need.

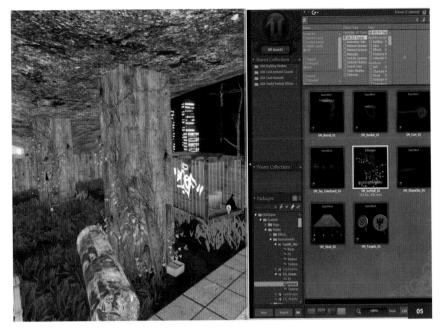

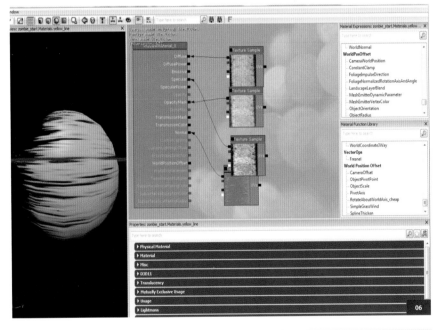

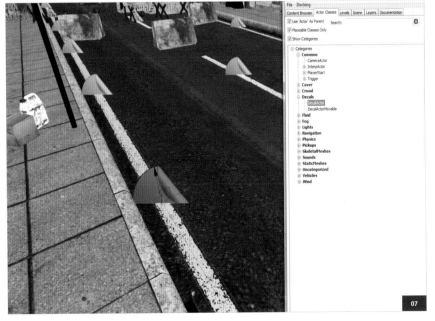

Place a large tree next to the garage in the playground area (**Fig.04**).

The pillars under the motorway have a lot of wall space with nothing on them, which is quite boring, so add some wall-climbing bushes to make this area look unkempt and overgrown (**Fig.05**).

> ## "To place the decal in the scene, select the material we just created, and in the Actor Classes window, select Decals > DecalActor and drop it into the scene"

To further break up the repeats of textures and surfaces, we can use decals to project a texture onto a surface. This will be very useful for us on the road surface – we can add white lines and graffiti onto the walls.

To be able to use a decal, we need to create a special Decal Material by right-clicking in the UDK Asset browser and selecting New Decal Material. You can then set up the material the same as any other material in the scene.

Use an Alpha texture to cut out the detail that you want to be projected. For the Alpha to take effect, we also need to change the Blend mode of the material to Blend_Masked (**Fig.06**).

To place the decal in the scene, select the material we just created, and in the Actor Classes window, select Decals > DecalActor and drop it into the scene. You can now scale, move and rotate the decals into position. You can see that I have placed the yellow and white lines in **Fig.07**.

Continue to do this for the rest of the scene along all of the visible roads (**Fig.08**).

You can see an aerial shot here showing all of the road decals in place (**Fig.09**).

Now is the time to make it interesting! Because this level is for a zombie game, we need to create an atmosphere and mood of danger – that bad things are happening!

A good way of doing this is to add blood, so we need to place some crashed cars in the scene. Using our imagination, we can give a reason for the crashed cars – maybe a hoard of zombies attacked the area and caused the vehicles to crash.

So, use blood decals to show the player that something has occurred here. Create a collection of blood designs, such as splats, drips, trails and hand prints. The blood material has high specular and reflectivity to make it realistic (**Fig.10**).

"Use blood decals to show the player that something has occurred here. Create a collection of blood designs"

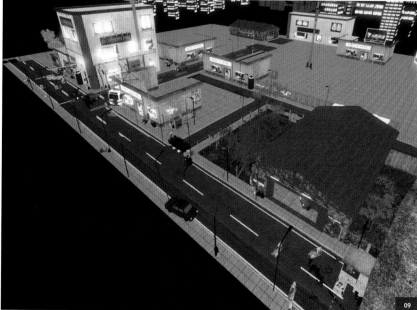

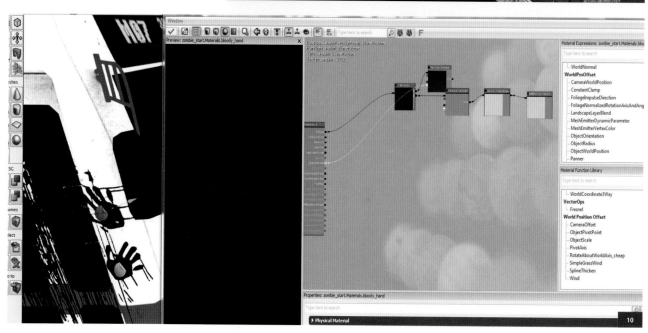

"Hand prints are good for giving the 'chill' factor, too"

Hand prints are good for giving the 'chill' factor, too. Place these decals all over the bus, particularly around the doors, with trails leading away (**Fig.11**).

Continue the blood throughout the environment, making sure to put it in places that will be visible to the player, but also making sure it looks realistic (**Fig.12**).

The security hut is also no place for refuge – blood-splatter and trails through the barbed wire can be used, as in **Fig.13**.

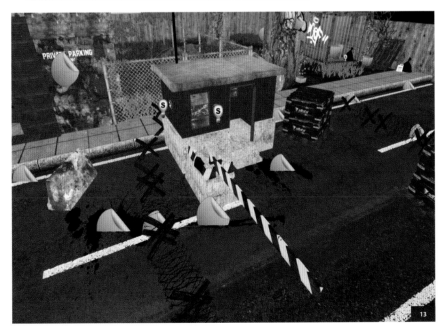

ZOMBIE TOWN
LEVEL CREATION

CHAPTER FOUR
LIGHTING FIRST PASS AND FINALIZATION

For the first lighting pass, we want to place the assets down first, before placing any light emitters. Start with the street lights; they are normally spaced out evenly along streets, so this stifles the creativity a little. To combat this, we can break some of the lights to create shadowed areas – or even flickering, damaged lights, to add to the scary atmosphere.

Fig.01 shows the typical spacing for the street lights in the scene. As well as these lights, add two additional light assets that can be found in the UDK library: a strip light and a security light.

In the Assets browser, search for 'lights' in the Static Meshes to find suitable assets. Place strip lights above the doorways and a security light on the security hut.

Continue to lay the streetlights down the un-walkable areas, spacing them out a little more down here. We don't want the area to be too bright, distracting the player from where they are supposed to be focused (**Fig.02**).

Fig.03 shows a view from above so you can more clearly see the layout design for the street lights. Note that they are also positioned down the side road and back road.

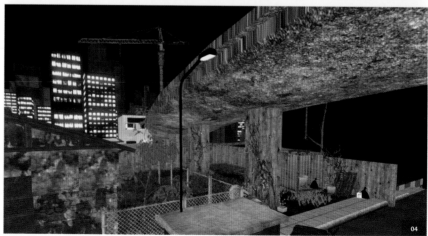

At the far end of the map, place security lights on the pillars and security hut. These are just for aesthetics – little pockets of detail to make the composition interesting (**Fig.04**).

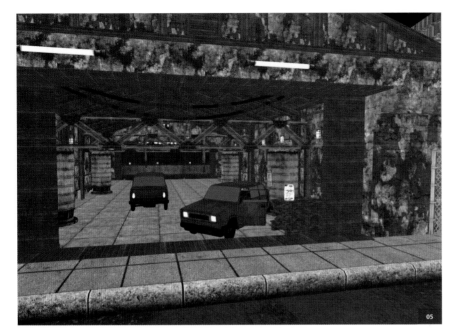

Inside the garage, place strip lights above the doorway, and wall lights along the inner walls. We will also be utilizing the lights on the cars to illuminate the scene (**Fig.05**).

In **Fig.06**, you can see the three cars and the bus vehicle. Again, we will take advantage of their headlights and brake lights to cast some interesting light and shadows in the scene.

In addition to this, place two security lights on the giant billboard to illuminate the advertisement. Also add the neon 'Open' sign to a couple of the shops.

These assets don't cast any light in the scene, so we are still working in Unlit Mode until we finish placing all the assets.

Starting with the streetlights, place Spot Lights with enough of a Radius to hit the floor and cover the terrain with enough light. Give them a light yellow color. All of these lights along the main stretch of road should have the same values, as it would look odd if they had different colors and intensities.

Give the streetlights that are in the distance – where the player will never be able to walk – different settings, so they don't stand out too much and interfere with the foreground (**Fig.07**).

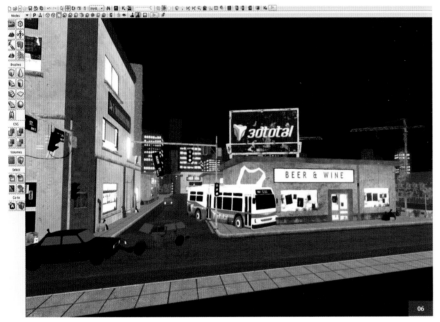

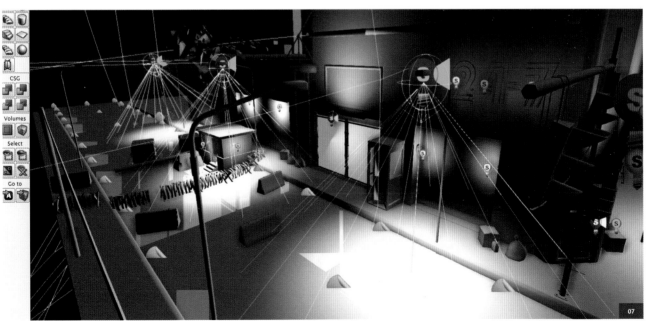

Also notice I only place the Spot Lights on the far side of the road. I don't add them on the ones closest to the camera – this is because the scene will become overpowered with light and we want the player's eyes to be drawn away from the closest assets. The lack of light will keep them in shadow and silhouetted.

Staying in this area, use Omni lights on the security lights and strip lights – this will give us contained pools of light (**Fig.08**).

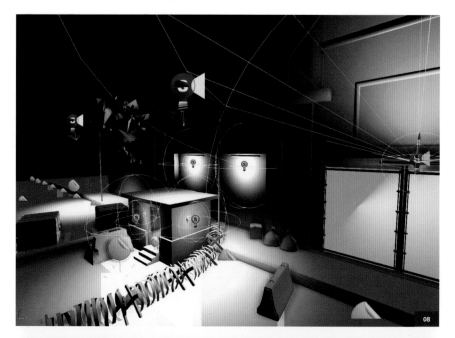

> ## "Neon lights aren't that strong – the light doesn't travel very far, so keep the Omni light's Radius quite small"

The neon sign will glow once we have added the post effects, but we still want the neon lights to emit light onto the building. Use an Omni light for each number, and color it the same color as the Diffuse texture.

Neon lights aren't that strong – the light doesn't travel very far, so keep the Omni light's Radius quite small (**Fig.09**).

Moving on to the traffic-light junction, add Spot Lights for the red lights and green lights. We want the light to be reflected on the road surface and the cars. In reality, the light from the traffic lights would not be powerful enough to light this area, but we're using some artistic license to get the effect we want!

For the other traffic lights, use a small Omni light that represents the diffuse color – this is just to illuminate the immediate area around the light and will not affect the road (**Fig.10**).

We still want the headlights and brake lights of the crashed cars in the center of this area to be working, so use Omni lights with a smaller Radius and color them red for the brake lights. The headlight is a bluish-white color and is more intense, as headlights are quite strong (**Fig.11**).

The bus headlights are slightly different, as we want to use Spot Lights for these to get a dramatic effect. The Directional Light will be cast over the rubble and shining onto the road surface (**Fig.12**).

The shop has quite intense self-illumination on the windows, which would spill out onto the road area, so place Spot Lights with a smaller Radius – but a larger cone angle – so it covers a larger area quickly. The light from the windows would spread quite quickly and fade, so the shorter Radius lets the light die in a more natural way. Give the lights a warmer, orange color to reflect the color of the inside of the shop. The building also has sign lighting, so use upward-facing spot lights to illuminate the sign, giving these a yellowish tint to replicate an ordinary lightbulb (**Fig.13**).

"Directional Light in the center of the scene; it doesn't really matter where this is placed as it is directional, but it's a good idea to keep it in a place we can find easily enough"

To finish off the shop building, there is a neon sign on the wall, so place a red Omni light with a small Radius near to the sign (**Fig.14**).

There is another crashed vehicle in the foreground that has hit a streetlight. Earlier, I mentioned that I didn't want the close streetlights to cast any light, but on this occasion, I decide to give the tilting streetlight a Spot Light. This is so it can illuminate the crashed car. The car also has blood decals over the windscreen, so the light will help to show them off to the player – in turn, creating a more chilling atmosphere (**Fig.15**).

To give the interior of the garage some visibility to the player, place wall lights along the interior wall of the garage. Add Omni lights with a warm orange color, keeping the intensity quite low so it's not too bright – we don't want the player to get distracted by the garage and thinking they can enter it.

There are also two cars inside the garage. Place the usual Omni lights for the brake lights, but this time use Spot Lights for the headlights of the car. This is so we can direct the light towards the doorway and reflect them in the road's surface.

Above the doorway, have two strip lights. We can copy the Omni lights from the previous strip lights and place them here, as they should all have the same values (**Fig.16**).

As well as the man-made lighting, we need to place the natural light. Place a Directional Light in the center of the scene; it doesn't really matter where this is placed as it is directional, but it's a good idea to keep it in a place we can find easily enough.

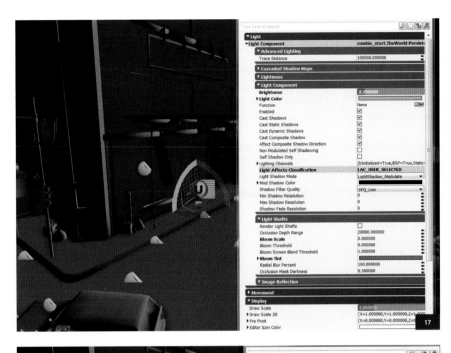

17

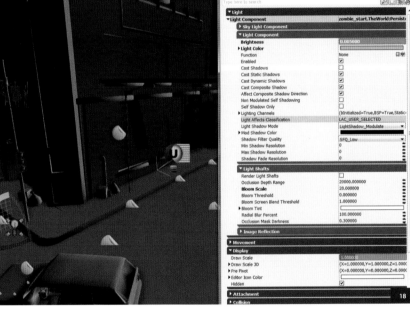

18

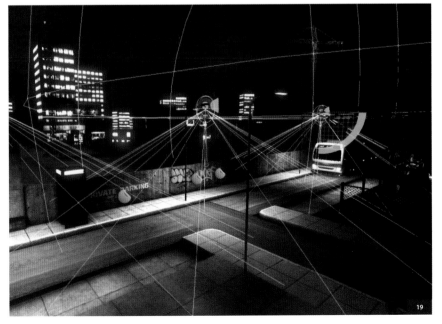

19

Point this light towards the camera, away from the main city. Use a low Brightness and give the light a warm orange color. We choose this color because we want it to look like the light pollution from the city is filtering down to where the player is. Also, the results we get from this color are more pleasing than if we were to use the color of the sky (**Fig.17**).

"You're always going to get some bounce light illuminating the shadowed area when lighting an exterior environment"

Now we have a Directional Light in the scene, it will put all of the back faces in shadow. This isn't natural – you're always going to get *some* bounce light illuminating the shadowed area when lighting an exterior environment…

We can place a special kind of light that doesn't cast shadows and doesn't have a direction. In the Actor Class browser, look for a Sky Light and drop this into the scene. It doesn't matter where it is placed. Keep the value very low – just enough to have an effect on the shadowed areas. Give it a light-blue color (**Fig.18**).

The road running horizontally behind the shop and garage also has streetlights placed, so add Spot Lights to these, but this time make the cone angle larger to affect more area. The intensity is a bit lower than the lights in the foreground, so they don't compete with them (**Fig.19**).

The 2D cranes in the background are looking a little flat, so add some Omni lights to represent the red warning lights you see on high objects in the city. Also, add a white Omni light to make some of the diffuse texture visible (**Fig.20**).

The abandoned car has fire coming from the barrels, which will cast light here. So place an Omni light with a smaller Radius and an orange color (**Fig.21**).

Add Omni lights with a slightly larger Radius onto the pillars under the motorway, so it casts light onto the motorway geometry. I like the way the lights pick out the silhouette of the foliage and graffiti on the walls (**Fig.22**).

> ## "I like the way the lights pick out the silhouette of the foliage and graffiti on the walls"

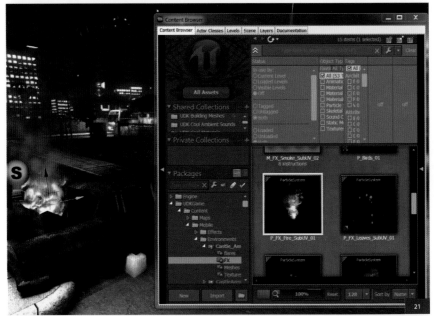

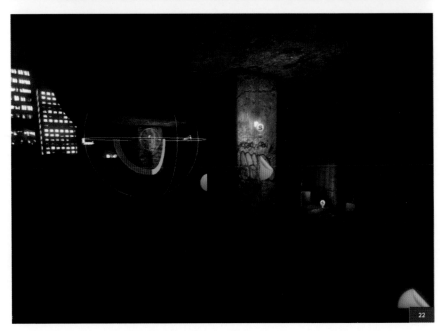

UNREAL
GAME ENGINE

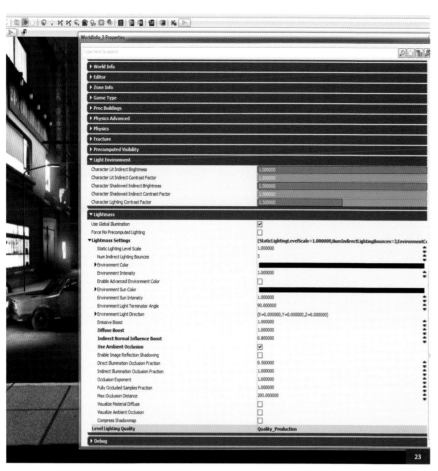

23

"Now it's time for a final bake, using the production settings to get the best quality possible"

We now need to enable Lightmass so UDK can calculate the bounce light in the scene. In the WorldInfo Properties window, scroll down to Lightmass and make sure Use Global Illumination is enabled, as well as Use Ambient Occlusion. The Ambient Occlusion will really help our assets bed down into the environment, and not look like they are floating (**Fig.23**).

Now it's time for a final bake, using the production settings to get the best quality possible (**Fig.24**).

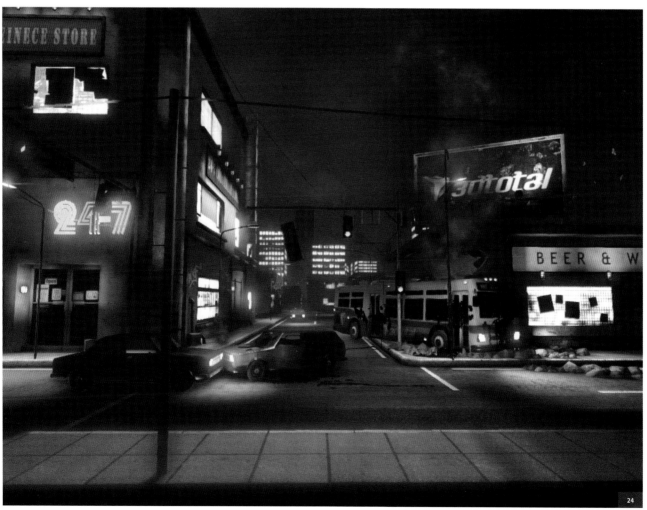

24

ZOMBIE TOWN
LEVEL CREATION

CHAPTER FIVE
SKY SET UP AND PFX PLACEMENT

The Sky Dome is a huge sphere that encompasses the environment. Use a stormy, cloudy texture with some lighter areas so it's not completely blacked out. Also, being slightly lighter, this will allow the buildings to be silhouetted better (**Fig.01**).

The material for the sky needs to be self-illuminating as we don't want any of the lights in the scene to affect the sky dome.

In **Fig.02**, you can see the material to use for the sky. Plug a Constant node with a value of 0.05 into a Multiply slot, along with the Sky Diffuse texture. This is then pushed through another Multiply node, which is then linked to an Add node and finally linked into the Emissive slot of the material.

This insures the texture's bright areas aren't glowing, which they would do if you plugged the texture directly into the Emissive slot.

Fog is very important as well; it adds a huge amount of atmosphere to the environment and gives depth to the scene.

In UDK, we can use a Height Fog Actor to add the fog to our scene. Height Fog is good because it doesn't black-fill the screen with fogging. As it is height-based, it allows us to move the actor in the Z axis to make the fog denser at the lower levels, which is much more natural.

If you wanted to create a foggy weather environment, you would move the Fog Actor higher, so more of the environment was covered. For this scene, we want the fog to stay lower.

01

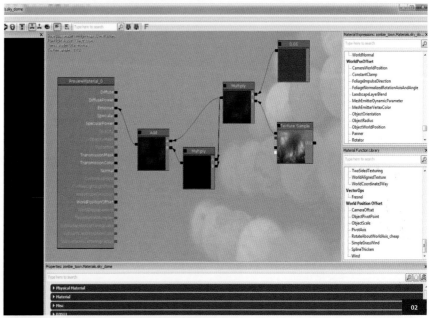

02

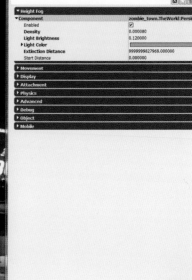

03

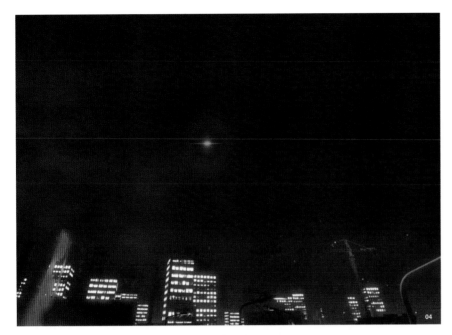

"Place special effects into the environment to really start to polish the artwork to a professional standard"

Fig.03 shows the settings to use – they are quite low but will give us the effect we are after. Use an orange tint for the fog color; this is because we want the city lights to be giving off a lot of light pollution into the atmosphere, and also the orange color best suits our color palette.

You can try using different colors and choose one that looks suitable; I almost went for a lighter bluish tint but ultimately I thought the orange was more suitable here.

We can now start to place special effects into the environment to really start to polish the artwork to a professional standard. A good effect to use is the light LensFlare; UDK has some good LensFlare in the Asset browser library – again, search for 'lens flare' and you will be given a few to choose from.

I choose a flare that has an orange glow similar to what you get in real life on streetlights. The flare also has a horizontal streak – you get this kind of effect when looking through the lens of a camera. **Fig.04** shows the LensFlare floating in the sky, so you can see it more clearly.

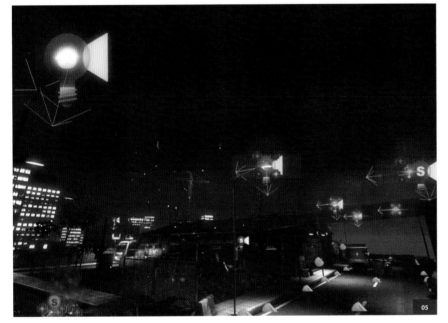

Place the LensFlare on every foreground lamppost in the scene that casts light. If you place them on the lampposts in the background, they can become overwhelming and end up ruining the composition. Position the flare just below the light, so it doesn't intersect with the geometry (**Fig.05**).

To continuing adding special effects to the environment, we now want to add particles, such as smoke and fire. Particles add movement to the scene – as a static environment is quite boring and lifeless.

UDK has a large amount of PFX in its library. Use P_FXSmoke_SubUV_01 to emit a small column of smoke from the grills of the crashed cars (**Fig.06**).

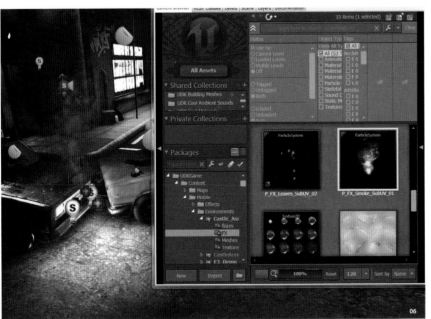

"We want to add some movement in the distance, so add a large covering of smoke rising from behind the far wall"

Place a larger plume of smoke on top of the bus to show it has just crashed into the building (**Fig.07**).

A very interesting PFX that UDK has in its library are fireflies. Place these in the abandoned play-area part of the environment – this is a dark area, so the fireflies will really stand out here. The flies also move quite quickly, adding a lot of movement to the scene (**Fig.08**).

We want to add some movement in the distance, so add a large covering of smoke rising from behind the far wall. You can't see the source of the smoke, only its effect. This also gives the illusion that something else bad has happened as a result of the zombie apocalypse (**Fig.09**).

Continue this across the road in the distance, and also add a large plume of smoke in the far distance (**Fig.10**).

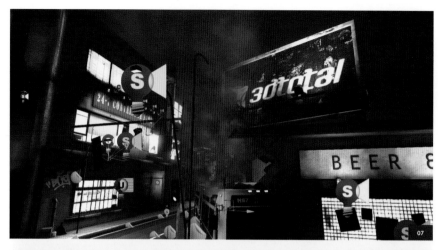

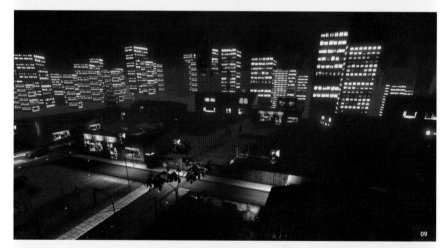

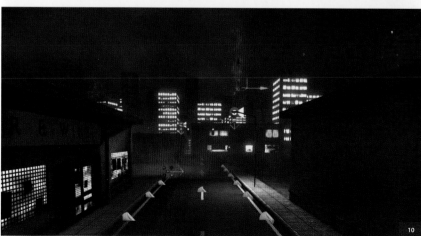

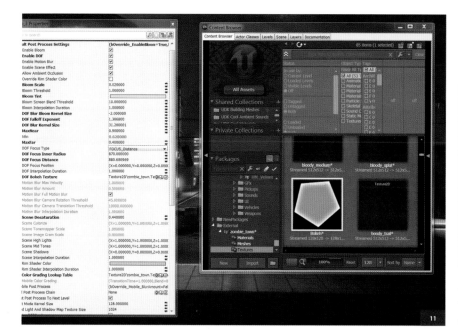

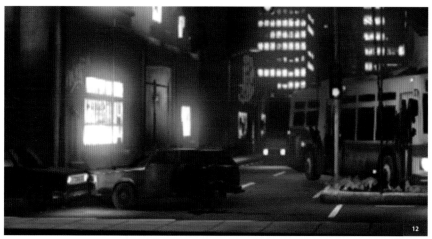

11

"You will see little pentagon shapes making up the lights, when the light is out-of-focus in the distance. It's a good, subtle effect that enhances the realism in a scene"

A good camera effect to use is called 'Bokeh'. When a hotspot of light enters the camera and is out-of-focus, you get shapes appearing – we can emulate this effect by creating a pentagon shape texture (**Fig.11**).

When you import this texture into UDK, make sure you change the LOD Group rollout to Bokeh, or else UDK will not read it correctly. Plug this texture into the DOF Bokeh Texture setting in the WorldInfo Properties window.

Now you will see little pentagon shapes making up the lights, when the light is out-of-focus in the distance. It's a good, subtle effect that enhances the realism in a scene (**Fig.12**).

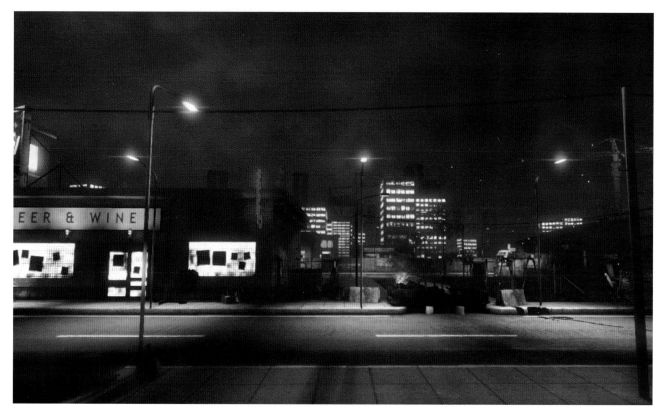

12

ZOMBIE TOWN
LEVEL CREATION

CHAPTER SIX
POST EFFECTS AND FINISHING TOUCHES

Color grading is one of the final things to do when creating your environment. You can drastically change the way your scene looks, creating many different moods and atmospheres.

As described in the previous environment sections, you can grab a screenshot of your scene to paste it into Photoshop. Drop the LUT texture onto a new layer. Use three Adjustment layers: Levels, Hue/Saturation, and Color Balance. Edit them to get the desired effect.

Use a bluish color with a slight tint of green, as this will emphasize the night-time scene. Also desaturate the scene, as this will give the horror-movie feel we want to achieve. When you're happy with your changes, hold Ctrl and click on the LUT Layer – this marquee selects the pixels in the layer.

Click on Copy Merged to copy the effect to the above layers you have on the LUT. You can now paste this into a new document in Photoshop and save it as a new texture (**Fig.01**).

When you import this texture into UDK, it is very important to change the LOD Group settings in the Import Options rollout. Change this to TextureGroup_ColorLookup. If you don't, then UDK will be reading this texture incorrectly, and the results won't be identical to what you have just made in Photoshop (**Fig.02**).

With the texture still selected, go to the WorldInfo Properties window and locate Color Grading Lookup Table. Paste the texture into the slot. You will instantly see the Photoshop adjustments appear in UDK and color grade the scene (**Fig.03**).

01

02

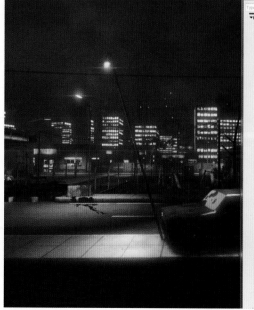

03

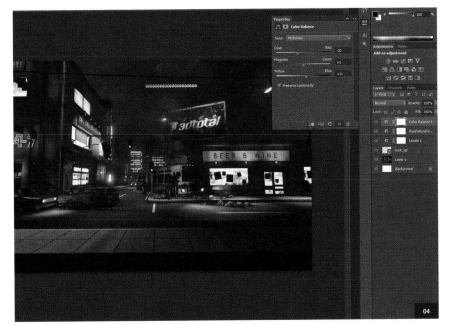

Depth of field will be of great use to us on this project. Not only can we blur the distance and focus the player's eye on the foreground, but we can also blur out the assets close to the camera that we have silhouetted, really adding to the camera effect we want to achieve.

In the WorldInfo Properties window, ensure Enable DOF and Enable Bloom are switched on. There are a few settings I tweak to get the desired results; you should play around with these settings to get a better understanding of what they all do.

The following settings are the ones I use:
- DOF Blur Bloom Kernel Size -2.0
- DOF Falloff Exponent 1.3
- DOF Blur Kernel Size 31
- Max Near 0.9
- Max Far 0.4
- DOF Focus Inner Radius 870
- DOF Focus Distance 880

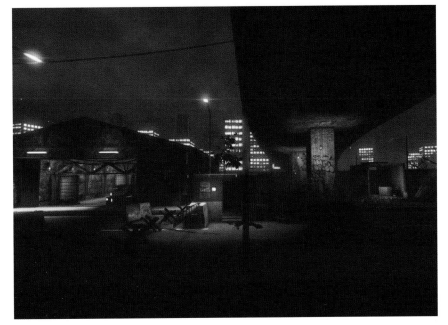

These settings give the far distance a subtle blurring, keeping the main road surface in focus, but also blur the near pavement and other assets. It is a case of trial and error to see what settings best suit your environment. With these settings now activated, the Bokeh effect really starts to stand out (**Fig.04**).

The zombie town environment is now complete; we have created a very simple level using simple assets, that looks as good as anything you will find in a game of this type released today. You will now be in a position to create exciting and detailed environments that would impress any potential employer, helping you to nail your dream job.

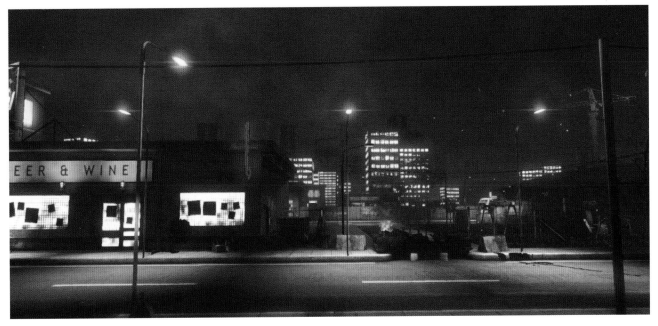

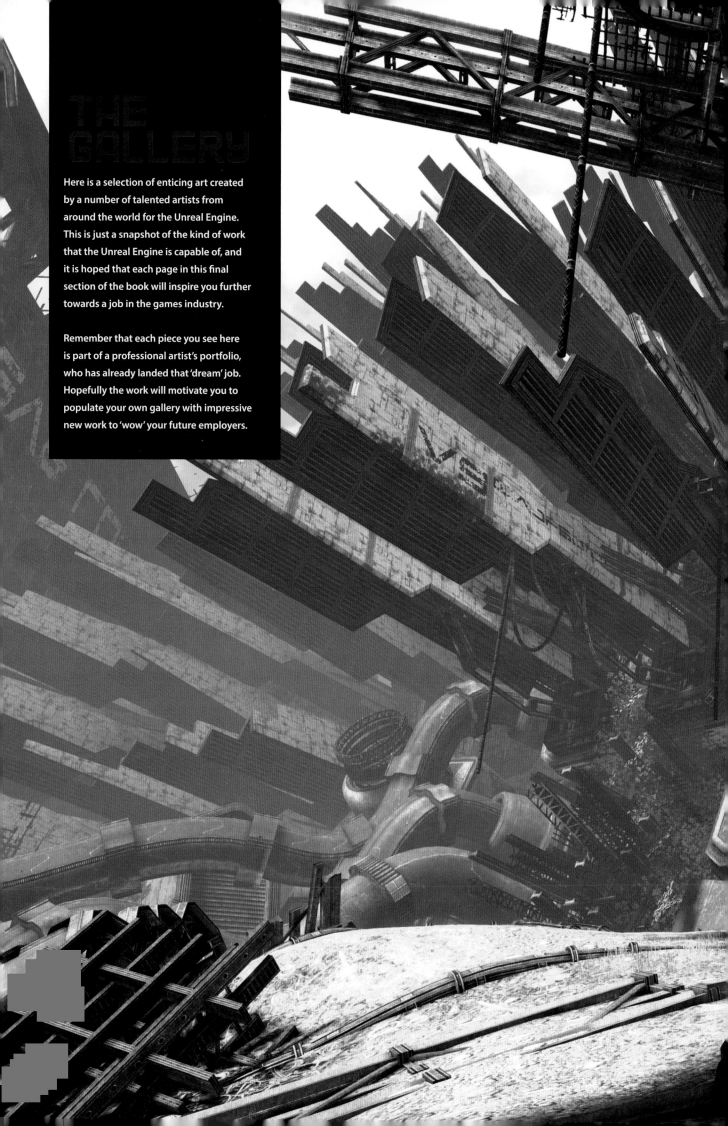

THE GALLERY

Here is a selection of enticing art created by a number of talented artists from around the world for the Unreal Engine. This is just a snapshot of the kind of work that the Unreal Engine is capable of, and it is hoped that each page in this final section of the book will inspire you further towards a job in the games industry.

Remember that each piece you see here is part of a professional artist's portfolio, who has already landed that 'dream' job. Hopefully the work will motivate you to populate your own gallery with impressive new work to 'wow' your future employers.

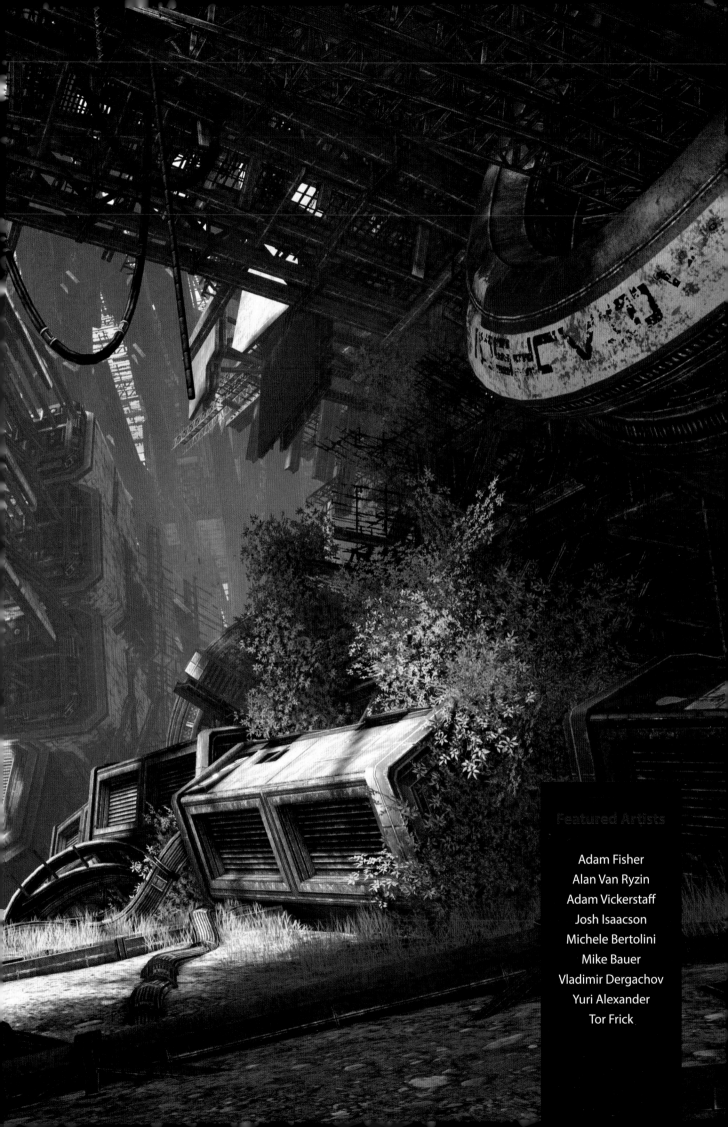

Featured Artists

Adam Fisher
Alan Van Ryzin
Adam Vickerstaff
Josh Isaacson
Michele Bertolini
Mike Bauer
Vladimir Dergachov
Yuri Alexander
Tor Frick

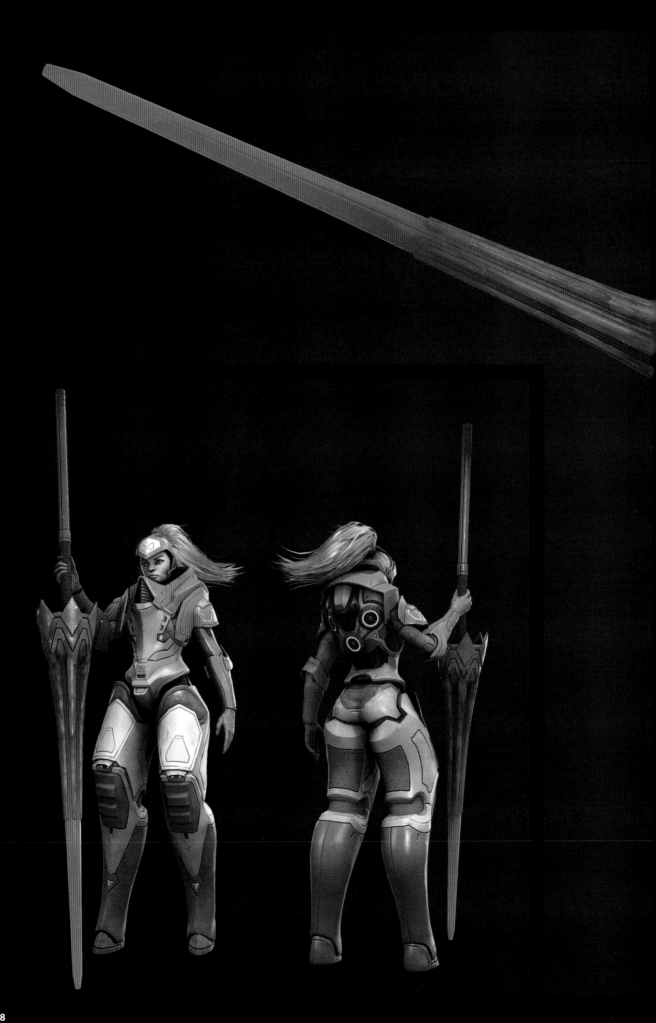

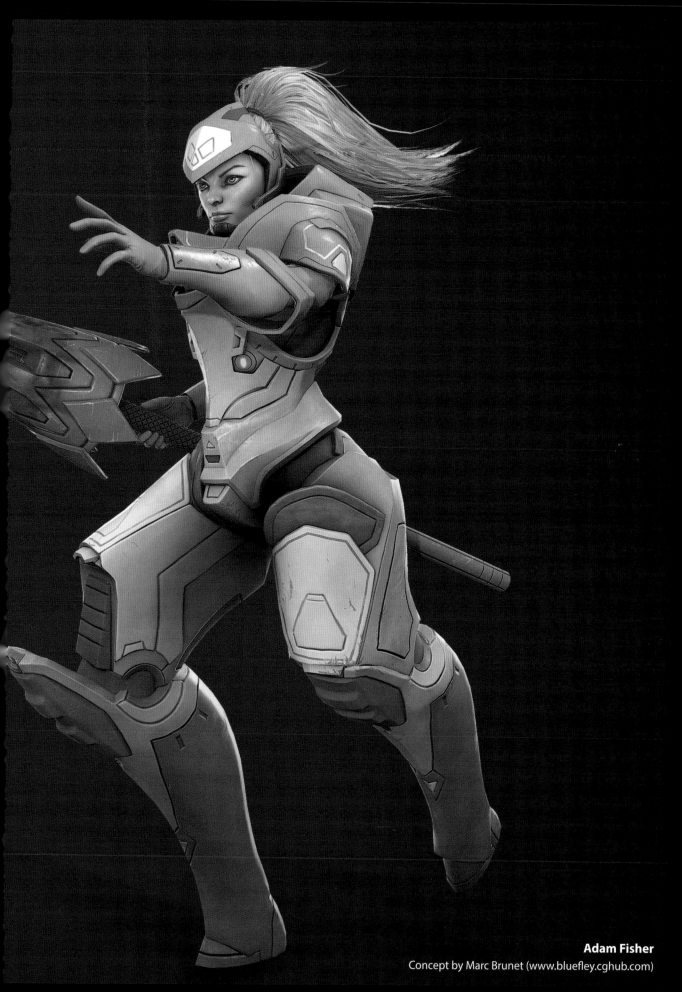

Adam Fisher
Concept by Marc Brunet (www.bluefley.cghub.com)

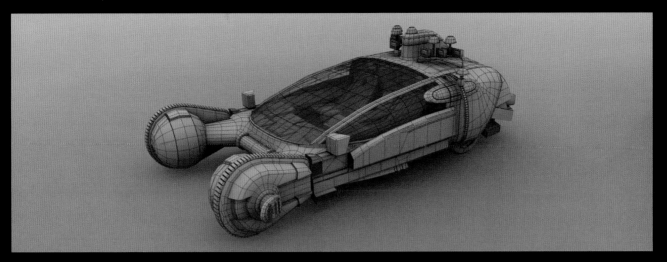

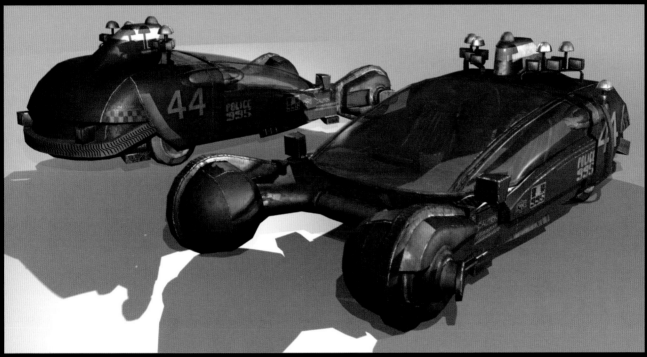

Adam Vickerstaff
www.thevicker.com
©Adam Vickerstaff 2012

© 2 Dawn 2011

© THQ 2006

© THQ 2006

© 2 Dawn 2011

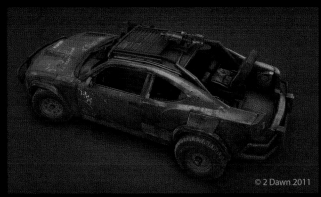

© 2 Dawn 2011

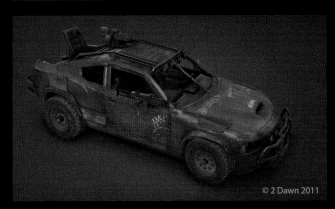

© 2 Dawn 2011

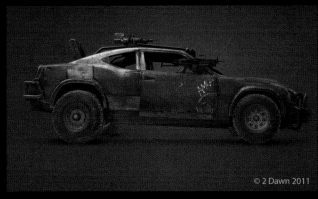

© 2 Dawn 2011

Alan Van Ryzin
www.polygoo.com

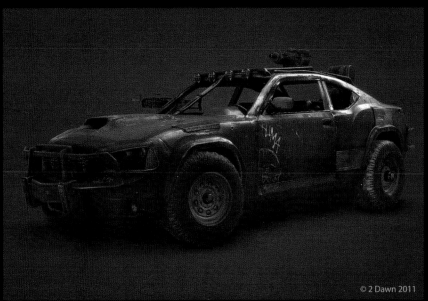

© 2 Dawn 2011

UNREAL
GAME ENGINE

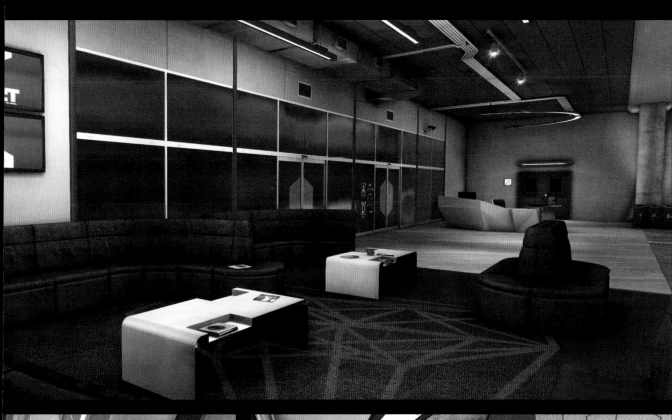

Josh Isaacson
www.josh-isaacson.com

Michele Bertolini
www.budello.com
©Michele 'Budello' Bertolini 2013

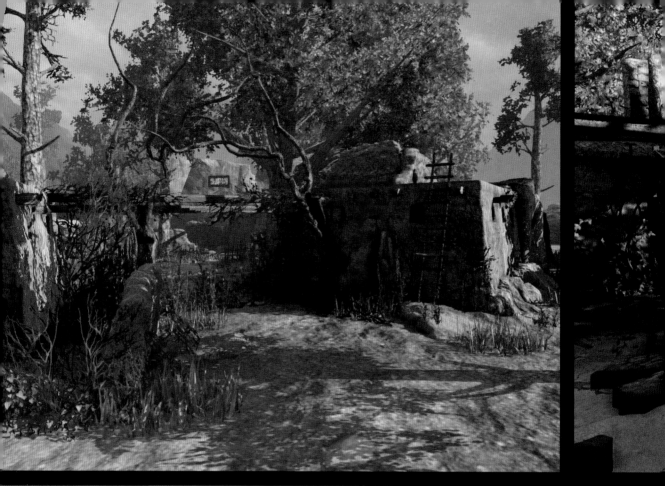

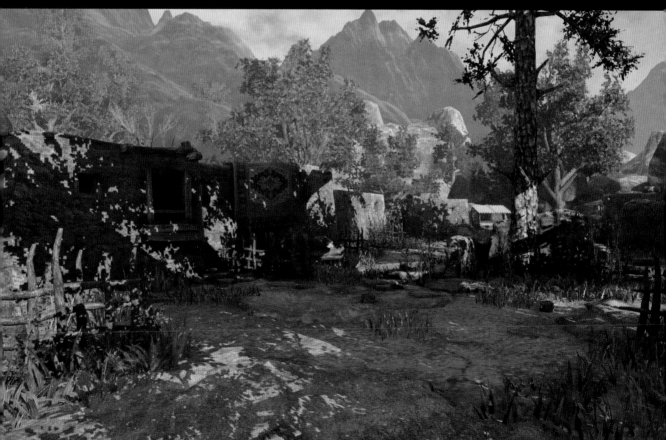

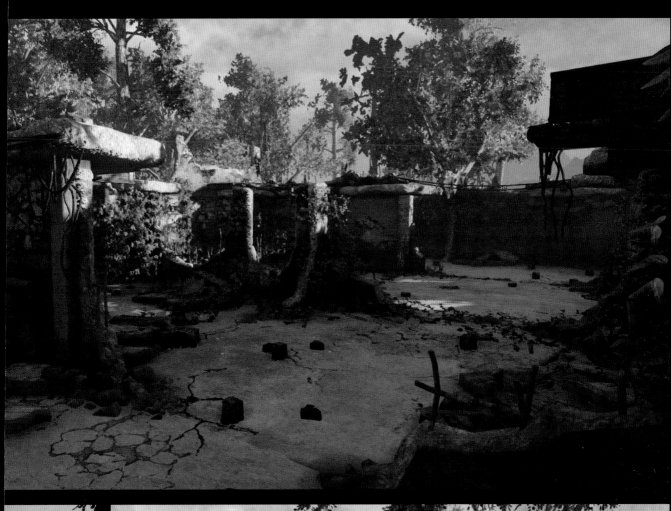

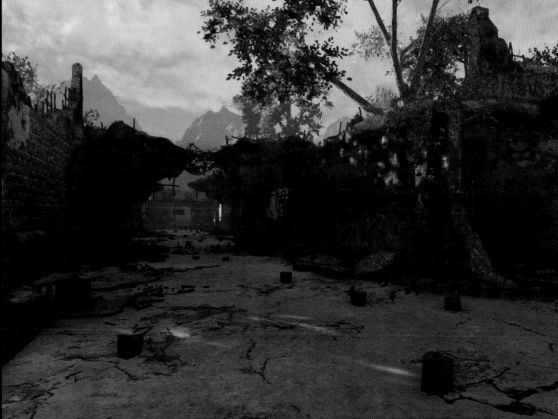

Mike Bauer
www.bauervision.com

Vladimir Dergachov
www.matroskinworks.com
©Vladimir Derachov

Yuri Alexander
www.yurialexander.com

Tor Frick
www.torfrick.com
©Tor Frick 2011

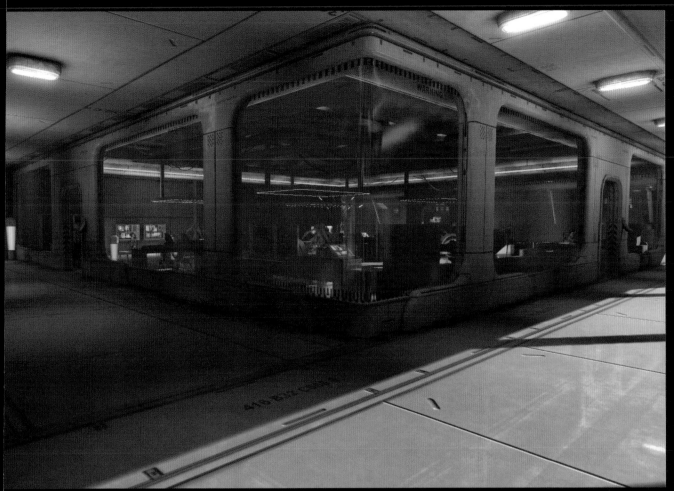

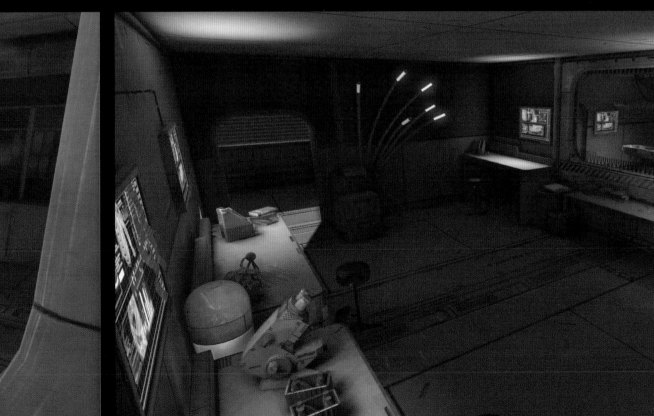

Tor Frick
www.torfrick.com
©Tor Frick 2011

Tor Frick
www.torfrick.com
©Tor Frick 2013

Tor Frick
www.torfrick.com
©Tor Frick 2013

GLOSSARY
UNREAL GAMES ENGINE

3ds Max: Modeling package.

Alpha map: A texture that creates see-through areas on a surface.

Ambient Occlusion (AO): Shadowing that occurs when two objects are in close proximity.

Bloom tint: Gives the hotspot a color tint.

Bloom: When light reaches a certain value, it bleeds out and creates hotspots.

Bokeh: The way the lens renders out-of-focus points of light.

BSP: A brush that can create geometry in UDK.

Camera: A placeable Actor to show what to render.

Content browser: UDK's way of displaying all the content for the environment.

CrazyBump: Normal map-generation tool.

Decal: An Actor placed in UDK that projects a texture onto a polygon.

Depth of Field (DOF): A way of setting the focal point for a camera.

Diffuse map: A color map to give a surface a texture.

Directional light: A direction of light with no origin.

Editable Poly: A tool in 3ds Max to enable geometry editing.

Export: Getting data out of a package.

Global Illumination: Light bounced off surfaces to illuminate other surfaces.

Height map: A black-and-white image to dictate height data when used in CrazyBump.

Import: Getting data into a package.

Light shaft: Creates a fog-like effect emitted from the light source.

Lightmass: A UDK tool that calculates Global Illumination.

Look Up Table (LUT): A way of bringing in color-grading information from Photoshop.

Marmoset Toolbag: A program to display assets in a game environment.

Material: Combines texture maps to create a surface's look and behavior.

mental ray: A rendering tool in 3ds Max.

Motion blur: Blurs the screen when it is moved.

Normal map: A map to influence how a surface reacts to light.

Omni light: A spherical point of light placed in the scene.

PFX: Particle effects

Photoshop: Texturing package.

Post process: An effect displayed on the screen to create certain effects.

Render to Texture: The process of creating a 2D image of the 3D model.

Self-illumination map: A map that creates a fake illumination.

Skeletal Mesh: A mesh that is animatable.

Sky Dome: A hemisphere of geometry to act as the sky.

Specular map: A map the dictates how a surface reacts to light.

Spot Light: A directional cone of light placed in the scene.

Static Mesh: A model imported into UDK that has no animation.

UDK: A package for creating game content.

UVs: UV mapping is the 3D modeling process of making a 2D image representation of a 3D model.

INDEX
UNREAL GAMES ENGINE

ZBrush Character Sculpting V1

Projects, Tips & Techniques from the Masters

"Often you find a little information here or there about how an image was created, but rarely does someone take the time to really go into depth and show what they do, and more importantly why. This book contains clear illustrations and step-by-step breakdowns that bring to light the power of concepting directly in ZBrush, using it for full-on production work and using the software with other programs to achieve great new results."

Ian Joyner | Freelance Character Artist
http://www.ianjoyner.com

ZBrush has quickly become an integral part of the 3D modeling industry. *ZBrush Character Sculpting: Volume 1* explores the features and tools on offer in this ground-breaking software, as well as presenting complete projects and discussing how ZSpheres make a great starting point for modeling. Drawing on the traditional roots of classical sculpture, this book also investigates how these time-honored teachings can be successfully applied to the 3D medium to create jaw-dropping sculpts. Featuring the likes of **Rafael Grassetti**, **Michael Jensen** and **Cédric Seaut**, *ZBrush Character Sculpting: Volume 1* is brimming with in-depth tutorials that will benefit aspiring and veteran modelers alike.

This book is a priceless resource for:
- Newcomers to ZBrush and digital sculpting in general
- Artists looking to switch from a traditional medium
- Lecturers or students teaching/studying both traditional and digital modeling courses
- Hobbyists who want to learn useful tips and tricks from the best artists in the industry

Softback - 22.0 x 29.7 cm I 240 pages
ISBN: 978-0-9551530-8-2

Available from www.3dtotal.com/shop

3DTOTAL.COM
Visit 3dtotalpublishing.com to learn more about our book range

Photoshop
for 3d artists |v1
Enhance your 3D renders!
Previz, Texturing and Post Production

Photoshop for 3d artists

v1

3dtotal

Available Now!
Photoshop
for 3d artists |v1

"Since I started working in CG I've been looking for a book that teaches everything a 3D artist needs to know about Photoshop and drawing techniques, and this book does that perfectly and even more. I'm learning new things from every chapter. This is a must-have for every professional or student who wants to be a 3D artist."

Rafael Grassetti | Freelance Senior Character Artist: *Assassins Creed Revelations, Lords of the Rings: War in the North*
http://grassettiart.com

A comprehensive Photoshop guide exclusively for 3D artists covering key stages in the pipeline, including pre-visualization, texturing and post-production.

• Written by professionals who share the latest cutting edge techniques
• Step-by-step tutorials, highlighted tips and tricks included
• Additional links to free downloadable content such as custom brushes and scene files
• An excellent learning tool to accompany 3D design classes.

The tutorials in *Photoshop for 3D Artists: Volume 1* cover a variety of different subjects, from the initial concept stage through to post-production. Pre-viz and concepts are explored, showing the advantages of using Photoshop to plan and visualize projects. Combining library images in Photoshop to create custom textures is also featured, as well as how Photoshop can be used as an efficient alternative to lengthy render tests by focusing on compositing passes, adding particle effects, improving light and color adjustments. These post-production techniques are becoming increasingly popular within the industry as Photoshop becomes a more powerful and time-saving tool, enabling almost every 3D artist to enhance their final renders.

With the expertise of the individual contributors, the clearly written tutorials and work-in-progress images, *Photoshop for 3D Artists: Volume 1* is a timeless resource for veteran and beginner artists alike.

Softback - 21.6cm x 27.9cm | 224 Full Colour | ISBN: 978-0-9551530-3-7

3DTOTAL.COM
Visit 3dtotalpublishing.com to see our full range of book products

3D**MASTERCLASS**

THE
SWORD**MASTER**
IN 3DS MAX AND ZBRUSH

THE ULTIMATE GUIDE TO CREATING A LOW POLY GAME CHARACTER

"Any artist would be hard-pressed to find a more comprehensive and easy-to-understand character creation tutorial than The Swordmaster by Gavin Goulden. You often hear artists throw terms around like "I wish I could download your brain" or "I want all your powers" – well this is as good as it gets."
Lead Character Artist | Trion Worlds

Follow in an experienced character artist's footsteps to create a breathtaking low poly game character fit for any portfolio.

3D Masterclass: The Swordmaster in 3ds Max and ZBrush offers a truly comprehensive, step-by-step guide to modeling, sculpting, unwrapping, texturing and rendering a low poly game character. The professional workflow detailed in this book is typical of the games design industry and anyone looking to produce a portfolio-worthy character will benefit from talented character artist Gavin Goulden's extensive experience.

• Aspiring 3D artists wanting to learn a professional workflow and produce a portfolio-worthy final image
• Lectures and students teaching/studying 3D art courses
• Character artists wanting to brush-up on their character modeling workflows

Softback - 21.0 x 29.7 cm | 200 pages
ISBN: 978-0-956-817174

Available from www.3dtotal.com/shop

3DTOTAL.COM
Visit 3dtotalpublishing.com to learn more about our book range